RHAPSODIES IN BLACK

RHAPSODIES IN BLACK
ART OF THE HARLEM RENAISSANCE

Hayward Gallery institute of international visual arts UNIVERSITY OF CALIFORNIA PRESS
 BERKELEY LOS ANGELES LONDON

sbc

Jointly published by the Hayward Gallery, the Institute of International Visual Arts and
the University of California Press on the occasion of the exhibition *Rhapsodies in Black: Art of the
Harlem Renaissance,* organised by the Hayward Gallery, London in collaboration with
the Corcoran Gallery of Art, Washington D.C., and the Institute of International Visual Arts, London.

EXHIBITION TOUR

Hayward Gallery, London	19 June – 17 August 1997
Arnolfini, Bristol	6 September – 19 October
Mead Gallery, University of Warwick	1 November – 6 December
M.H. de Young Memorial Museum, San Francisco	17 January – 15 March 1998
The Corcoran Gallery of Art, Washington D.C.	11 April – 22 June

Exhibition devised and selected by Richard J. Powell and David A. Bailey
Exhibition organised by Roger Malbert, assisted by Julia Risness and Julia Coates
Architectural installation at the Hayward Gallery designed by Caruso St John

Catalogue edited by Joanna Skipwith
Designed by Martin Farran-Lee with Henrik Bodilsen
Production coordinated by Uwe Kraus GmbH

Front cover: **Archibald J. Motley Jr**, *Blues*, 1929 (detail) (cat. 87)
Back cover: **Aaron Douglas**, *Aspiration*, 1936 (cat. 18)

Cataloging-in-Publication data is on file with the Library of Congress

ISBN 1 85332 163 X (pbk) (Hayward Gallery edition)
ISBN 0-520-21263-0 (cloth) (University of California Press edition)
ISBN 0-520-21268-1 (pbk) (University of California Press edition)

Printed in Italy
9 8 7 6 5 4 3 2

Foreword

To read about Harlem in its heyday is exhilarating, especially in the words of its most eloquent protagonists. The retrospective accounts of writers such as Langston Hughes and Claude McKay are tempered with irony and political regrets. Like avant-garde movements in Europe between the wars, the black renaissance in North America in the 1920s had as many facets as there were creative people within it. It embraced all art forms, and politics in its largest sense. The history of its literature, music and art is well documented in numerous publications, and this book does not attempt to replicate those essential studies. It offers instead a selection of views from both sides of the Atlantic, by writers for whom the Harlem Renaissance has a profound and living meaning.

Rhapsodies in Black focuses on a subject that has been explored in exhibitions in the United States, but never in Britain, or indeed anywhere in Europe. The exhibition seeks to recontextualise those artists who were working broadly within the frame of the New Negro arts movement, in such a way as to reflect the real interaction that occurred, between 'black' and 'white', and across borders, in the 1920s and beyond. It explores the Harlem Renaissance not as a phenomenon confined to a few square miles of Manhattan, but as an historical moment of global significance, with links to Africa, Europe, the Caribbean and elsewhere in the United States.

The fact that the Harlem Renaissance is especially significant for black British artists and writers today should come as no surprise. A common language and connected histories are reason enough; but the developing dialogue between diasporan people on both sides of the Atlantic gives an additional impetus to a collaboration such as this, which draws on the experience, knowledge and skills of art historians and curators in Britain and the United States. The premise behind the collaboration was that these differing perspectives can bring something new to the subject, something of interest to both the British and American public. That principle has been further extended in this book, where eight contributors consider aspects of the visual arts, film, theatre and performing arts of the period.

The exhibition has been devised and selected by Richard J. Powell, Professor of Art and Art History at Duke University, North Carolina, and David A. Bailey, Co-Director of the African and Asian Visual Artists' Archive, the University of East London. They have provided its essential ingredients, and we owe an immense debt to them for the originality of their vision and their tireless dedication. Similarly, we extend our thanks to our institutional collaborators: the Corcoran Gallery of Art in Washington D.C., and particularly Philip Brookman, Curator of Photography and Media Arts, who has remained whole-heartedly committed from our first meeting and has worked in close liaison with us throughout; and the Institute of International Visual Arts, London, whose Director, Gilane Tawadros, has given determined and crucial support. Not least, we are grateful to our lenders, who have responded so generously and positively to our requests to borrow works. Many others have helped as the project has developed; they are listed in the Acknowledgements, and we thank them warmly for their contributions.

It is particularly gratifying that this exhibition, which originated as one of the Hayward Gallery's National Touring Exhibitions, is receiving showings not only at the Hayward in London, at Arnolfini in Bristol and at the Mead Gallery at the University of Warwick, but also in the United States at the M.H. de Young Memorial Museum in

San Francisco and the Corcoran. We are delighted that the exhibition stimulated a collaborative project at London Printworks, where the New York artist Glenn Ligon worked with British artist Yinka Shonibare in the months leading up to the show, reminding us that the issues of the Harlem Renaissance still resonate today.

Writer and broadcaster Paul Oliver has provided a selection of outstanding music of the period, which we anticipate will accompany the exhibition on its journey in Britain and the United States. The education programme associated with the exhibition at both its British and American showings has been partly funded by a grant from the Annenberg Foundation, and we are grateful to them for helping our joint initiative to extend into this crucial area of activity.

Susan Ferleger Brades
Director, Hayward Gallery

Roger Malbert
Senior Curator, NTE, Hayward Gallery

Acknowledgements

We thank the following:
Paula Allen, Maria Amidu, Petrine Archer-Straw, John P. Axelrod, Stephenie Barron, Lutz Becker, Carolyn Blackmon, Lauren Bon, David Boxer, Sonia Boyce, Elizabeth Broun, Timothy Burgard, Mary Ann Calo, Mary Cash, Eddie Chambers, Ruth Charity, Karen Cirillo, John Cowley, Amanda Daly, Amina Dickerson, Howard Dodson, Brent Edwards, Ali Emory Evans, Walter and Linda Evans, Marquette Folley, Hugh Ford, Merry Foresta, Janet Fries, Lindsay Fryer, Solomon and Harriet Fuller, Henry Louis Gates Jr, June Givanni, Thelma Golden, Michael and Teresa Grana, Richard Green, Howard Greenberg, Stuart Hall, Deborah Hamlin, Linda Hartigan, Mark Haworth-Booth, Beth House, Tessa Jackson, Thomas Johnson, Kellie Jones, Loïs Mailou Jones, Isaac Julien, Robert Kashey, Harriet and Harmon Kelley, Gwendolyn Knight, Chap Kusimba, Diana Lachatanere, Josephine Lanyon, Jacob Lawrence, Tammi Lawson, Jem Legh, Robert and Carrie Lehrman, David C. Levy, Glenn Ligon, Robert Littman, Richard A. Long, Virginia Mecklenburg, Cynthia Moody, Archie Motley, Laura Mulvey, Donna Mussenden VanDerZee, Paul Oliver, David Page, Julia Peyton-Jones, Harry S. Parker III, Mike Phillips, Aminah Pilgrem, Michael O'Pray, Mr and Mrs Tjark Reiss, Francoise Reynaud, Jock Reynolds, Betty Rogers, Michael Rosenfeld and Hallie Harrisburg, Maria Carmen Salis, Lawrence Savoy, Mark Sealy, Jacqueline Serwer, Sarah Shalgosky, Helen Shannon, Mieke Smith, Pauline de Souza, Janet Stanley, Gary Stewart, Jeffrey C. Stewart, Betty Teller, David Thompson, the Estate of Thurlow Evans Tibbs Jr, Els van der Plas, Kirsten Verdi, Charmaine Watkiss, Steven Watson, Joyce and George Wein, John Wetenhall, Adriana Williams, Valena Minor Williams, C.T. Woods-Powell, Beryl Wright and Tomas Ybarra-Frausto, Mary Yearwood.

In Memoriam Thurlow Evans Tibbs Jr (1952-1997): a collector, chronicler and patron of African-American art and culture

Lenders

Addison Gallery of American Art, Phillips Academy, Andover
The Amistad Research Center, Tulane University, New Orleans
The Art Institute of Chicago
John P. Axelrod
Wallace Campbell
The Cecil Higgins Art Gallery, Bedford
The Corcoran Gallery of Art, Washington D.C.
The Walter O. Evans Collection
Henry S. Field
The Field Museum, Chicago
Harriet Fuller
Michael and Teresa Grana
Hampton University Museum, Virginia
The Harmon and Harriet Kelley Collection
Milwaukee Art Museum
Cynthia Moody
Archie Motley and Valerie Gerrard Browne
Museum of Art and Archaeology,
 University of Missouri-Columbia
Donna Mussenden VanDerZee

National Museum of American Art, Smithsonian Institution,
 Washington D.C.
The National Portrait Gallery, Smithsonian Institution,
 Washington D.C.
New-York Historical Society, New York
University of Oregon, Eugene
Vernon Pratt
W. Tjark Reiss
Jock Reynolds and Suzanne Hullmuth
Schomburg Center for Research in Black Culture,
 The New York Public Library
South Caroliniana Library, University of South Carolina, Columbia
Tate Gallery
The Estate of Thurlow Evans Tibbs Jr
L. Treillard, Paris
George and Joyce Wein
Whitney Museum of American Art, New York
York City Art Gallery
Private collection, L.A. Courtesy of Michael Rosenfeld Gallery,
 New York
Private collection, Mexico, D.F.
Private collection, New York

INTRODUCTION

DAVID A. BAILEY

Rhapsodies in Black is intended to challenge conventional representations of the Harlem Renaissance and to provoke new readings of the period from a contemporary perspective. For the first time, British and American writers and curators have joined together to explore this subject in a collaborative partnership, to discuss the relation between art and social history, to look at black and white relationships, and at ideas of nationhood and internationalism. One of our aims has been to focus on the important contribution made by people from the African diaspora to the art and culture of this century.

Rhapsodies in Black initially grew out of my interest in Jacob Lawrence's 'The Migration Series'. Between 1940 and 1941, Lawrence produced a narrative cycle of sixty paintings in tempera, chronicling the great twentieth-century exodus of African-Americans from the rural South to the urban North. In 1993, the Museum of Modern Art, New York, and the Phillips Collection, Washington D.C., who each own half of 'The Migration Series', exhibited it in a number of cities in the United States. What attracted me to this work was Lawrence's conceptual use of a painted narrative, as if in a series of film stills, and the theme of migration inspired me to reflect upon the universal theme of black migration across the globe.

It was through discussions with Roger Malbert about Jacob Lawrence's work, and my reading of Henry Louis Gates's article in the October 1994 issue of *Time* magazine, about different African-American renaissance movements, that I realised that an opportunity existed for an exhibition that would introduce the British public not just to a single artist, but to a number of artists of the Harlem Renaissance period, such as Aaron Douglas, Archibald J. Motley Jr and William H. Johnson. Although the work of these artists has been published and exhibited widely in North America, it remains virtually unknown outside the United States. The idea of a major touring exhibition began to take shape, a show that would also help to establish an international dialogue between a range of artists and institutions on both sides of the Atlantic and provide a platform of debate within British visual arts and culture.

In thinking of black cultural movements outside America, it was clear to us that there were certain parallels between the ideas and issues that concerned the artists and writers of the Harlem Renaissance and those of black artists in Britain during the 1980s. There was in Britain at that time what could be described as a black renaissance movement, in which black artists, curators and cultural practitioners began developing work which prised open new perspectives on black experiences and identities. One cannot, for example, look at the work of independent film-makers such as Isaac Julien and Martina Attille without seeing parallels with the work of Oscar Micheaux; the writings of Rhodes scholar Stuart Hall with the philosophy of Rhodes scholar Alain Locke; the theatrical work of Double Edge Theatre with the work of Orson Welles's Mercury Theatre Group; the music of Courtney Pine, Sade and Soul To Soul with the sound of Fletcher Henderson and Bessie Smith; or the visual art of Keith Piper, Sonia Boyce, Zarina Bhimji, Sokari Douglas Camp and Rotimi Fani-Kayode with the work of Aaron Douglas, Loïs Mailou Jones and Richmond Barthé. All of these artists from the diaspora have produced modernist autobiographical works that explore issues of representing the body, migration, memory and cultural hybridity.

During these early conceptualisation stages, we invited Richard J. Powell to participate in the project. He brought to our discussions an intimate knowledge of African-American art and the fruits of his research into artistic movements across the world. In our initial meetings, hosted by the Institute of International Visual Arts, Richard Powell developed the idea of an exhibition that went beyond earlier exhibitions on this subject in three fundamental respects: by treating the Harlem Renaissance as

a phenomenon not confined to a single geographical location, but rather as an international movement linked to diasporan communities elsewhere in the world; by representing a range of media and other art forms, such as theatre, film, and book and magazine graphics; and by including the work of white artists such as Carl Van Vechten, Doris Ullman, Jacob Epstein, Edna Manley, Jean Renoir, Edward Burra and Man Ray.

Richard Powell's innovative vision stemmed from his interpretation of the complex international connections between the artists of the Harlem Renaissance era. In the late 1930s, for example, the Jamaican artist Ronald C. Moody, living in Europe, was exhibiting in the United States with artists such as Richmond Barthé, Archibald J. Motley Jr and Jacob Lawrence. Ronald C. Moody's work was put together with African-American artists not only because of the colour of his skin; it was also because the ideas, style and nature of his sculptures explored themes of modernity and Africanness which were the shared vision of the artists with whom he was exhibiting. Stylistic and iconographic references to an African heritage can be found in the work of many other artists of the early modern period. Not all of these artists were Harlem-based, nor were all of them African-American, and not all of them were black.

Examples of these interconnections can be found in all art forms. Orson Welles's *Macbeth* production of 1936 was influenced by the writings of Aimé Césaire and by international events in the Caribbean, which Welles masterfully integrated and visualised in a theatre in Harlem, in collaboration with a number of black artists and performers. In her studio in Paris, Loïs Malou Jones painted *Les Fétiches* in 1938, with its African mask and Haitian symbolism. In the film *Songs of Freedom* of 1936 (shot in London and on location in Africa), Paul Robeson discovered his African royal ancestry. Jacob Lawrence's first major series of paintings, produced in Harlem, focused on the life of Toussaint L'Ouverture, the leader of the first Caribbean revolt in Haiti, in 1804. Josephine Baker, in a French feature film of 1934, *Zou Zou*, performed in a Paris night-club as a caged bird singing about her 'beloved Haiti'. Jean Renoir, after seeing Josephine Baker and Johnny Hudgins perform in Paris, was inspired to write and direct a short experimental science-fiction film called *Charleston*, about an encounter between a black space traveller and a white woman. The point is that these artists, black and white, were part of a movement working with new ideas of internationalism and cultural heritage. It is this broader view, rather than the definition of the Harlem Renaissance as an historical period narrowly circumscribed by the Red Summer of 1919 and the Great Crash of 1929, that has inspired this project.

The collaborative spirit of the Harlem Renaissance period is reflected in *Rhapsodies in Black*, in which film-makers, curators, performers, visual artists, art historians and cultural critics have been brought together to consider some of the key artists and issues of the time. Some writers, such as Martina Attille and Paul Gilroy, were invited to relate these ideas directly to contemporary artistic movements. Others have reflected upon a single figure, an icon of the time: Jeffrey C. Stewart on Paul Robeson, Andrea D. Barnwell on Josephine Baker, and Simon Callow on Orson Welles. Henry Louis Gates and Richard Powell have explored and mapped out a crucial moment in twentieth-century history and its impact on art and culture throughout the world.

RE/BIRTH OF A NATION

RICHARD J. POWELL

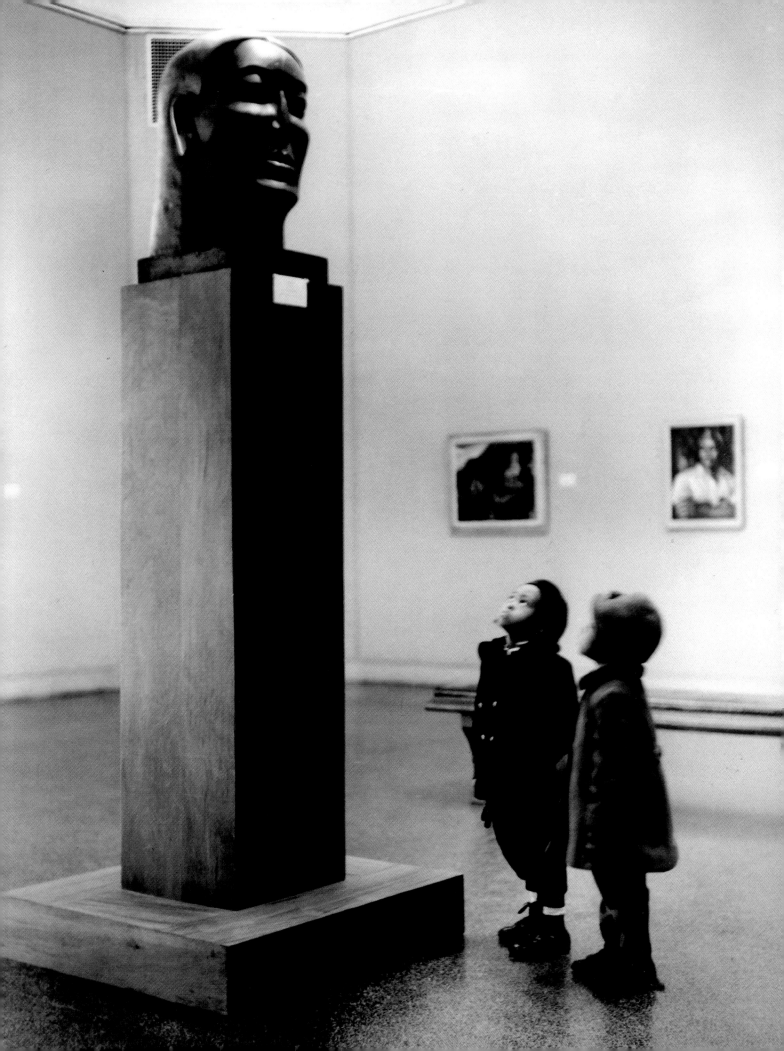

Jazz Age Harlem and Beyond

In 1923 the African-American writer Jean Toomer wrote 'Song of the Son', a poem that attempts, through imagistic writing and metaphor, to describe the peoples and landscape of the southern United States. The setting that Toomer created was one bountiful in nature and gushing with a strange, anthropomorphic life force. The last two stanzas are particularly evocative, conjuring images of an African-American past that, like fruit ripened on the vine, exude an accumulative aura of life, death, violence, artistry and remembrance.

> O Negro slaves, dark purple ripened plums,
> Squeezed, and bursting in the pine-wood air,
> Passing, before they stripped the old tree bare
> One plum was saved for me, one seed becomes
> An everlasting song, a singing tree,
> Caroling softly souls of slavery,
> What they were, and what they are to me,
> Caroling softly souls of slavery.[1]

Prior to writing 'Song of the Son' Toomer made a symbolic sojourn from a bustling, artistically rich literary scene in New York City to the insular, backwater town of Sparta, Georgia. He stayed in this bleak, southern outpost long enough to conduct an inventory of its sights and sensations, to grasp a deeper understanding of its black folk life and to obtain artistic inspiration for 'Song of the Son', which he included (along with other poems, short stories and a play) in his book *Cane* (1923), now considered one of the most important literary works produced during the period of the 'Harlem Renaissance'.

The Harlem Renaissance – proclaimed in a collection of prophetic black tracts and manifestos, and distinguished by the iconic bodies and voices of Paul Robeson, Marcus Garvey, Josephine Baker and others – was a cultural and psychological watershed, an era in which black people were perceived as having finally liberated themselves from a past fraught with self-doubt and surrendered instead to an unprecedented optimism, a novel pride in all things black and a cultural confidence that stretched beyond the borders of Harlem to other black communities in the Western world. The 'Renaissance' artists who immediately come to mind – painter Aaron Douglas, author Langston Hughes, jazz musician Duke Ellington, blues singer Bessie Smith, dancer Josephine Baker and the consummate all-round performer Paul Robeson – had certain attitudes about the black-experience-as-art that, through paintings, writings, musical compositions and performances, explored an assortment of black representational possibilities, from Langston Hughes's and Bessie Smith's images of the rural and folkloric to Aaron Douglas's and Duke Ellington's invocations of the progressive and ultra-modern.

The term 'Harlem Renaissance' (as employed by many historians and critics, especially after the 1950s) usually describes an African-American, New York City-based cultural experience. It not only locates this black creativity in Harlem but situates it between the end of the First World War and the 1929 stock-market crash and ensuing worldwide economic depression. It also refers to a particular type of art (overwhelmingly literary and musical, and occasionally visual) and frequently

Previous page:
Children looking up at Ronald
C. Moody's *Midonz (Goddess of Transmutation)*, taken in 1939
© Cynthia Moody

excludes certain art forms (like film and, curiously, graphic design) and certain artists (particularly African-Americans from places other than New York City, and European-American, European and Caribbean artists). Similarly, the term's association with the 1920s presupposes that the Great Depression (and the related, ideological shift to economic and populist concerns) interrupted this race renewal impulse. Scholarly debate about the Harlem Renaissance has too often concluded that it was no more than a decade-long window of opportunity for black culture: a lone, shooting star in what was otherwise a vast, black void of artistic gloom and inertia.[2]

However, the arts, artists and ideals of the Harlem Renaissance did not evaporate once they entered less exalted eras. Most of the major Harlem Renaissance figures continued to create important work in the 1930s and later; their legacies were handed down to the next generation of artists; and their historical importance increased in the years to follow. The celebration of this distinctly African-American time and place – recognized in the 1920s but apparently first named 'a Harlem Renaissance' in 1947 by the eminent historian John Hope Franklin – expanded with each passing decade, so much so that by the late twentieth century the idea of a burgeoning, early-twentieth-century African-American and Harlem-based cultural groundswell was endemic to modern American arts and letters.[3]

The plethora of past exhibitions and publications addressing 'the art of the Harlem Renaissance' has, however, provided little more than a series of introductory art surveys: pictorial 'roll calls' that, in their endeavor to present names and figures accurately, too often omit the artistic motives and implications of the work itself. What are we to make of Aaron Douglas's slit-eyed, streamlined silhouettes, for example, or of Richmond Barthé's sensuous African nudes in bronze? How can we reconcile the caricatured, grinning, 'darky' types in the 1930s paintings of Palmer C. Hayden? And what are we to glean from Harlem Renaissance works if the artists are *not* from Harlem but, say, from Chicago, San Francisco, the southern United States, London, Paris, or even Kingston, Jamaica? Are these works still the products of the Harlem Renaissance, or are they the fruits of some other, thus far unnamed, concurrent cultural phenomena? And what are we to garner from artists such as Carl Van Vechten, Winold Reiss and Doris Ulmann, who were passionately engaged in black representational discourses and yet not black themselves? Do we dismiss these artists entirely, or do we include them in the larger investigation surrounding the artistic pursuit of an earthy, unapologetically hybrid, subversive modernity?

In addition to focusing on the 'visual' within this black aesthetic frame, what is needed is a reformulation of the Harlem Renaissance concept: a reconceptualization that, while retrospective, is also revisionist and resourceful, given the creative, mutable presence of the Harlem Renaissance ideal in assorted post-Harlem Renaissance cultural forms (literary and art criticism, exhibitions and contemporary cinema). For the purposes of this exercise the insertion of a virgule (/) into the word *Re/Birth* (or *Re/Naissance*) underscores this act of reconceptualization. By diacritically separating the prefix *Re* (which in Latin means 'back', 'again', 'anew' and 'over again') from the suffix *Naissance* (whose Latin root *natus* refers to 'birth', 'descent', 'beginning', 'dawn' and 'rise') we emphasize the concept's original sense of cultural and intellectual renewal and its visual agenda to rediscover and recreate a modern body (in this case a black one). Furthermore, by isolating *Naissance* and encouraging aspects of the Latin suffix *natio* to re-emerge (and, consequently, allude to 'tribe', 'race', 'people' and 'class'), we invite interpretations of the *Harlem Re/Naissance* that take into consideration the movement's often overlooked objective of establishing a

new, spiritual, political, and self-conscious *nation*.

With these modifications in mind, *Harlem Re/Naissance* no longer functions as an essentially literary, racialized phenomenon, isolated from assorted art forms and creative forces in the years between the two great World Wars. Rather, *Harlem Re/Naissance* is a provocative response to a new art era: an aesthetic retort that, like Jean Toomer's anthropomorphic, plum-bearing perennial, transcends time to celebrate identity, creativity, the past, the present and the body politic. With the visual arts of the 1920s and 1930s anchored by black peoples, we can recollect and reimagine this twentieth-century moment when Harlem was not only 'in vogue', or 'on the minds' of a complacent few, but also a geo-political metaphor for modernity and an icon for an increasingly complex black diasporal presence in the world.

Black Like Me

Rest at pale evening,
A tall, slim tree,
Night coming tenderly
Black like me.

Langston Hughes[4]

Although first conceived *circa* 1920, *Ethiopia Awakening* (cat. 24) by the New England-based, Rodin-trained sculptor Meta Vaux Warrick Fuller was art for the future. In spite of the sculpture's roots in early-twentieth-century Pan-Africanist thought, and in the part classical, part allegorical forms of Antoine-Louis Bayre and Augustus Saint-Gaudens, Fuller's vision of an ancient Egyptian noblewoman, aroused and emerging from the cloth and papyrus wrappings of the dead, was a spirited message of rebirth and self-realization: an artistic statement articulated by many African-Americans in the aftermath of slavery and the post-Reconstruction period, and one that clearly resounded with black modernists in the 1920s and 1930s.

This figure, looming from a cocoon-like sculptural base, gave concrete form and signification to the uprooting and resettlement process experienced by blacks in the early twentieth century, whether African-Americans migrating in droves from the rural South to the urban North or blacks from the Caribbean and Africa moving in ever increasing numbers to Paris, London and other European cities. This diaspora-wide arousal, akin to a reawakening, was the rediscovery of an African identity that had been submerged under decades of peonage, servitude and stultifying tradition, but was now freed from a chrysalis-like state in order to explore and interact with an industrialized world and to see the self and other peoples of African ancestry in a new light.

In a 1925 essay entitled 'The New Negro', Howard University Professor of Philosophy Alain Locke described this transformation as not relying on older, time-worn models but, rather, embracing a 'new psychology' and 'new spirit'. Central to Locke's prescription was the mandate that the 'New Negro' had to 'smash' all of the racial, social and psychological impediments that had long obstructed black achievement. Six years prior to Locke's essay, the pioneering black film-maker Oscar Micheaux called for similar changes. In his 1919 film *Within our Gates*, Micheaux presented a virtual cornucopia of 'New Negro' types: from the educated and entrepreneurial 'race'

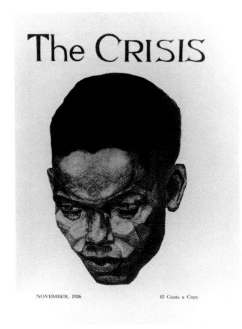

The CRISIS

NOVEMBER, 1926 15 Cents a Copy

Aaron Douglas
The Crisis, November 1926

man and woman to the incorrigible Negro hustler, from the liberal white philanthropist to the hard-core white racist. Micheaux created a complex, melodramatic narrative around these types in order to develop a morality tale of pride, prejudice, misanthropy and progressivism that would be revisited by Locke and others.[5]

Photography was another medium through which artists sought to visualize this new racial entity in modern society. A cursory look through the pages of *The Crisis* (the monthly magazine published by the National Association for the Advancement of Colored People) shows an editorial interest in depicting the 'New Negro'. From the painterly soft-focus studio portrait to the crisp identification picture (or 'mug shot') culled from assorted educational institutions nationwide, *The Crisis* visually linked the enterprising black man, woman and child to the larger, contemporaneous, race-based movement then in progress. Sociologist Charles S. Johnson's 1925 observation that a 'new type of Negro is evolving – a city Negro' was subliminally affirmed in countless photographs of black folk, dressed up and placed in front of studio backdrops or standing before elevated train stations and urban brownstone stoops. Even in the photographs of Richard S. Roberts (taken in Columbia, South Carolina, among the black businesses and homes revealingly referred to as 'Little Harlem'), a citified image of African-Americans reflected the phenomenon of a growing black urbanism and the marketing of a black urban identity to public policy advocates and the common people alike.[6]

Richard Roberts's unidentified portrait of an anonymous young man brandishing a pistol (cat. 101) – a precursor to today's 'gangsta' rap videos showing black male bravado – certainly spoke to this new, emerging black identity, but without the aesthetic allegorical airs of Fuller's chrysalis-like figure. One is reminded here of the 'con-artists' of Rudolph Fisher's assorted Harlem stories or of the mean and tough men sung about in certain blues recordings of the period. That this young man's aggressive display would have dissipated in the face of southern US white male dominance and racial violence is worth noting, yet Roberts's intentions are clear: an embodiment of power and, simultaneously, an imagined black male as social outlaw and predator.[7]

In contrast, Charles Alston's *Girl in a Red Dress* (cat. 1) depicted his 'New Negro' subject as neither allegory nor social agent but, rather, as an expressive contemporary persona. Physically elongated and resembling an African figurine, Alston's sitter had as much in common with the women in Amedeo Modigliani's Parisian paintings as with images of women from New York, South Carolina or other 'New Negro' areas. And as with the female protagonist in *The Blacker the Berry* (Wallace Thurman's 1929 novel about race, gender and self-image), Alston's woman is defiantly black, beautiful and feminine, yet also unsettled, mysterious and utterly modern.[8]

These representations of the 'New Negro' went far beyond Alain Locke's 1925 admonition that 'Art must discover and reveal the beauty which prejudice and caricature have overlaid.' By photographing this young man as a pistol-wielding transgressor, and by painting this woman as a lovely yet impenetrable enigma, Roberts and Alston challenged the stock characterizations of the modern black man and woman, investing them not only with beauty, light-heartedness and urban sophistication but with psychological depth, a Toomer-like allegiance to 'the soil of one's ancestors' and a growing social presence. These 'New Negroes' – not only *reborn*

but *self-made* – sprang from the imaginations and real-life narratives of an at times exhilarated, at other times disillusioned post-First World War generation that, despite characterizations to the contrary, took on as many forms, shapes, colors and perspectives as these modern times required.[9]

The Eternal Radio

(Harlem) is romantic in its own right. And it is hard and strong;
its noise, heat, cold, cries and colours are so. And the
nostalgia is violent too; the eternal radio seeping through
everything day and night, indoors and out, becomes somehow the
personification of restlessness, desire, brooding.

Nancy Cunard[10]

In a 1931 issue of the Parisian journal *La Revue du Monde Noir*, Paul Guillaume, the famous collector and promoter of 'modern' and 'primitive' arts, is quoted as having said that 'the mind of the modern man and woman must be Negro.' While such a claim could be dismissed as an outrageous pronouncement, the idea that modernity was at least *partially* informed by an unrecognized black diaspora factor was certainly in the air. Modern poets, novelists and playwrights of the 1920s and 1930s, who incorporated black characters into their writings (William Faulkner, Fannie Hurst, Julia Peterkin, Claude McKay and Eugene O'Neill, for example) suggest that this interest in blackness was not inconsequential. Similarly, modern musicians and composers of the same era who appropriated key elements from assorted traditional, popular and religious black musical forms (George Antheil, Duke Ellington, George Gershwin, Darius Milhaud and William Grant Still, among many others) were often forthright in their praise of (and acknowledged borrowings from) African, Caribbean and black American aural arts.[11]

In terms of visual art, the role that black people, their art and their ideas has played in the construction of modernity remains resolutely unrecognized by some. Despite the amount of documented European indebtedness to African art and peoples, recognition of the centrality of *l'art nègre* to modernist thinking and the restating of Alain Locke's theses or Robert Goldwater's writings on this subject, there are those who argue that blackness was immaterial (or even antithetical) to modernity in the visual arts. For these naysayers, blackness is equated with a fleeting, superficial fascination, more about nostalgia and timelessness than about speed, technology and the future.[12]

Yet several artists during the 1920s and 1930s succeeded in visualizing a *modern* black culture. In the works of New Yorker James VanDerZee, Washingtonian James Lesesne Wells and the San Francisco Bay area sculptor and graphic artist Sargent Johnson, black people and communities were often portrayed in a streamlined, modern 'style'. The visible markers employed in these and other artists' works read like an inventory from a Sears Roebuck catalog or, better yet, from advertisements in *Vanity Fair*: images of paved streets, factory smokestacks, Pierce-Arrow Runabouts, and 'flappers' and 'sheiks' wearing racoon coats, pomade-laden hair, and striking elegant sculptural-like poses.

In Sargent Johnson's *Lenox Avenue* (cat. 33), the legendary Harlem locale

was visualized not as an urban landscape but rather as an abstract compilation of carefully drawn elements: a pencil, piano keys, palette-like forms and, of course, Johnson's ubiquitous referencing of African facial physiognomy (as seen in his linear treatment of full everted lips). Johnson's modern black city took its form from a perceived racial distinctiveness, from the tools and implements of creativity and, most importantly, from those parts of the black body that provide speech *and* song: vocalizations that, from the black nationalist Marcus Garvey to the blues singer Bessie Smith, bore poetic witness to the modern black condition.

In the paintings of Chicago artist Archibald J. Motley Jr, signs of modernity fused with compositional fracturing and chromatic freedom, resulting in works that, while ever conscious of the figurative tradition, forged ahead with a pictorial dynamism and thematic complexity that complemented works by many European and white American modernists. Motley's *The Plotters* (cat. 91), for example – with its cubist/realist repartee and implied conspiratorial scenario – echoed similar representations of a gendered and territorial urbanism present in many 1930s paintings and films. And in Motley's *Saturday Night Street Scene* (cat. 92) the artist's recurring fascination with Chicago's 'Bronzeville' community invoked comparison with Stanley Spencer's provincial community and Phillip Evergood's 'taxi-dancing' Manhattanites. The parade of 'black, tan and beige' humanity in a street patrolled by a white cop and scrutinized by an unruly haired, impervious black girl, underscored the absurdities, dangers and possibilities of life in this new urban milieu.

With the move from small towns to cities, and with the branching out into previously off-limit professional terrains, blacks embraced a new set of rules. The proverbial, old-time 'Bandanna Days' (mockingly sung about by the popular musical duo Sissle and Blake) were superseded by a time when clothes were pressed and store-

Archibald J. Motley Jr
Black Belt, 1934
oil on canvas, 80.6 x 100 cm
Hampton University Museum,
Hampton, Virginia
© Archie Motley

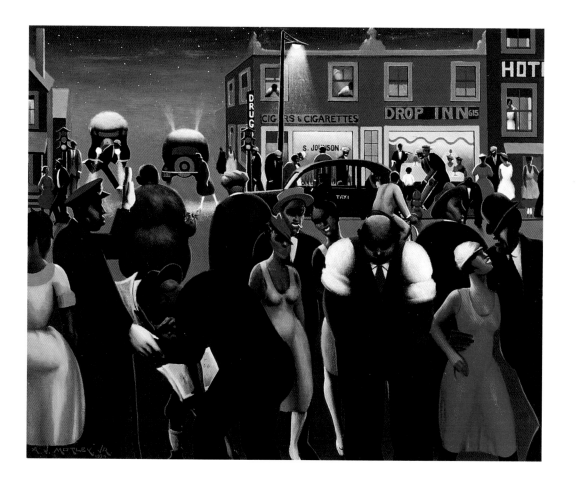

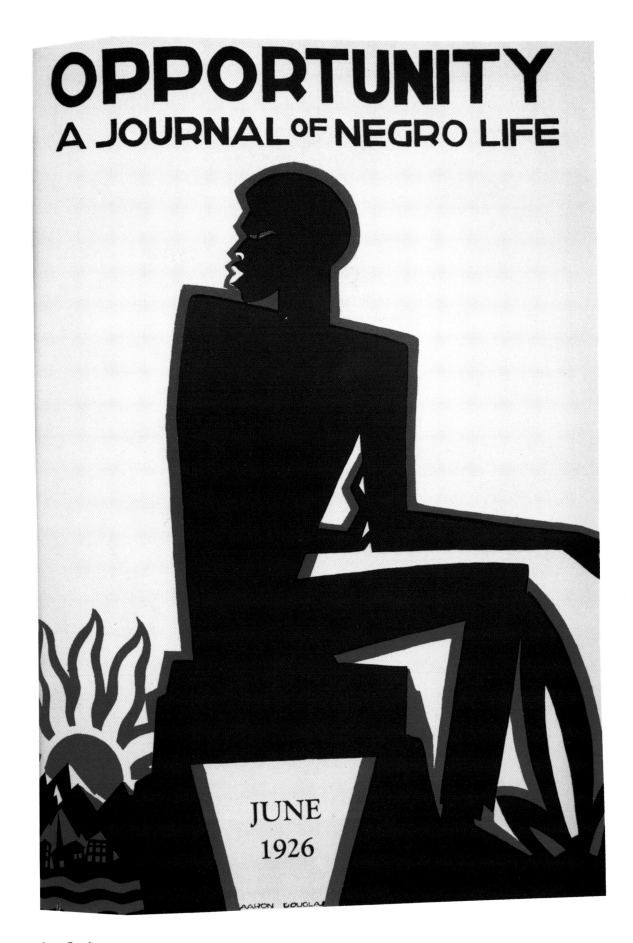

Aaron Douglas
Opportunity, June 1926

bought, and when the new invocation was 'race progress'. 'In the very process of being transplanted,' wrote Alain Locke in 1925, 'the Negro is becoming transformed.'[13]

For the African-American painter Aaron Douglas, this 'transformed' Negro was an art-deco silhouette, enveloped in tonally graded arcs, concentric circles and waves, and hieratically placed in a neo-Egyptian *jazz moderne* setting. For the British-born Jamaican sculptor Edna Manley, this same silhouetted, upward-looking entity made a cult out of progressivism, turning popular religion and mysticism into a statement on race pride. Like Sargent Johnson, Manley layered her cultural nationalist sympathies on to modern art and, in the process, made contemporary icons out of the politically awakened (and duly transformed) 'folk'. This new, diaspora-informed, black visual modernism developed out of an inherent contradiction: a celebration of skyscrapers, Cadillacs and progressivism that existed alongside indelible memories of rural shacks and mule-drawn wagons – what Aaron Douglas articulated in 1925 as his desire to create an art that was 'transcendentally material, mystically objective. Earthy. Spiritually earthy. Dynamic.'[14]

Vamped by a Brown-skin

I hate to see de evenin' sun go down,
Hate to see de evenin' sun go down,
'Cause my baby, he done lef' dis town ...

W.C. Handy[15]

Rhapsody in Blue by the Mexican artist Miguel Covarrubias represents more than an illustration of what one might have seen upon entering a Harlem cabaret in 1927. Although all of the likely characters (the blues singer, the musicians, the enthralled and slightly inebriated audience members) are there, what is also present is a synaesthetic exploration of pictorial space and color: a response to an observed, heard and sensed performance that spoke to the essentialness of a multi-experiential reception of black culture.

By way of juxtapositions, color contrasts and cylindrical, Fernand Léger-like formations, Covarrubias turned a *seen* Harlem cabaret into an *intuited* one: a composition that, like Gershwin's of the same name, moved effortlessly between the documentary, the artistic and the delirious. The earth-colored background of this cabaret scene – punctuated by deep shadows and atmospheric highlights – functioned as a machine-like counterpart to the sensuous, undulating blues singer. In her electric teal-colored dress, and with her golden, upper body pictorially frozen in an ecstatic, swaying gesture, the blues singer appears as if sprung from the big golden tuba and the quartet of black musicians behind her. And, like her 'sisters' in the audience, the blues singer's gestures communicate a *gendered* response to music, love and life that would have been understood automatically by many during 'the Jazz Age'. Although Covarrubias had only been a participant in New York City's burgeoning black cultural scene for about four years, *Rhapsody in Blue* provides evidence that he did more than simply illustrate the 'New Negro' arts movement: he visually excavated the rhythmic and emotional dimensions of black performance by placing it on the level of an aesthetic prototype.[16]

This jazz paradigm (or 'blues aesthetic') explains to some extent why the moniker 'the Jazz Age' is attached to this period. Yet critics are often at a loss as to how to articulate exactly what it was (beyond the popularity of Louis Armstrong, Duke Ellington, Bessie Smith and others) that made black music so central to a description of these times. While whites like Al Jolson, Eddie Cantor, Sophie Tucker, Bix Beiderbecke and Paul Whiteman were involved in performing and popularizing jazz and blues, most consumers of popular music acknowledged that 'Negroes' were the primary source for it, and that this racial group made jazz and blues not only *sound* different, but *appear* and *feel* different.

Even Jessie Fauset, a conservative writer, acknowledged black performing artists in the construction of a 'blues aesthetic' when (while writing for Locke's *The New Negro*) she quoted the popular saying: 'If you've never been vamped by a brown-skin, you've never been vamped at all.' In his painting *Blues* (cat. 87), Archibald J. Motley Jr placed this notion of an enticing, performance-based black agency into immediate visual action. Set in a Parisian 'Black and Tan' club (where a clientele, comprised mostly of blacks from Africa, the Caribbean and the US, would fraternize, dance and listen to the latest black American music), *Blues* gives form, color and meaning to the Harlem Renaissance idea of a part aural, part performative act of black enchantment. Motley's dense composition of cabaret patrons, wine bottles, musicians, instruments and seemingly disembodied arms and legs all add up to a pictorial *gumbo* of black creativity: a painted space where musical layering and sexual partnering parallel a fractured, cubistic approach to art and representation. But, unlike the emotional and cultural distance from artistic subject matter found in the 1920s cubist paintings of Picasso and Braque, Motley's *Blues* is bold in its racial and cultural locus, and assertive in its aesthetic privileging of black performers.[17]

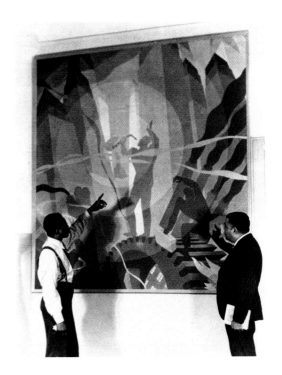

Aaron Douglas presents *Aspects of Negro Life: Song of the Towers* to Arthur Schomburg (right) in 1934
Schomburg Center for Research in Black Culture, Art & Artifacts Division, The New York Public Library, Astor, Lenox and Tilden Foundations

In *Song of the Towers* Aaron Douglas perhaps paid the ultimate tribute to the black performing artist, with his commanding image of a black man with a saxophone held high above his head. This figure, rendered in Douglas's tonally gradated and silhouetted painting style, functioned within the narrative as the embodiment of the 'New Negro Arts Movement' and the personification of the African-American experience up to 1934. As an avatar of black creativity and self-expression, the man with the saxophone is flanked by two other symbolic personae: the great African-American migration (in the guise of a running and valise-carrying figure in the lower right corner) and Depression-era apprehension (in the form of a fallen and dazed figure in the lower left corner). All three representations of a twentieth-century African-American experience are depicted by Douglas as standing upon, running on top of, or having fallen off a huge cogwheel, the same symbol of an industrial rat race that Hollywood legend Charles Chaplin would employ in his 1936 film, *Modern Times*.

Song of the Towers – along with three other paintings by Douglas collectively titled *Aspects of Negro Life* – hung over the heads of readers in the 135th Street branch of the New York Public Library with a specific mission: to celebrate past and present African-American achievements and to help viewers link art with struggle. Like Francis Ford Coppola's homage to the Jazz Age and human endurance in his 1984 film *The Cotton Club*, Douglas's *Song of the Towers* addressed an American tragedy that African-Americans were intimately familiar with during this period: dis-

illusionment with the American dream and, concurrently, the desire and longing for a home among the city's tall buildings and within a transcendent, spiritual realm. Like Ellington's metaphoric 'Harlem Airshaft', Aaron Douglas, Archibald J. Motley Jr and Miguel Covarrubias channelled African-American realities through an urban machine whose conduits and vents profoundly altered all that flowed through them.[18]

What these and other artists had discovered was that the rumbling of a stride piano, or the dipping and sliding of a black dancer, contained a host of interpretive possibilities: rhapsodies in black set against race and class politics, and capitalism's call for mechanization and depersonalization. 'Sooner or later', wrote the French Surrealist Paul Morand concerning the centrality of black performers to contemporary life, 'we shall have to respond to this summons from the darkness, and go out to see what lies behind this overwhelming melancholy that calls from the saxophones.'[19]

How Much of You is Still Savage?

My aim is to express in a natural way what I feel, what is in me, both rhythmically and spiritually, all that which in time has been saved up in my family of primitiveness and tradition, and which is now concentrated in me.

William H. Johnson

The above section title and epigraph were written in the early 1930s, the former by the Martiniquan scholar Louis Achille and the latter by the African-American painter William H. Johnson. From their respective bases (in France and Denmark) they shared an interest in the then popular notion of 'the primitive'. In his essay 'The Negroes and Art' Achille attempted to describe the 'Negro's aesthetic constitution', a sensibility informed by an innate sense of rhythm and spirituality. For Johnson, creating paintings that ultimately reflected a primal and interior self resonated with Achille's views and with those of the European modernists who were also proponents of primitivism. Despite the unscientific (and often racist) presuppositions of these two points of view, what they both argued for was an acknowledgement of the cultural importance and artistic genius of the 'folk'.[20]

The inspirational capacity of the 'folk' (and 'black folk' in particular) was perhaps most evident in the writings of the period. Jean Toomer, Langston Hughes, Zora Neale Hurston and Claude McKay all made strong cases for a focus on the lives of everyday black people, despite opinions to the contrary (W.E.B. Du Bois's 1926 art and propaganda essay, 'Criteria of Negro Art', for example). For visual artists like Malvin Gray Johnson, Albert Alexander Smith and Doris Ulmann, this same interest in the common black man and woman was part of a larger international art movement: images of the working class, examinations of labor and leisure among this socio-economic strata and figural studies on the theme of community.

To the undiscerning this modern cult of the primitive was a throwback to an earlier tradition of 'plantation' art and 'colonialist' literature. Yet Ulmann's photographs were a radical way of looking at something old and familiar: a view infused with respect, awe and (as Toomer and others implied) a modern 'ancestorism'. More difficult to distinguish from the plantation art tradition was the work of the

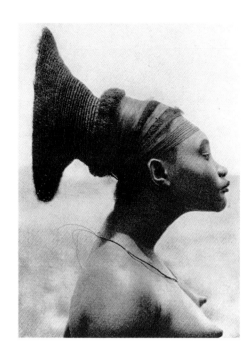

OPPORTUNITY
A JOURNAL OF NEGRO LIFE

MAY, 1927

15c

Far left:
George Specht
Nobosodrou, Femme Mangbetu,
c. 1924
from Georges-Marie Haardt's book, La
Croisière Noire, Paris, Librarie Plon, 1927

Left:
Aaron Douglas
Opportunity, May 1927

Right:
28 **Malvina Hoffman**
Mangbetu Woman, 1930

African-American painter Palmer C. Hayden. *10th Cavalry Trooper* (cat. 27), painted by Hayden in the early 1930s, had a discomforting resemblance to nineteenth-century racist black imagery. But so did many of the writings of Zora Neale Hurston, the 'Hokum blues' recordings of various musical groups and the 'downhome' antics of Louis Armstrong, Bill 'Bojangles' Robinson and other black performers. This tendency towards a humorous and expressionistic image of black culture was a terrain that many of the more radical artists were willing to enter in order to infuse their art with the totemic allure of 'the folk'. At this moment of economic deprivation, proletarianism and spiritual soul-searching, a painting like *Cavalry Man* – with its broad humor and fantastic imagery – served as a cultural pressure valve and a statement (quoting Nancy Cunard) of 'violent nostalgia' for the citizens of Harlem and other black communities in transition.[21]

Art historian Robert Goldwater argued in his 1938 book *Primitivism in Modern Painting* that this fascination with the arts and cultures of subaltern peoples was only one component of primitivism. Another major current was the celebration of the primordial in art: truth, beauty and power residing in basic elemental forms, rather than in overwrought ones. Thus the paintings of Georgia O'Keeffe, the photography of Edward Weston, the writings of Jean Toomer and the sculptures of the Jamaican artist Ronald C. Moody all subscribed to an aesthetic that, while subsumed under the tenets of a nature-inspired early-twentieth-century modernism, also embraced a decidedly non-European artistic animism. As signified in the widely published photograph of two African-American children looking up at Ronald C. Moody's *Midonz (Goddess of Transmutation)* (cat. 84), the art of the 'New Negro' was capable of making a shrine out of creativity itself and a fetish out of racial and cultural difference.[22]

Louis Achille's sarcastic question – How much of you is still savage? – was answered by many of these artists in images of the masses, in disclosures of an absurdist and at times ribald world, and in a coded art of sexuality and vitalism. Cloaked in the propriety of an art ostensibly about 'Africa' and 'the performing arts', Richmond Barthé's *Feral Benga* (cat. 4) was publicly lauded by legions of Harlem Renaissance

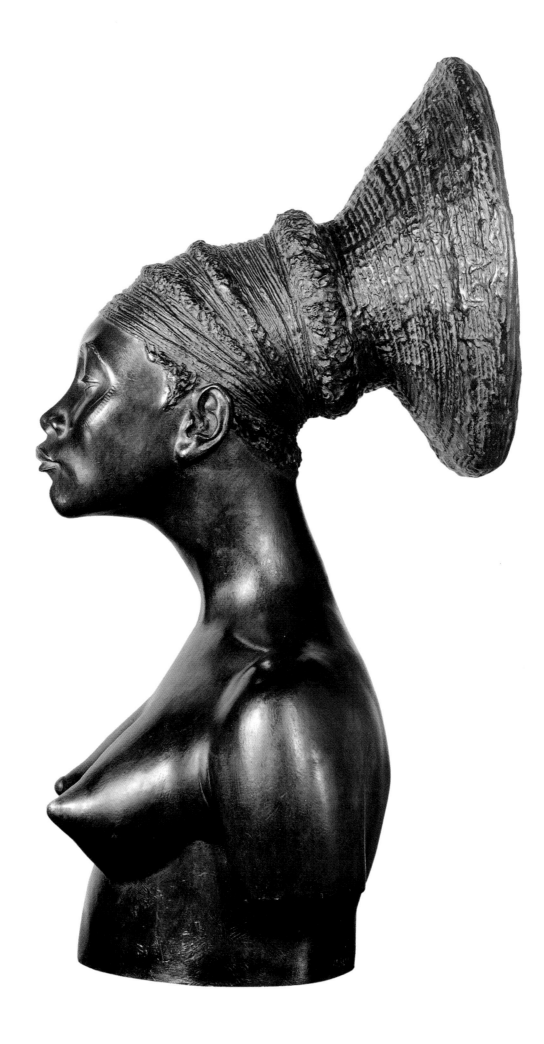

patrons, from Carl Van Vechten and Alain Locke to the administrators of the philan-
thropic Harmon Foundation. Rather than asking themselves how much of one's
nature was 'still savage', Barthé's admirers could avoid the question, although their
fondness for these veiled works of black eroticism ultimately implicated them. Barthé,
Moody, Hayden and the other neo-primitives, laboring in the asphalt and concrete
jungles of the West, willingly placed their reputations on the altar of the 'New Negro'
in the hope of obtaining recognition, recompense, or at least a modicum of personal
and professional fulfilment for this unprecedented baring of the black soul and self.

Africa? A Book One Thumbs

In 1913 the white American poet Vachel Lindsay conjured an image of Africa that,
despite almost a century of re-education and enlightened revisionism about the
continent, still remains embedded in the Western cultural conscience. In countless
literature classes students have read aloud and remembered the following lines from
Lindsay's popular poem 'The Congo: A Study of the Negro Race' with an obvious,
recitative flair:

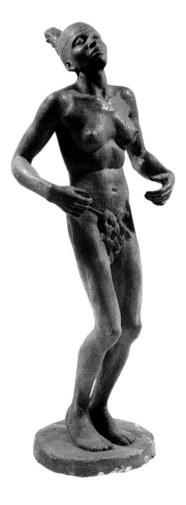

3 **Richmond Barthé**
African Dancer, 1933
Whitney Museum of American Art, New
York. Purchase 33.53

> THEN I SAW THE CONGO, CREEPING THROUGH
> THE BLACK,
> CUTTING THROUGH THE FOREST WITH
> A GOLDEN TRACK.

'The Congo' perpetuated an image of Africa that drew upon centuries of nega-
tive portrayals of Africa's peoples, cultures and geography. At the height of the New
Negro Arts Movement, these same stereotypes – Africa as dark, savage, deadly and
sensual – were employed by a range of artists, from Richard Bruce Nugent and Countee
Cullen writing about an imagined 'dark continent' to Archibald J. Motley Jr and
Richmond Barthé making art works about ethnic types and racial temperaments.
African-American singer and actor Paul Robeson also contributed to this mythology
with several films created in the 1930s, each with imaginary African settings and
Edgar Rice Burroughs-like encounters between noble whites and savage blacks.[23]

Africa's visual arts faired better, though still tainted by the broad, perceptual
spectre of primitivism. Mixing commendation with discredit, many early-twentieth-
century critics (like the avant-garde Mexican intellectual Marius De Zayas) could say
that African art was 'without history, without tradition and without precedent' and
yet proclaim that it served as 'the stepping stone for a fecund evolution in our art'.
Writings that extolled the virtues of the arts of Africa, and exhibitions that gathered
some of the most striking examples of African artistry, encouraged many visual artists
of African descent to look at their 'legacy of ancestral arts' and to base their work
upon this inheritance. For some this amounted to little more than the insertion of an
African mask or figurine into an academic still life, as if its very presence among the
flowers and furnishings racialized these paintings. For others the integration of mask-
like forms and sculptural elements into semi-representational formats was a visual
retort to Jean Toomer's prophetic African-American cultural equation: 'The Dixie Pike
has grown from a goat path in Africa.'[24]

In contrast to American notions about Africa (conditioned by long-standing

negative perceptions and an uneasy relationship with Africa's New World descendants), the French view of Africa and its peoples (informed by at least half a century of military intervention, colonialism and economic exploitation) was more complex. France's socio-political heterogeneity after the First World War, along with Paris's status as the world's cultural capital, made those parts of Africa then under French colonial dominion fodder for France's appetite for validating, appropriating and reinterpreting world culture. According to Herman Lebovics (in his 1992 book *True France*), to be 'modern in France was to seek a colonial [i.e. an African and Asian] vision of the world'. What Lebovics meant was that as a result of several large-scale Franco-African colonial projects (the Citroën-sponsored Croisière Noire expedition across Central Africa in 1925, for example, and in 1931 the Exposition Coloniale that re-created African and Asian architecture in Paris's suburbs), the modern French cultural agenda frequently placed the arts and peoples of the continent within exotic, subservient and/or hierarchical frames of reference. For example, *Noire et Blanche* by Man Ray derived its meaning not only from the juxtaposition of the head of a white Frenchwoman with a black African mask (specifically a Baule mask from the French West-African colony of Côte d'Ivoire) but from the photograph's subtext of a French regard for *l'art nègre* that often verged on the obsessive.[25]

Yet many artists (especially those who were ideologically attuned to the aspirational aspects of the 'New Negro') raised the level of discourse surrounding Africa and its peoples. During this period the African-American artist Aaron Douglas and the white American sculptor Malvina Hoffman both encountered George Specht's evocative photograph of the Mangbetu woman Nobosodru (taken in 1925 during the Croisière Noire expedition) and countered with art works of their own that spoke directly to a new racial and cultural consciousness. Douglas's drawing of Nobosodru, appearing on the May 1927 cover of *Opportunity*, signaled a shift in his art, from a generic Africa to one where pride was signified in an uplifted head and anatomical elongation. Malvina Hoffman's life-size bronze portrait-bust softened Nobosodru's exaggerated pose and transformed Specht's photograph of her into a positive black image, something rarely envisioned by white artists. Ironically, the settings for the display of Hoffman's *Mangbetu Woman* (cat. 28) – first the 1931 Exposition Coloniale and, several years later, the Field Museum of Natural History's Hall of Mankind in Chicago – added to the sculpture an ethnographic and pseudo-scientific view of Africa and Africans that would take decades to rectify.[26]

Loïs Mailou Jones's 1938 *Les Fétiches* (cat. 39) departed dramatically from these earlier depictions of Africa and Africans. The Paris-based African-American painter has merged an African art 'legacy' with the surrealistic tendencies of *l'art nègre*, reinvigorating the African mask, sculpture and spirit, and transforming them from objects of a French colonial fixation to expressive yet problematic components of a modern black identity. Like the poetry produced under the African and Caribbean literary movement known as Negritude, *Les Fétiches* emphasized Africa's rhythmic and mythic dimensions (as pioneered in Lindsay's 'The Congo') but also attributed a deeper meaning to the continent, a process of reclamation where artifacts, atmosphere and a heightened consciousness created a new sense of what it meant to be 'African' (or 'black') in the twentieth century.[27]

Envoi: Who Will Give Me Back My Haiti?

The Harlem Renaissance gradually evolved into a 'Reformation', where earlier revivalisms and innovations were pushed to unprecedented extremes (as seen in the provocative paintings of Palmer C. Hayden and Archibald J. Motley Jr), or abandoned for more socially 'relevant' positions within the arts (the community-based works of artists Aaron Douglas and Augusta Savage, for example). The cultural consequences of the Great Depression and of the Works Progress Administration's Federal Arts Projects did not make significant impact on Harlem Renaissance artists and their audiences until the middle-to-late 1930s; the ideological deviation from the 'New Negro' to the 'New Deal' was almost imperceptible.[28]

Of special note within these changing tides was the growing significance of Harlem itself. With its ever expanding boundaries and ever increasing black population, the Harlem of the 1930s was the quintessential 'city-state': a territory where Duke Ellington, Father Divine, Joe Louis and the Reverend Adam Clayton Powell Jr had hero status, and where such institutions as the Savoy Ballroom, the Apollo Theatre and the Harlem Art Workshop were shrines. Indeed Harlem's status as a 'city-within-a-city' was firmly established during these years. Ironically, a riot during the Spring of 1935 reinforced this sense of a socially isolated and culturally independent Harlem and it increasingly began to compare itself to other legendary (and embattled) 'black republics' like Ethiopia, Liberia and Haiti.[29]

Thematic forays into a black community (or a racially demarcated 'nation-within-a-nation') had actually begun long before the Harlem Renaissance (in the proto-black nationalist writings of the turn-of-the-century African-American author Sutton E. Griggs and of the pre-First World War West-African novelist J.E. Casely-Hayford). But the work of art that perhaps galvanized the Harlem Renaissance's fascination with black nationhood (and black leadership) was Eugene O'Neill's 1920 play, *The Emperor Jones*. A thinly veiled drama about the failures of Henri Christophe's despotic reign over the island of Haiti, *The Emperor Jones* was an important vehicle not only for actors like Charles Gilpin and Paul Robeson, but for visual artists as well (Aaron Douglas's blockprint illustrations for the play in 1926 and Dudley Murphy's film treatment of the play in 1933). Although *The Emperor Jones* presented the idea of black nationhood and leadership in a negative, racially atavistic light (no doubt with Marcus Garvey's 'Africa for Africans' rhetoric and his failed attempts at nation-building in mind), its focus on black agency and independence was not lost on Harlem Renaissance audiences.[30]

The history, propaganda and mystique that surrounded Haiti – beginning with the US military invasion and occupation of the island in 1915 – took on a life of its own during the Harlem Renaissance. In addition to *The Emperor Jones*, scores of novels, plays, ethnographic studies and journalistic exposés used Haiti and its peoples for a range of purposes. While Haiti's tortured political history and its cultural links to certain African traditions were viewed by many commentators as evidence of its geo-political weakness and savagery, these same attributes were viewed by others as reasons for recognizing the potential for black political power among *all* peoples of African descent and celebrating Africa's gifts (via Haiti) to world culture. With the removal of the US Marines from Haiti in 1934, this fascination with the island and its mythologies manifested itself in interesting ways, from Josephine Baker's staged musical portrayal of a caged Haitian songbird in the 1934 film *Zou Zou*, to two major

63 **Jacob Lawrence**
Toussaint L'Ouverture Series,
1937–38
No. 24: *General L'Ouverture
confers with his principal aides
at the city of Dondon.*
gouache on paper, 27.9 x 48.3 cm
Aaron Douglas Collection, The Amistad
Research Center, Tulane University,
New Orleans, Louisiana

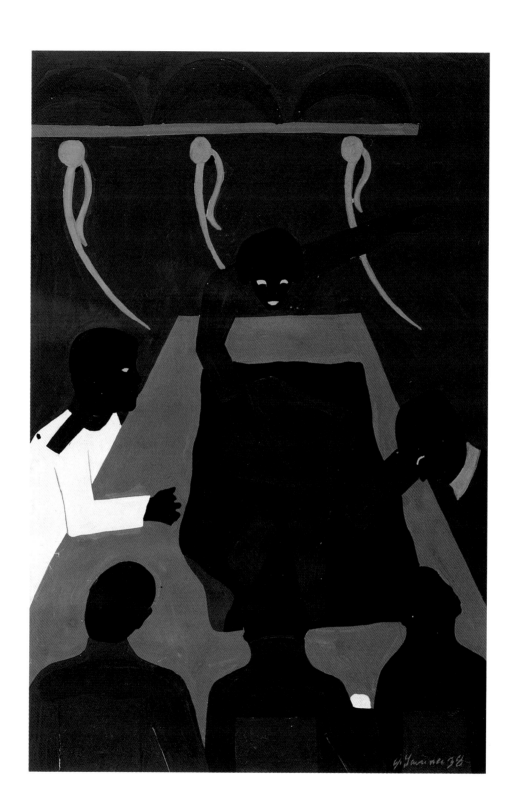

off-Broadway plays dealing with black political intrigue, Haitian-style: John Houseman's and Orson Welles's *Macbeth* (1936) and William DuBois's *Haiti* (1938).[31]

Haiti, the second of the two Harlem theatrical productions, was especially memorable for Jacob Lawrence, a 21-year-old African-American artist. Sensing that the play had parallels with contemporary life, Lawrence felt vindication for his decision in 1937 to begin a multi-panelled series of paintings on the life and deeds of Toussaint L'Ouverture, the former slave turned military leader of the Haitian Revolution. Based on historical and fictional descriptions, the DuBois play and Lawrence's vivid imagination, the 41 paintings stunned viewers at their 1939 Baltimore unveiling. Works such as number 25 – *General Toussaint L'Ouverture defeats the English at Saline* (cat. 64) – were remarked upon not only for their high-key colors and narrative strengths but for their clear and unapologetic allusions to black agency. Looking back on the *Toussaint L'Ouverture* series and its thematic volleying between Haiti and Harlem, Lawrence noted in 1941 that 'if these people (who were so much worse off than the people today) could conquer their slavery, we certainly can do the same thing.'[32]

Lawrence's observations on the sorry state of affairs that the people of Harlem found themselves in during and after the Depression, and the necessity for recognizing one's historical, cultural and political allies in the struggle for full citizenship, resonated with a statement made by W.E.B. Du Bois in 1925: 'We face, then, in the modern black American, the black West Indian, the black Frenchman, the black Portuguese, the black Spaniard and the black African a man gaining in knowledge and power and in the definite aim to end color slavery and give black folk a knowledge of modern culture.' One sees in Lawrence's *Toussaint L'Ouverture* series a response to Du Bois's 1925 call for political and economic self-awareness among peoples of African descent. Taking this challenge from one of the architects of the Harlem Renaissance, Lawrence turned first to history and then to what literary critic Houston Baker describes as a 'cognitive exploration' of culture in his reformulation of the 'New Negro' ideal.

Linking these discursive strategies to a Depression-era plea for black nation-building (Garveyesque in its origins yet street orator-like in its colorful, rhythmic style), Jacob Lawrence functioned as both the *concluder* of a Harlem Renaissance and the *convener* of another, yet-to-be-recognized, black cultural 're/birth': a 'Negro Caravan' of social realism and abstract expressionism during and after the Second World War. This reformation's invitation to impose a new social, economic and political order on to the 'New Negro' essentially rendered it obsolete. However, it was in the 1940s that the Renaissance, barely cold in its grave, was resurrected by historians and critics and, like a jazz-age 'School of Athens', found its way into the history books and annals of a modern imagination. Indeed, these Harlem Renaissance 'seeds' – once considered dry and lifeless in comparison to such 1940s 'sequoias' as Richard Wright, Charlie Parker, Lena Horne and Jacob Lawrence – became 'everlasting songs' and 'singing trees', growing strong, providing cultural sustenance and multiplying with each succeeding generation. As a late-twentieth-century, post-modern emblem of black artistic genius and community, the visual, literary, performative and ultimately conceptual dimensions of the Harlem Renaissance both illuminate a shadowy past and prescribe a brilliant future.[33]

Notes

1. Jean Toomer, *Cane* (1923), Harper and Row, New York, 1969 edition, p. 21.
2. Mary Schmidt Campbell, *Harlem Renaissance: Art of Black America*, Abrams, New York, 1987.
3. John Hope Franklin, 'A Harlem Renaissance', in *From Slavery to Freedom: A History of American Negroes* (1947), Alfred A. Knopf, New York, 1956 edition, pp. 489–511.
4. Langston Hughes, from 'Dream Variations', in Alain Locke, ed., *The New Negro* (1925), Atheneum, New York, 1980 edition, p. 143.
5. Joseph A. Young, *The Black Novelist as White Racist: The Myth of Black Inferiority in the Novels of Oscar Micheaux*, Greenwood Press, New York, 1989.
6. Charles S. Johnson, 'The New Frontage on American Life', in Alain Locke, ed., *The New Negro*, op. cit., p. 285.
7. Rudolph Fisher, 'The City of Refuge', in Alain Locke, ed., *The New Negro*, op. cit., pp. 57–74; Jon Michael Spencer, 'The Mythology of the Blues', in *Blues and Evil*, University of Tennessee Press, Knoxville, 1993, pp. 1–34; and Thomas Johnson and Philip Dunn, *A True Likeness: The Black South of Richard S. Roberts, 1920–1936*, Algonquin Books of Chapel Hill, Chapel Hill, N.C., 1986.
8. Wallace Thurman, *The Blacker the Berry* (1929), Scribner's Paperback Fiction, New York, 1996.
9. Alain Locke, 'The Legacy of the Ancestral Arts', in *The New Negro*, op. cit., p. 264; and Richard J. Powell, 'Ethiopia: Reborn and Re-Presented', in *Black Art and Culture in the 20th Century*, Thames and Hudson, London, 1997, pp. 41–50.
10. Nancy Cunard, 'Harlem Reviewed', in *Negro: An Anthology* (1933), Frederick Ungar, New York, 1970 edition, pp. 47–55.
11. Ann Douglas, *Terrible Honesty: Mongrel Manhattan in the 1920s*, Farrar Straus and Giroux, New York, 1995.
12. Robert Goldwater, *Primitivism in Modern Painting* (1938), reprinted as *Primitivism in Modern Art*, The Belknap Press for Harvard University Press, Cambridge, 1986; Abraham A. Davidson, *Early American Modernist Painting, 1910–1935*, Harper and Row, New York, 1981; William Rubin and Kirk Varnadoe, eds., 'Primitivism', in *Twentieth Century Art: Affinity of the Tribal and Modern*, 2 vols, Museum of Modern Art, New York, 1984; and George Hutchinson, 'Cultural Nationalism and the Lyrical Left', in *The Harlem Renaissance in Black and White*, The Belknap Press for Harvard University Press, Cambridge, 1995, pp. 94–124.
13. Alain Locke, 'The New Negro', in *The New Negro*, op. cit., p. 6.
14. Aaron Douglas, letter to Langston Hughes, 21 December 1925, Langston Hughes Papers, James Weldon Johnson Memorial Collection of Negro Arts and Letters, Beinecke Rare Book and Manuscript Library, Yale University, New Haven, Connecticut, USA.
15. W.C. Handy, 'St. Louis Blues', in *Blues: An Anthology* (1926), Da Capo, New York, 1990 edition, pp. 82–83.
16. Lucia Garcia-Noriega y Nieto, ed., *Miguel Covarrubias: Homenaje*, Centro Cultural Arte Contemporaneo, Mexico, D.F., 1987.
17. Richard J. Powell, ed., *The Blues Aesthetic: Black Culture and Modernism*, Washington Project for the Arts, Washington, D.C., 1989; and Jessie Fauset, 'The Gift of Laughter', in Alain Locke, ed., *The New Negro*, op. cit., p. 166.
18. See Richard J. Powell, 'Art History and Black Memory: Towards a Blues Aesthetic', in Robert G. O'Meally and Genevieve Fabre, eds., *History and Memory in African American Culture*, Oxford University Press, New York, 1994, pp. 228–243.

19. Paul Morand, *Black Magic*, Viking Press, New York, 1929, pp. v-vi.
20. Louis Achille, 'The Negroes and Art', in *La Revue du Monde Noir* 1, 1931, pp. 28–31; and William H. Johnson, as quoted in Thomasius, 'Dagens Interview: Med Indianer-og Negerblod I Aarene. Chinos-Maleren William H. Johnson fortaeller lidt om sin Afrikarejse, primitiv Kunst, m.m.', *Fyns Stiftstidende*, 27 November 1932, p. 3.
21. James A. Porter, 'The New Negro Movement', in *Modern Negro Art* (1943), Howard University Press, Washington, D.C., 1992, pp. 99–100; and Richard J. Powell, 'The Cult of the People', in *Black Art and Culture in the 20th Century*, op. cit., pp. 67–85.
22. 'Baltimore Museum becomes the first in the South to stage large show of Negro art', *Newsweek* 13, 6 February 1939, p. 26.
23. Vachel Lindsay, 'The Congo: A Study of the Negro Race', in *Collected Poems* (1925), Macmillan, New York, 1969; Richard Bruce Nugent, 'Sahdji', and Countee Cullen, 'Heritage', in Alain Locke, ed., *The New Negro*, op. cit., pp. 113–114, 250–253.
24. Marius De Zayas, 'Preface', in Charles Sheeler, *African Negro Sculpture*, privately printed, New York, 1918, n.p.; James Johnson Sweeney, *African Negro Art*, Museum of Modern Art, New York, 1935; and Alain Locke, 'The Legacy of Ancestral Arts', in *The New Negro*, op. cit., pp. 254–267.
25. Herman Lebovics, *True France: The War over Cultural Identity, 1900–1945*, Cornell University Press, Ithaca, 1992; Whitney Chadwick, 'Fetishizing Fashion/Fetishizing Culture: Man Ray's *Noire et blanche*', *The Oxford Art Journal* 18, 1995, pp. 3–17; Alvia J. Wardlaw, ed., *Black Art/Ancestral Legacy: The African Impulse in African American Art*, Abrams, New York, 1989.
26. Georges-Marie Haardt and Louis Audouin-Dubreuil, *La Croisière Noire*, Librairie Plon, Paris, 1927; and Malvina Hoffman, *Heads and Tales*, Charles Scribner's Sons, New York, 1936.
27. Tritobia Hayes Benjamin, *The Life and Art of Loïs Mailou Jones*, Pomegranate Artbooks, San Francisco, 1994; and Michel Fabre, 'From the New Negro to Negritude: Encounters in the Latin Quarter', in *From Harlem to Paris: Black American Writers in France, 1840–1980*, University of Illinois, Urbana, 1991, pp. 146–159.
28. Alain Locke, 'The Negro: "New" or Newer: A Retrospective Review of the Literature of the Negro for 1938', in Jeffrey C. Stewart, ed., *The Critical Temper of Alain Locke*, Garland Publishing, New York, 1983, pp. 271–283.
29. David Levering Lewis, 'It's Dead Now', in *When Harlem Was in Vogue*, Alfred A. Knopf, New York, 1981, pp. 282–307; and Jervis Anderson, 'The Depression and the Arts', in *This Was Harlem*, Farrar Straus and Giroux, New York, 1981, pp, 272–284.
30. Eugene O'Neill, *Plays: The Emperor Jones, Gold, The First Man, & The Dreamy Kid*, Random House, New York, 1925.
31. Laënnec Hurbon, 'American Fantasy and Haitian Vodou', in Donald Cosentino, ed., *Sacred Arts of Haitian Vodou*, UCLA Fowler Museum of Cultural History, Los Angeles, 1995, pp. 181–197.
32. Jacob Lawrence, 'Biographical Sketch', 12 November 1940, Downtown Gallery Papers, Archives of American Art, Smithsonian Institution, Washington, D.C.; and Marvel Cooke, 'Pictorial History of Haiti Set on Canvas', *New York Amsterdam News*, 3 June 1939, p. 3.
33. W.E.B. Du Bois, 'The Negro Mind Reaches Out', in Alain Locke, ed., *The New Negro*, op. cit., pp. 385–414; and Houston Baker, *Modernism and the Harlem Renaissance*, University of Chicago Press, Chicago, 1987, p. 37.

VOODOO MACBETH

SIMON CALLOW

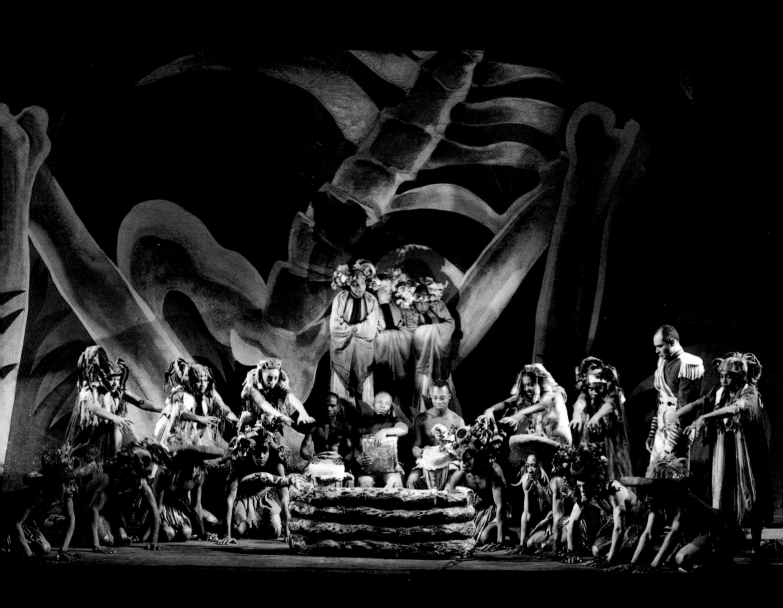

In 1935, a good five years after the Harlem Renaissance had unofficially come to an end, there was a surprising re-rebirth of Negro theatre right in the centre of Harlem itself, at the Lafayette Theatre. Here, John Houseman created the Negro Theatre Unit, one of the branches of the Federal Theatre Project, itself an offshoot of the Works Progress Administration, Roosevelt's instrument for getting America back to work after the ravages of the depression. The FTP was part of the second thrust of the New Deal, dedicated to creating jobs actively rather than simply relieving unemployment. Nowhere was this need more acutely felt than among black performers; if the depression was hard for white actors, it was savage for their black colleagues.

On the face of things, Houseman – a 35-year-old, half-Welsh, half-Alsatian Jew, born in Bucharest, educated in England, patrician in manner and impeccably tailored – was a curious choice to mastermind the revival of black theatre. A sometime corn merchant, screenplay writer and stage director, he had been proposed for the post by the great black actress Rose Maclendon (star of DuBose Heyward's *Porgy* and Langston Hughes's *Mulatto*), whom he had directed a year before in Virgil Thomson's exquisitely eccentric Gertrude Stein opera *Four Saints in Three Acts*, which had an all-black cast (for no reason other than that Thomson thought them more aesthetically pleasing). Maclendon (who would herself have been the obvious choice to head the project had she not been, by 1935, mortally ill) shrewdly concluded that Houseman had the weight and the political skill to ensure the Negro Project's survival in what was, administratively and bureaucratically, a white man's world. Houseman had the nous to surround himself with people, both black and white, who knew what they were doing. And, finally, he had the extraordinary confidence and flair to hire as director of only the third production at the Lafayette Theatre a plump young giant with a voice that sounded like God's, a rising actor and the author, at the age of 16, of a brilliantly fresh and witty edition of three of Shakespeare's plays. The fact that the young man – 20 years old at the time – had never before directed a play professionally gave Houseman no pause; he knew that he had adapted, designed, acted and directed a dozen school productions, not to mention having created, managed and fronted a semi-professional festival season, directing famous and immensely experienced actors. More than that, he knew that the young man was possessed of an encyclopaedic knowledge of Shakespeare's work, had dazzling and original ideas about how to stage them, limitless energy and even less limited courage. He would need all of these attributes for the task he was about to tackle. His name was Orson Welles and the production immediately established him as one of the most audacious figures in the theatre of his time.

Welles had been enlisted to the classical wing of Houseman's Project. Taking advice from Virgil Thomson, Houseman had divided the work into two: work by, for and with black actors, and classical work performed by black actors but staged and designed by white artists. The work of the second of these divisions he took as his own province; the work of the first he entrusted to his black colleagues, who formed a very distinguished team: the writers Countee Cullen and Zora Neale Hurston; the dancer Clarence Yates; the designer Perry Hopkins; Eubie Blake, Joe Jordan and Leonard de Paur, musicians. All of them were already distinguished in their respective spheres and, as a result of the Federal Theatre Project, became part of the mainstream of the theatre. To them was entrusted the first production of the Project, which would thus, very properly, open formally with a new play by a black writer.

Houseman's assistants were both black: Edward Perry, the stage manager from *Four Saints in Three Acts*, and Carlton Moss, 'bitter,' in Houseman's words, 'but brilliantly

Previous page:
A scene from Welles's sensational production of *Macbeth* with an all-black cast
Federal Theatre Archive, Library of Congress, Washington D.C.

clear about the "negro mind".' For the rest – for the personnel of the unit, actors, stage-hands, set-builders – he held open recruitment sessions. The result was pandemonium. Just as with any other section of the Project, the Negro Unit was inundated with applications from people who, desperate to work, were often only vestigially connected with the theatre – if at all. Since so many black performers were driven to pursue their careers in a sort of twilight zone, out of the professional mainstream, it was especially difficult to determine whose application was legitimate, and whose was not. Carlton Moss, with his bitter brilliant clarity, was particularly ruthless in weeding out the pretenders.

Houseman was determined from the start to run a tight ship; in fact he ran it, in the not unadmiring words of a black colleague, 'like a colonial governor'. There was, at the very least, no patronage. The Lafayette, 'a sordid, icy cavern when we moved in', wrote Houseman, 'was transformed in a month by the zeal of black technicians who had had nowhere to work, and who were denied the right of unionising themselves.' This was to be his experience at every level: finally allowed to function, black theatre-workers excelled themselves. Houseman fought an important battle early on: the white stage hands' union tried to apply the Jim Crow principle at the Lafayette. Houseman said, 'I'd be delighted to hire union stage hands if you'll furnish me with black ones, or allow my black ones to join your union.' They said, 'we can't do that, but you are going to hire union stage hands, otherwise we'll picket this theatre.' He said, 'If you seriously think you can picket a Negro theatre in Harlem for hiring Negroes, just come and try it.' There was no picket. His skills in manoeuvring were highly developed.

The first play, *Walk Together Chillun!* by Frank Wilson (the original Porgy), was no masterpiece but a play by a black, for blacks, with blacks. It was a modest success; the refurbishment of the Lafayette Theatre was admired, as were the technical innovations and the band. The second play, *Conjur' Man Dies*, written by a Harlem physician and novelist and directed by Joseph Losey, was fun and a smash hit locally, though snootily received by the press. The Negro Theatre Unit was now in business.

Meanwhile, Orson Welles and his actors rehearsed *Macbeth*, which would be the first production of the classical division. The notion of doing the play had come from Welles's wife Virginia, who saw the potential in setting it in Haiti at the end of the eighteenth century at the court of the Emperor Henri-Christophe. Houseman was delighted, and Welles and his designer Nat Karson set to work with passion, researching the period and the curious figure of the gigantic Grenadan slave who had become an emperor: leader of the Haitian forces of insurrection, he was first elected President, then, after a furious civil war, Napoleonically crowned himself. As Henri I, his vigorous rule was marred by avarice and cruelty; eventually his people revolted, and, cornered, he shot himself. The parallels with Shakespeare's hero are clear enough. For Welles the element in the transposition that really attracted him was that it enabled him to make the supernatural scenes a credible centre of the play.

The fact that most of his actors would have no experience whatever of blank verse, and that indeed many of them would have very little experience of acting at all, was only a further recommendation to Welles. His abhorrence of the polite approach to Shakespeare was absolute; rather complete ignorance than *that*. Professionalism per se had no appeal for him; he realised – as Houseman must have done – that there was no question of turning the Negro Unit into the Old Vic and that what was required were not tutorials in the iambic pentameter but leadership of a galvanizing, inspirational kind. The human material with which he had to work was varied in its abilities but eager,

Outside the theatre on opening night
Federal Theatre Archive, Library of Congress,
Washington D.C.

enthusiastic, energetic, expressive and, especially en masse, emotional. There were no more than five professional actors in the company, which otherwise consisted of a group of voodoo drummers assembled by the Sierra Leonian Asadata Dafora Horton and over 100 individuals with more or less glancing relationships to one or other of the performing arts. Welles sought to shape them into a highly drilled troupe.

What he had in mind was almost choreographic – literally so in the case of the scene where Banquo's ghost appears, which Welles had reconceived as a sumptuous ball. Every scene was shaped, and moved with dictatorial precision. These Harlemites were not accustomed to being bossed around by preppy young whites and from time to time he had to be gently taken aside by his Lady Macbeth ('Orson, don't do that; these people will take your head off') or have his Macbeth read the riot act ('So get back to work! You no-acting sons of bitches!' – a speech that nearly provoked the riot it was intended to head off). But he was shrewd enough – uncannily shrewd for a middle-class 20-year-old who had almost no experience whatever of working with black people – to temper his autocracy with fun and charm and crate upon crate of beer. (Himself he fuelled with whisky until Virgil Thomson advised him that 'if you do that, you fall', whereupon he switched to white wine).

With his principals he rehearsed separately and more calmly. They were a powerful group: Edna Thomas as Lady Macbeth; Jack Carter, Macbeth; Banquo, Canada Lee; Maurice Ellis, Macduff; Eric Burroughs (RADA-trained) as Hecate, so often cut from the play altogether, now placed in a pivotal position: 'the charm's wound up!' was in Welles's version the final line of the text. Welles formed particularly close relations with Edna Thomas and Jack Carter. Thomas he treated with the deference due to a great lady of the theatre, and that is indeed how she was perceived by the company, though in truth this owed more to her manner than to her career. A discreet and rather statuesque lesbian, she stood apart from the company but had great authority, with which she endorsed Welles, a crucial support. Jack Carter, his Macbeth, was an altogether different character, 'the most furious man I have ever known', wrote Houseman. He was 6'4" tall, had bright-blue eyes, and 'a skin so light he could pass as white anywhere in the world, if he'd wanted to. He didn't.'

His background was as swathed in myth as Orson's – was he born in a French château, not knowing that he was a Negro? Or did he really come from Harlem? Certainly he had a history of violence. Despite creating, to great acclaim, the role of Crown in *Porgy* and the eponymous *Stevedore* (one of the biggest hits of the Theatre Union) he did not work much as an actor, instead making a living through underworld connections in Harlem. Everybody, according to Houseman, was nervous about how he would behave in rehearsals, 'but from the moment at the first reading when Orson threw his arms around Jack, his eyes brimming with tears of gratitude and admiration, a close and passionate friendship had sprung up between these two giants.' 'I always seduce actors,' Welles told Barbara Leaming, 'I make them fall in love with me.' According to Houseman, 'Orson spent a quarter of his radio earnings on loans and handouts to the company; a quarter on props etc; a quarter on meals; and a final quarter on Jack Carter.'

Rehearsals – which went on for a staggering four months in, as Welles told a reporter, 'this theatre, auditoriums, hallways, fire escapes, paper bags, coal scuttles, trash barrels and my apartment' – started late and generally went through the night, to the fascination and sometimes consternation of the neighbourhood, as the voodoo drums pounded through to dawn. This impossible schedule partially accounts for the heightened levels of emotion flying around the rehearsal room. Houseman computed

that Welles was working 20 of the 24 hours. The remaining four were spent with his Macbeth, not, we may presume, giving him notes. According to Houseman, they hit the Harlem clubs and brothels.

Nat Karson, the Project's head of design, had devised a very simple, unchanging setting for the play: a castle laid in a jungle. He and Welles were attempting an exceptionally ambitious integration of all the production elements to create an emotional progression that, we can assume, may not have been present in the performances of the untrained company. They took the question of how best to serve the pigmentation of their actors extremely seriously; this affected every area of the work. 'This necessitated a scene painting that would absorb the type of lighting, rather than reflect.' There was, Karson says, the same problem with costumes: 'I found that a touch of light colour at the wrist line and the collar did a great deal to offset the particular person's colouring... I resorted to painting various fabrics... I hope that I arrived at an almost architectural form, the shoulders of the men representing the capital of a Greek column with its attendant decoration and tapering to the waistline.' He became convinced that because of the predominance of the voodoo scenes in this version, 'the actual scenery should at all times have an eerie, luminescent quality.' Clearly a great deal of the effect he and Welles intended was dependent on light, and they had in their collaborator Abe Feder an extraordinary innovator. Here, too, there was the question of the actors skins, difficult to light because of the light-absorbing properties of darker pigmentation. In collaboration with Nat Karson, Feder devised light-friendly make-ups and a series of gels specially suited to the actors' pigmentation; the rule of thumb hitherto had been 'amber for negroes'. Even the light was thus politicised, helping to break down the dehumanising visual stereotypes.

The most sensational element of the score was provided by the drummers under Asodata Dafora. Their first demand after being given the job was to request black goats, which were then ritually slaughtered in order, they said, to make skins for their drums. Their leader, Abdul, was a genuine witch doctor (Welles, unwisely, one cannot help feeling, insisted on addressing him as 'Jazbo'), and their chants consisted of real African spells.

The anticipation and controversy among the smart audience were expertly maintained by both Houseman and Welles; in Harlem, things were in the hands of Houseman's assistant, Carlton Moss, who had forged good relations with the community, building the local audience with patient propaganda, then, nearer the opening night, capping it with stunts like the luminous stencilled logos of *Macbeth* that appeared all over the neighbourhood, while garlands and balloons festooned the Tree of Hope. A free preview drew 3,000 more spectators than the theatre could hold; police had to disperse the crowd. When the first night itself arrived – on 14 April – all northbound automobile traffic was stopped for more than an hour while from trucks in the street floodlights flared a circle of light into the lobby and cameramen took photographs of the arrival of celebrities. The massed forces of the brass bands of the Monarch Lodge of Benevolent and Protective Order of Elks played, marching over the painted footsteps on the pavement – another of Moss's stunts. The mood inside the theatre was unlike that for any Shakespeare anyone had ever known. Perhaps it was a little like an audience at the Globe Theatre, one afternoon in 1600: rampant with expectation, oblivious of theatrical etiquette, keenly following the story.

The *beau monde* took the show up in a big way, as did theatre people (John Barrymore, Welles claimed, saw the show every night of its ten-week run). But its fame went beyond the theatre. 'No event in the art galleries this week', wrote the *New York*

Times art critic, 'could hope to rival in barbaric splendour the transmogrification of *Macbeth* by members of the Negro Theatre... deplore as one may the impenetrable fog that separates these swart thespians and the bard himself, the stage pictures at any rate constituted a sumptuous pageant of colour, form, pattern and movement, keyed to the pulsebeat of voodoo drums.' Whatever his original intention, Orson Welles had put on stage a highly original and exciting phenomenon, an integration of light, sound, movement and decor of overwhelming sensuous and visceral impact. The impression is of a sort of barbaric cabaret; the effect on its audiences was something like the impact of the Ballets Russes in Paris, 1911. Feder's lights, in conjunction with Karson's Douanier Rousseau backcloths (it is no accident that most of Karson's work had been at Radio City Music Hall and would in future be in the musical theatre) were co-ordinated with the sound score to a degree never before experienced by an American (or any other) audience. In the fevered words of a contemporary critic, they 'revealed a tragedy of black ambition in a Green Jungle shot with such lights from both heaven and hell as no other stage has seen'.

At the end of its run at the Lafayette, the show transferred to the Adelphi on West 54th Street, where it played for 11 performances. Jack Carter's self-restraint broke down; he started to drink heavily during a performance. When Edna Thomas burst into tears on stage, he simply walked off stage to his dressing room, then out of the theatre, and was seen no more. The Macduff, Maurice Ellis, took over, and it was he that led the subsequent triumphant nation-wide tour: Bridgeport, Hartford, Chicago, Indianapolis, Detroit, Cleveland, Dallas; something of a feat. 'You have to take into account that this was 110 black people', wrote John Silvera, the company manager. 'And travel for black people at that time... was not the most pleasant or easiest thing in the world. We were living in a strictly Jim Crow situation where hotel accommodations for blacks were non-existent in many cases. But there were no incidents.' In another way, then, the Negro Unit had blazed a trail. A hundred thousand people of all races saw the show.

In Indianapolis an event occurred that might have set back the cause of black theatre by many years. Maurice Ellis fell ill; his understudy, too, was sick; nor did the new stage manager know the role. As if it was what he had been waiting for all along, Welles jumped on to the next plane and took over the role, playing it in blackface. This well-attested event is best contemplated in awed silence.

The information contained in this piece has largely been drawn from *Orson Welles: The Road to Xanadu* by Simon Callow, published by Jonathan Cape, 1995.

Backstage
Federal Theatre Archive, Library
of Congress, Washington D.C.

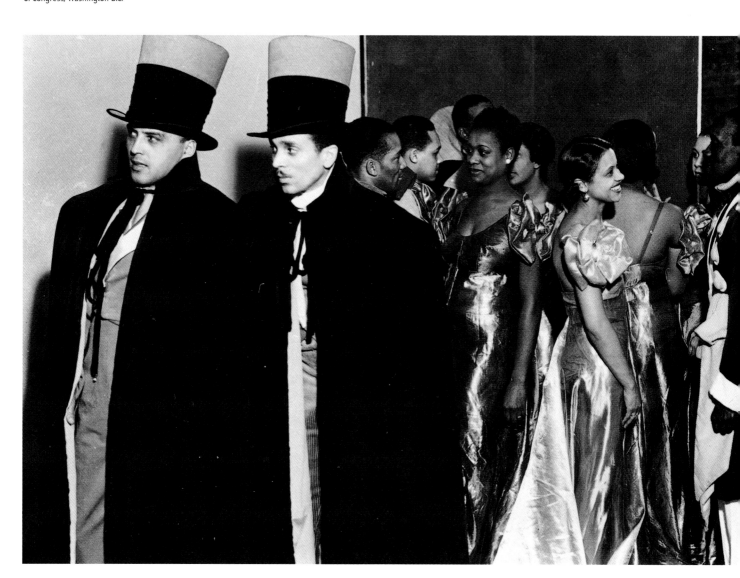

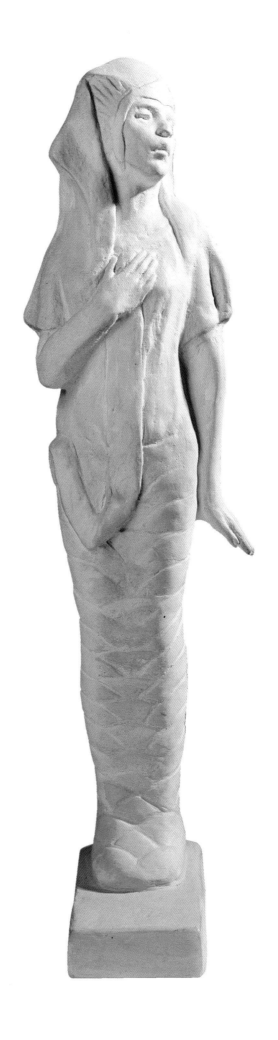

24 **Meta Vaux Warrick Fuller**
Ethiopia Awakening, n.d.

25 **Palmer C. Hayden**
Untitled (Life passing before him), n.d.

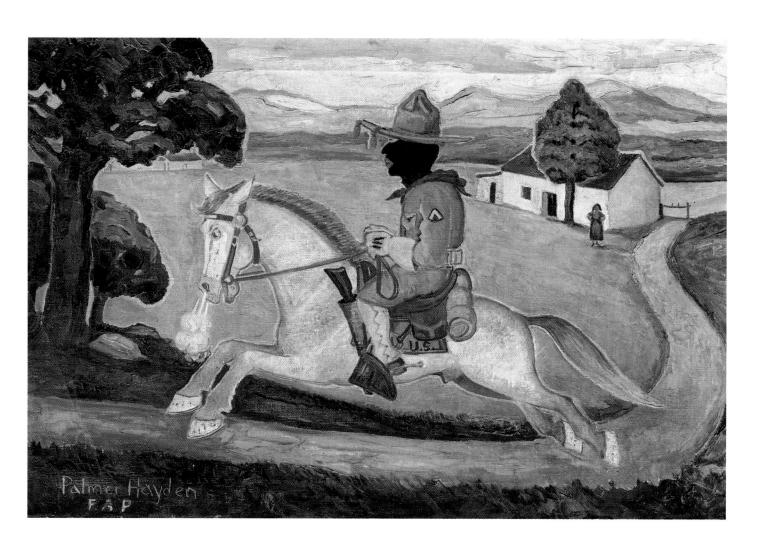

27 **Palmer C. Hayden**
10th Cavalry Trooper, May 1939

110 **Doris Ulmann**
Baptism Scene, South Carolina, 1929–30

111 **Doris Ulmann**
Black Grave, South Carolina, 1929–30

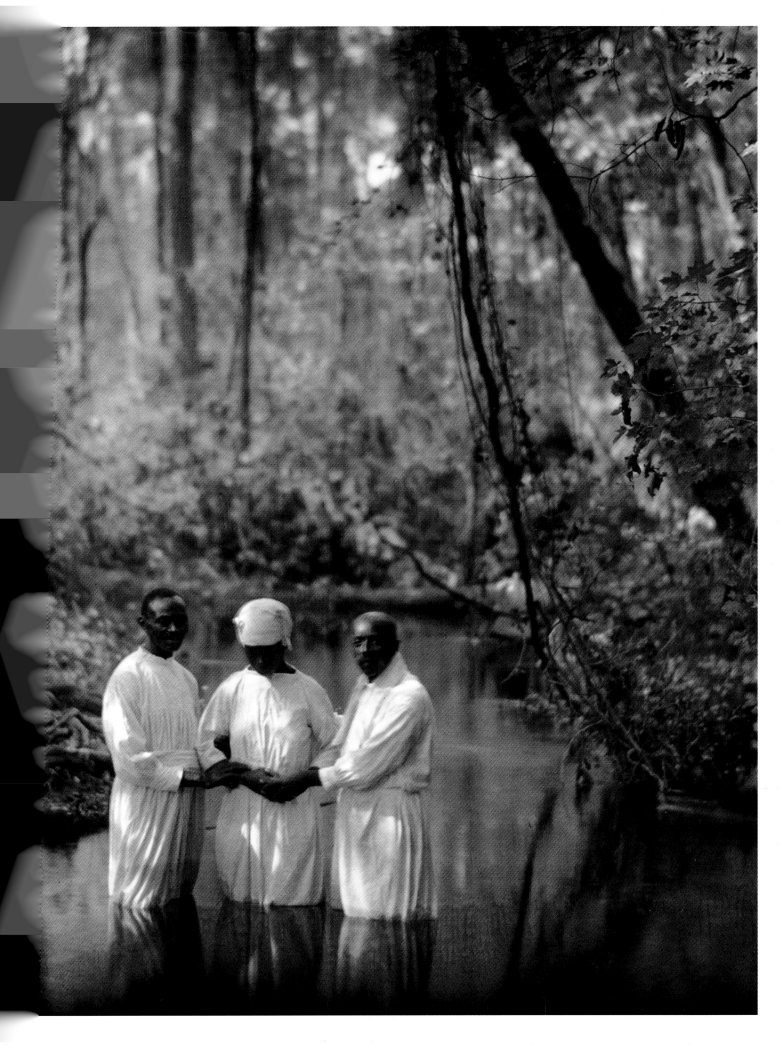

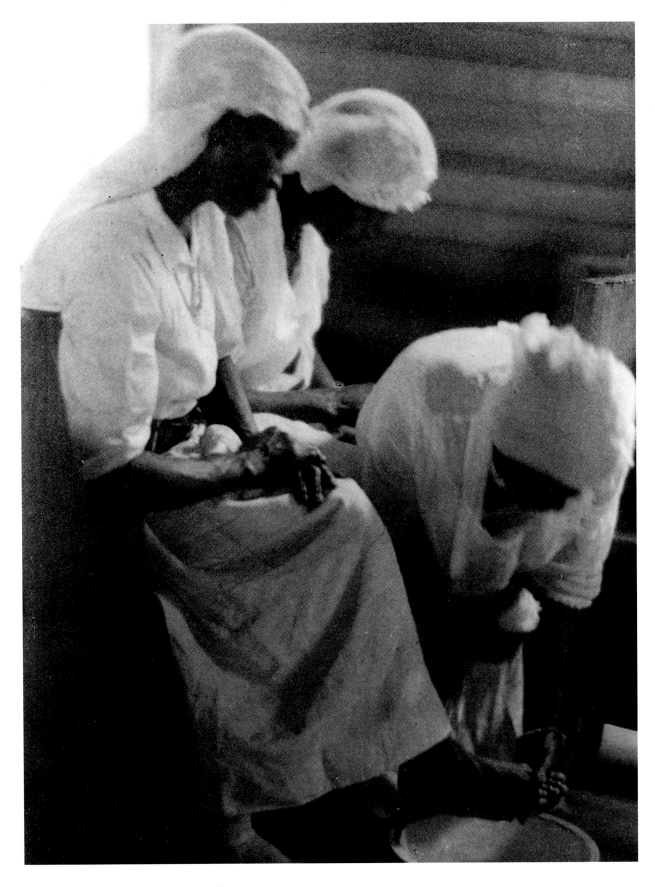

112 **Doris Ulmann**
Foot Washing, South Carolina, 1929—30

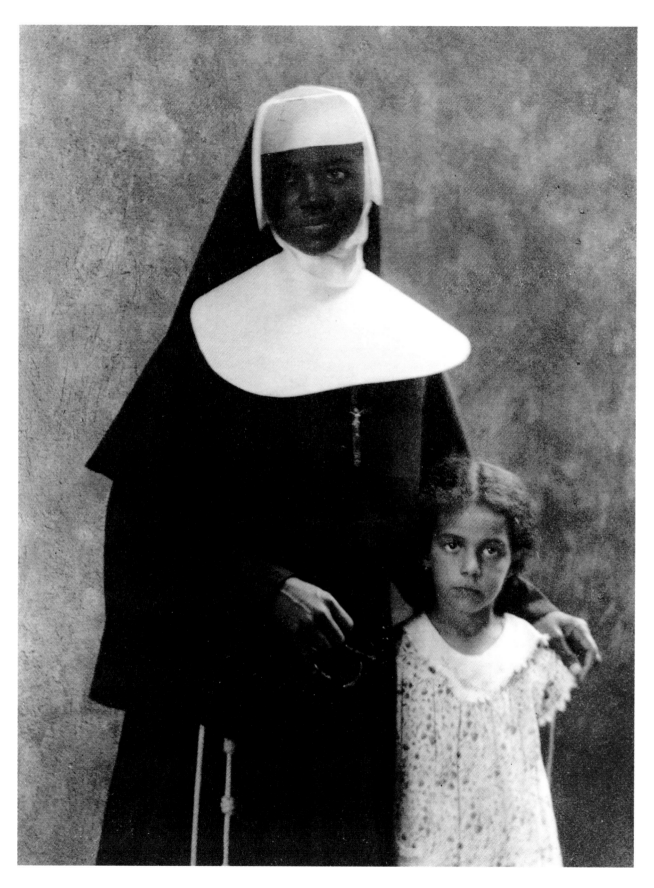

114 **Doris Ulmann**
Nun with Girl, New Orleans, 1931

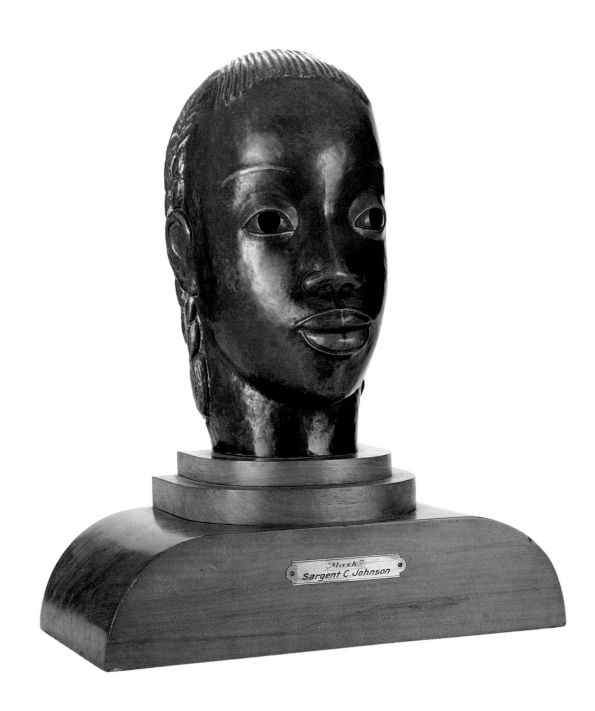

32 **Sargent Claude Johnson**
Mask, 1930—35

33 **Sargent Claude Johnson**
Lenox Avenue, c. 1938

94 Winold Reiss
Elise Johnson McDougald (1885–1971), c. 1924
National Portrait Gallery, Smithsonian Institution

98 Winold Reiss
Langston Hughes (1902–67), 1925
National Portrait Gallery, Smithsonian Institution

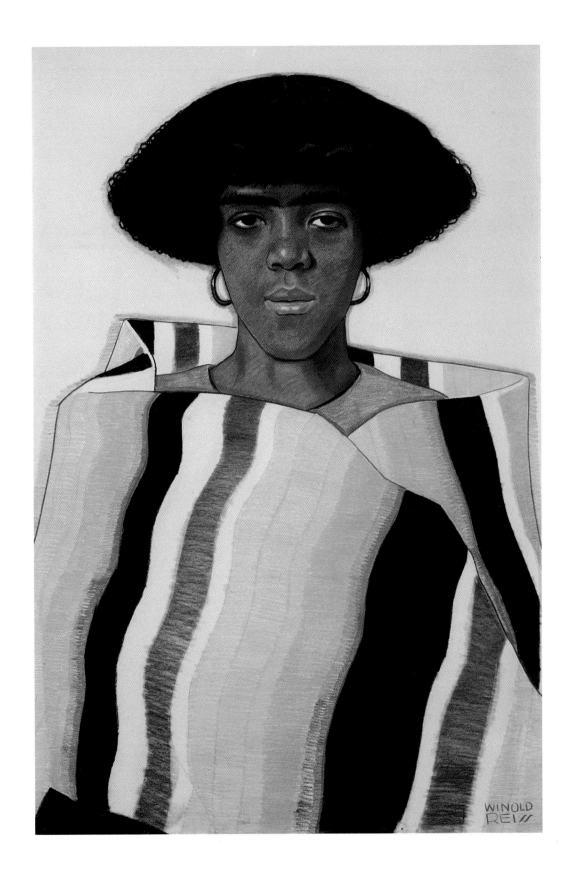

96 Winold Reiss
Harlem Girl with Blanket, c. 1925

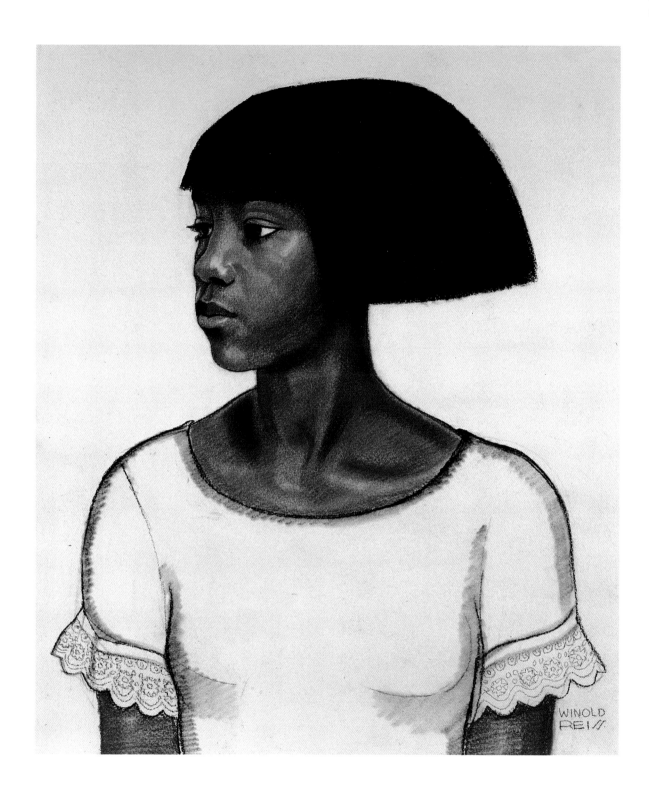

95 **Winold Reiss**
Harlem Girl, I, c. 1925

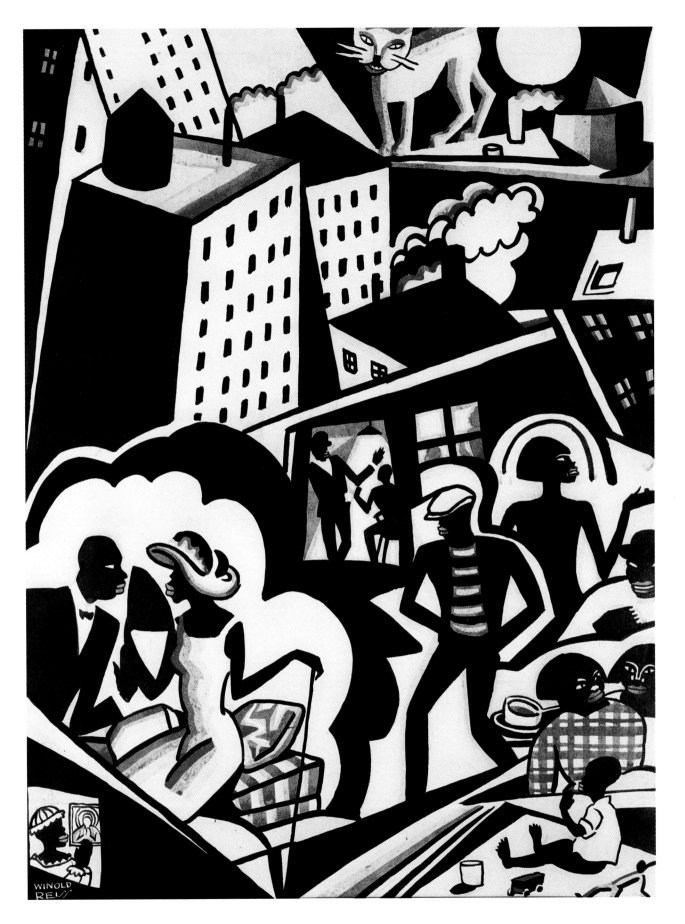

93 **Winold Reiss**
Harlem at Night, c. 1924

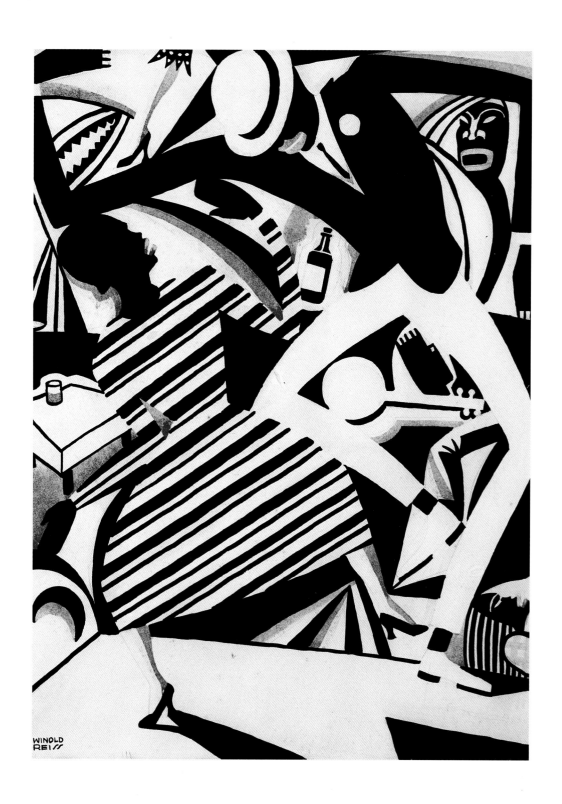

97 Winold Reiss
Interpretation of Harlem Jazz I, c. 1925

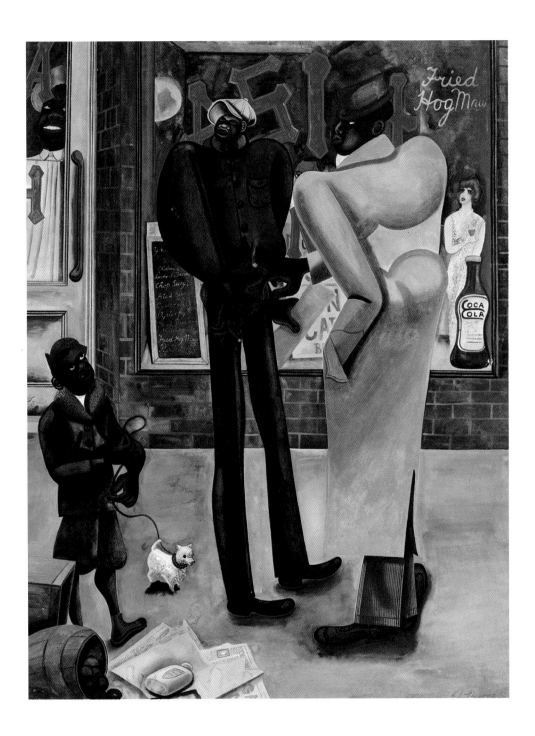

7 **Edward Burra**
Harlem, 1934

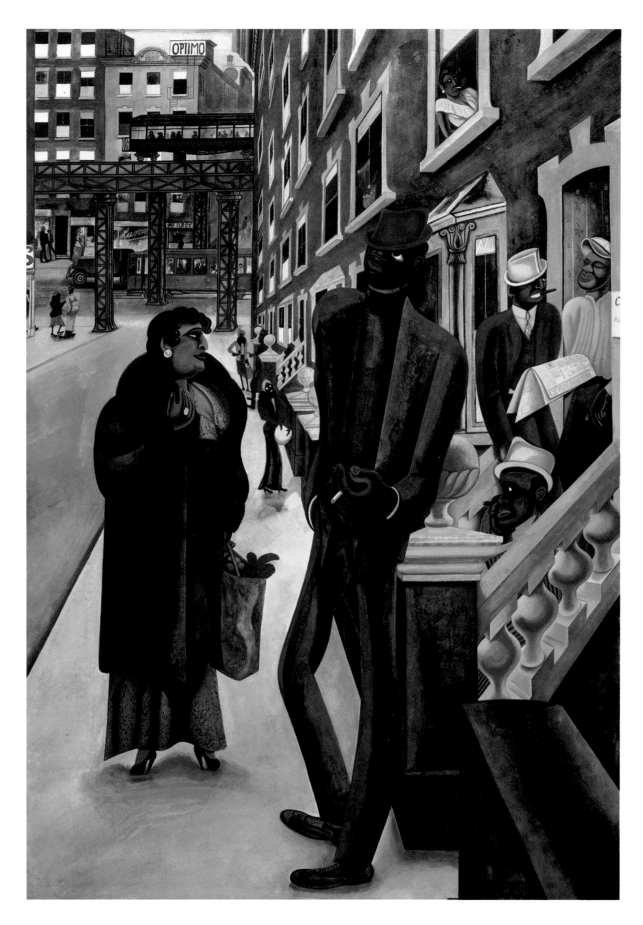

6 **Edward Burra**
Harlem, 1934

30 **Malvin Gray Johnson**
Postman, 1934
Schomburg Center for Research in Black Culture, Art & Artifacts Division,
The New York Public Library, Astor, Lenox and Tilden Foundations
photograph: Manu Sassoonian

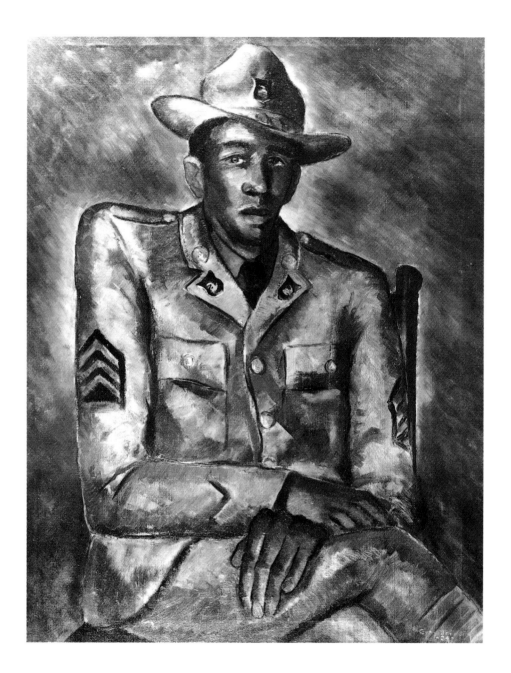

29 Malvin Gray Johnson
Negro Soldier, 1934
Schomburg Center for Research in Black Culture, Art & Artifacts Division,
The New York Public Library, Astor, Lenox and Tilden Foundations
photograph: Manu Sassoonian

100 **Richard S. Roberts**
Annie Mae Manigault (1907–76), 1920s

103 **Richard S. Roberts**
Unidentified portrait (well-dressed man), 1920s

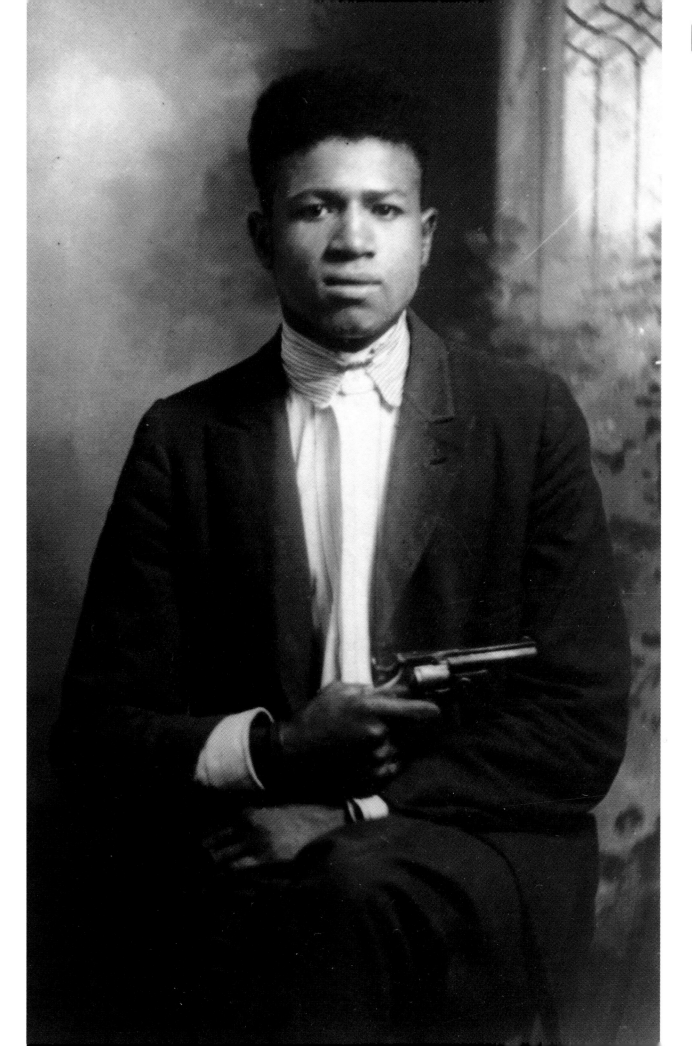

68

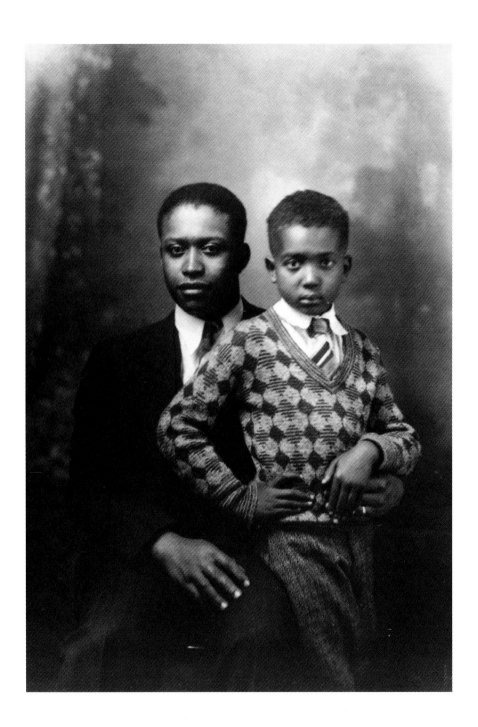

105 **Richard S. Roberts**
Robert Harper Kennedy (d. 1972) and nephew
Hale B. Thompson Jr (b. 1922), c. 1927

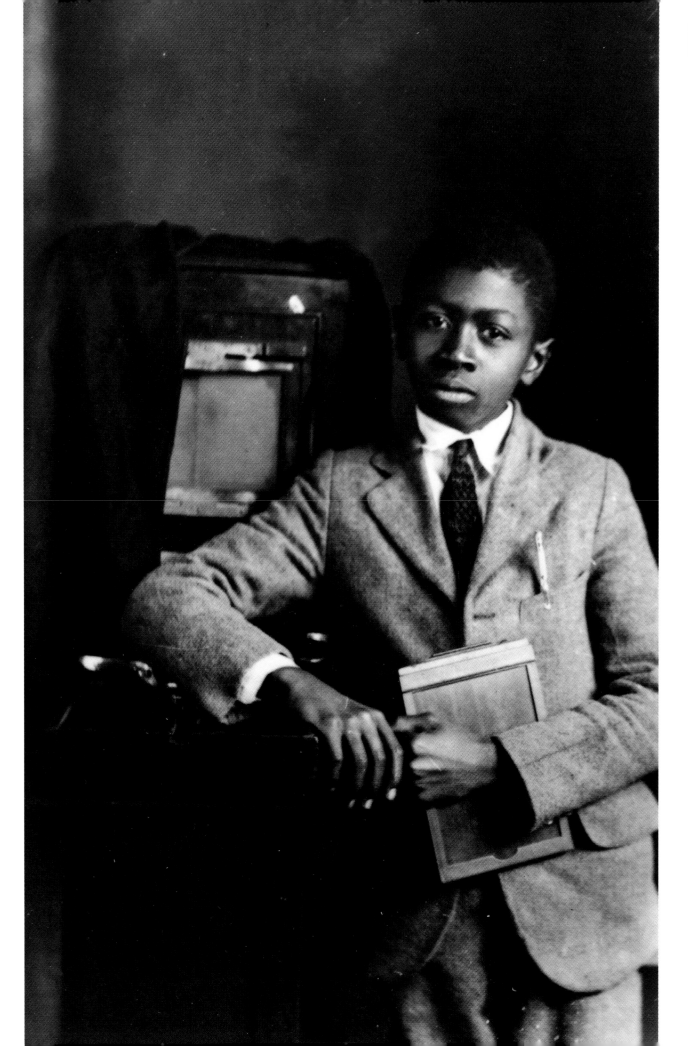

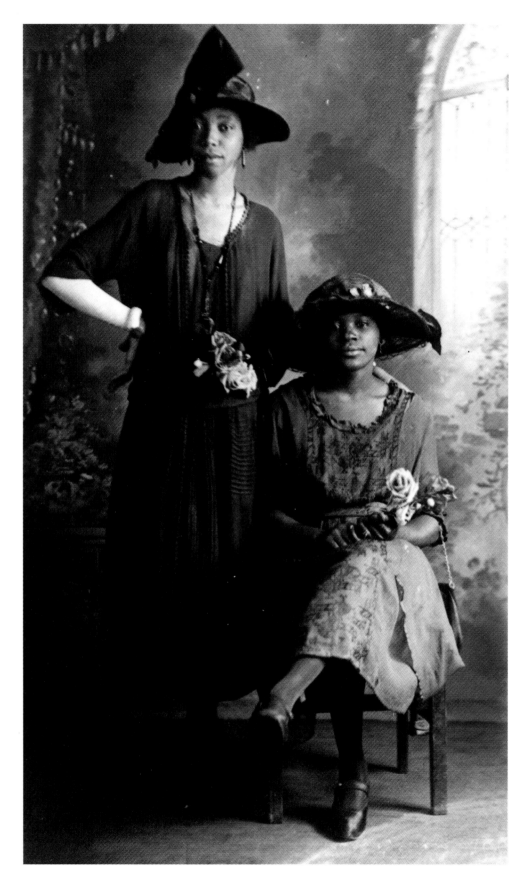

102 **Richard S. Roberts**
*Unidentified portrait (two young women
in hats with corsages),* 1920s

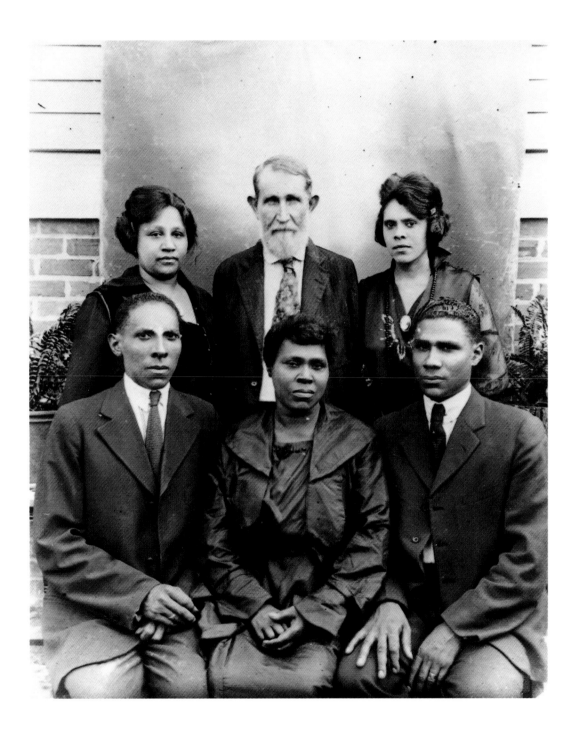

99 **Richard S. Roberts**
John Hiller (standing centre) and Alice Johnson Hiller
(seated centre) with their children Simmie, Bernice,
Samuel and Benjamin, 1920s

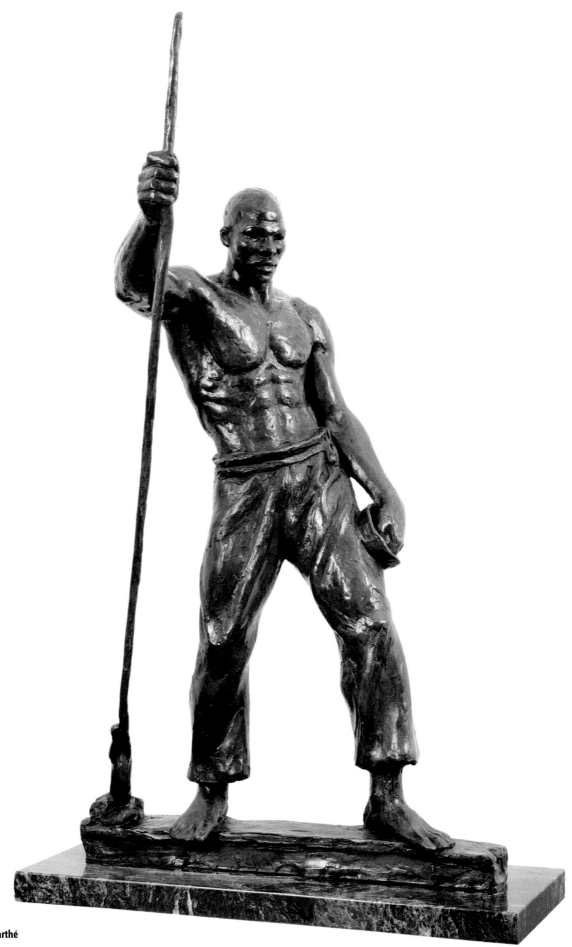

5 **Richmond Barthé**
Stevadore, 1937

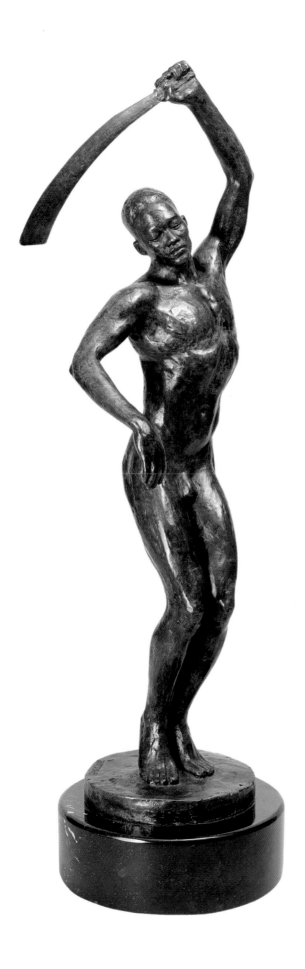

4 **Richmond Barthé**
Feral Benga, 1935

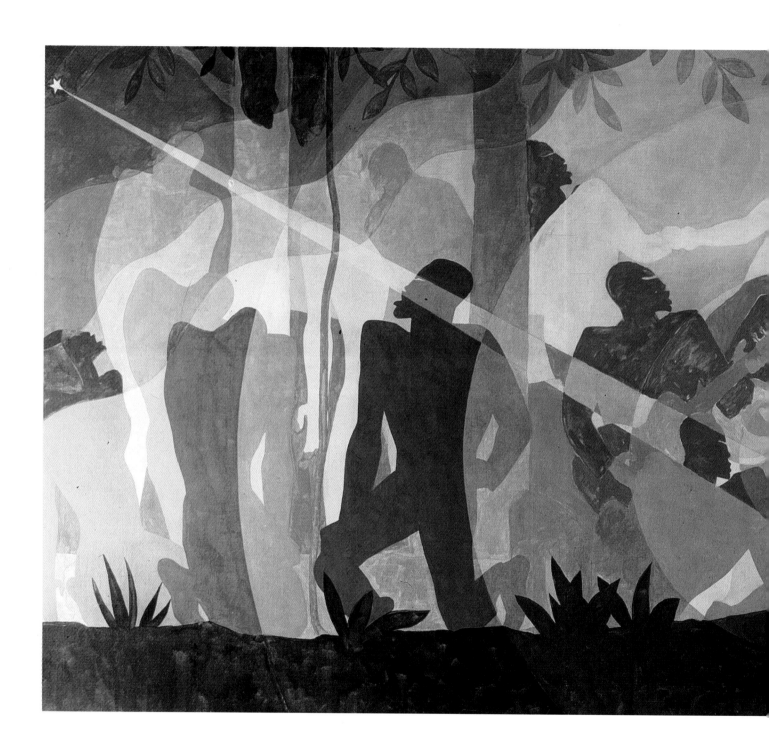

14 **Aaron Douglas**
Aspects of Negro Life: An Idyll of the Deep South, 1934
Schomburg Center for Research in Black Culture, Art & Artifacts Division,
The New York Public Library, Astor, Lenox and Tilden Foundations
photograph: Manu Sassoonian

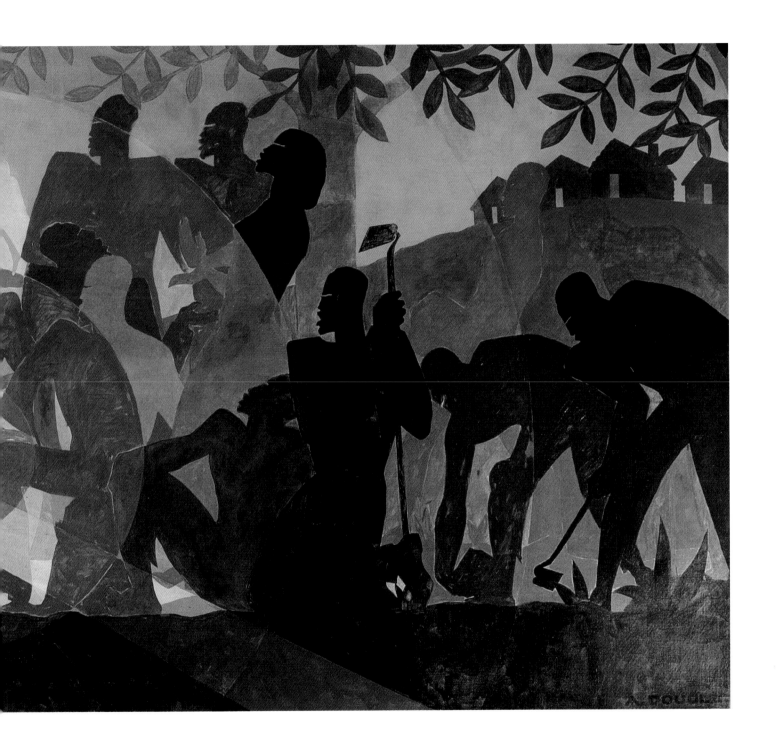

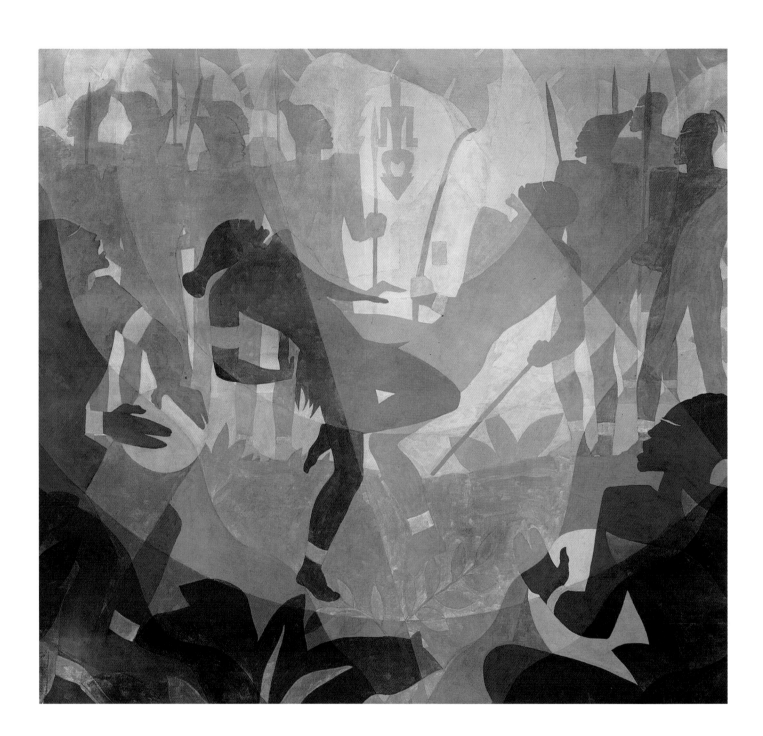

16 **Aaron Douglas**
Aspects of Negro Life: The Negro in an African Setting, 1934
Schomburg Center for Research in Black Culture, Art & Artifacts Division,
The New York Public Library, Astor, Lenox and Tilden Foundations
photograph: Manu Sassoonian

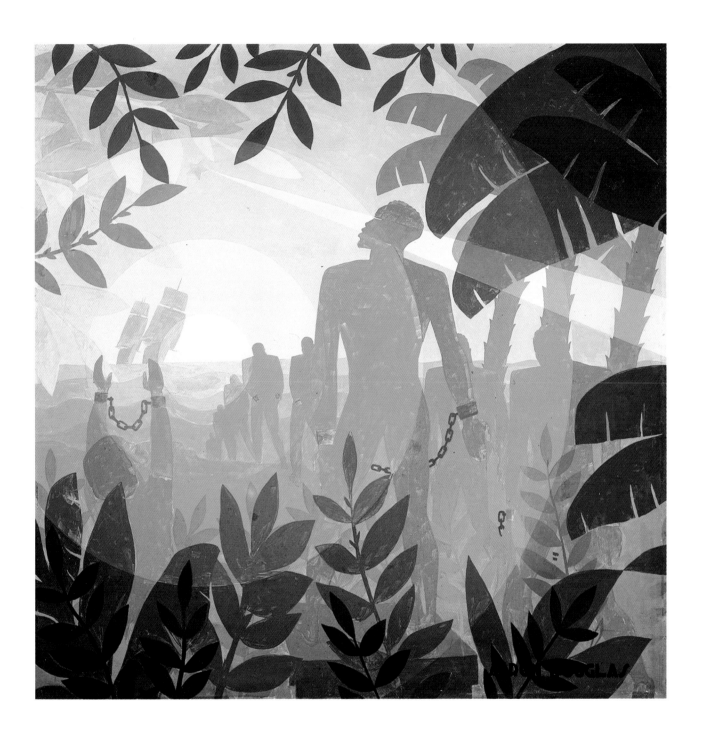

19 **Aaron Douglas**
Into Bondage, 1936

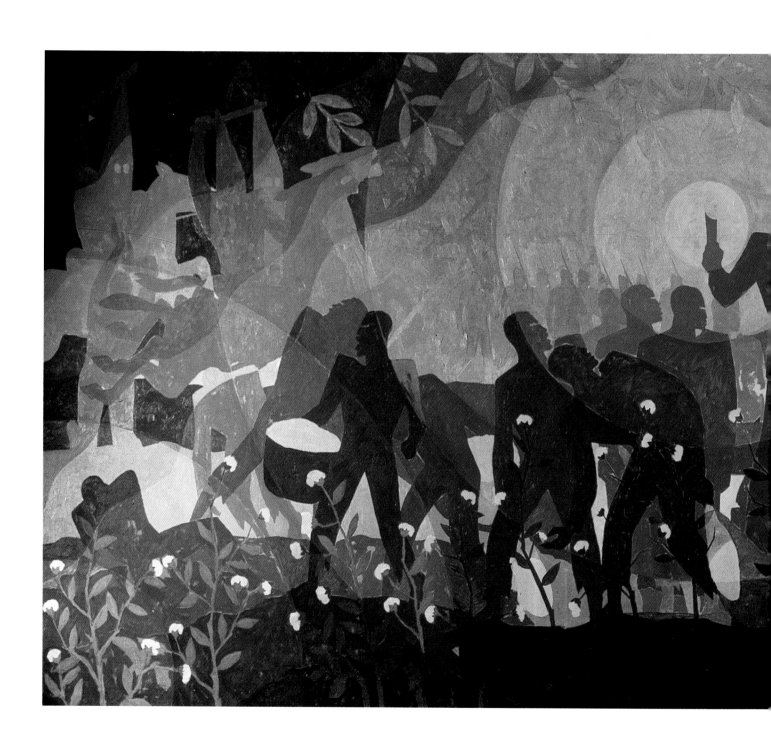

15 Aaron Douglas
Aspects of Negro Life: From Slavery Through Reconstruction, 1934
Schomburg Center for Research in Black Culture, Art & Artifacts Division,
The New York Public Library, Astor, Lenox and Tilden Foundations
photograph: Manu Sassoonian

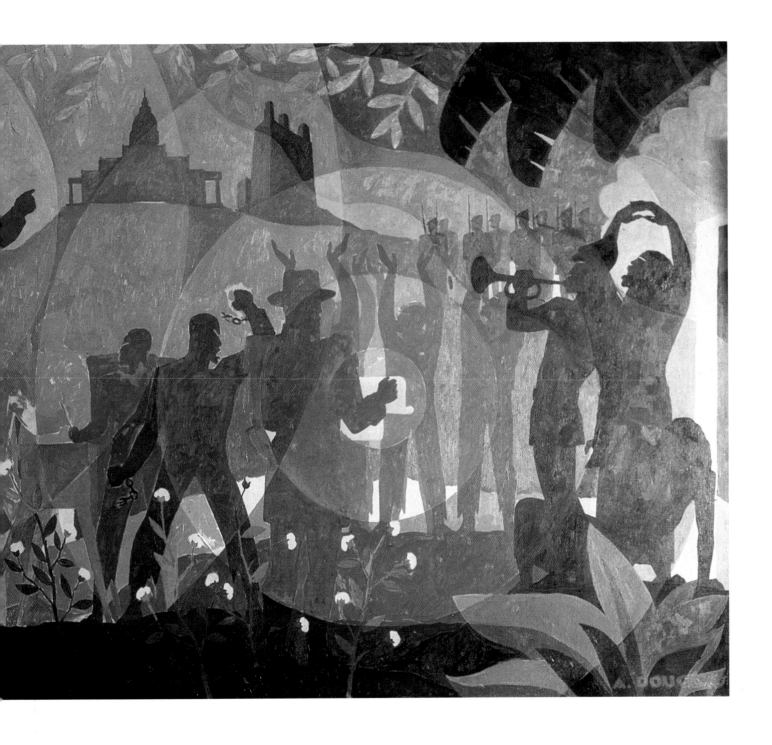

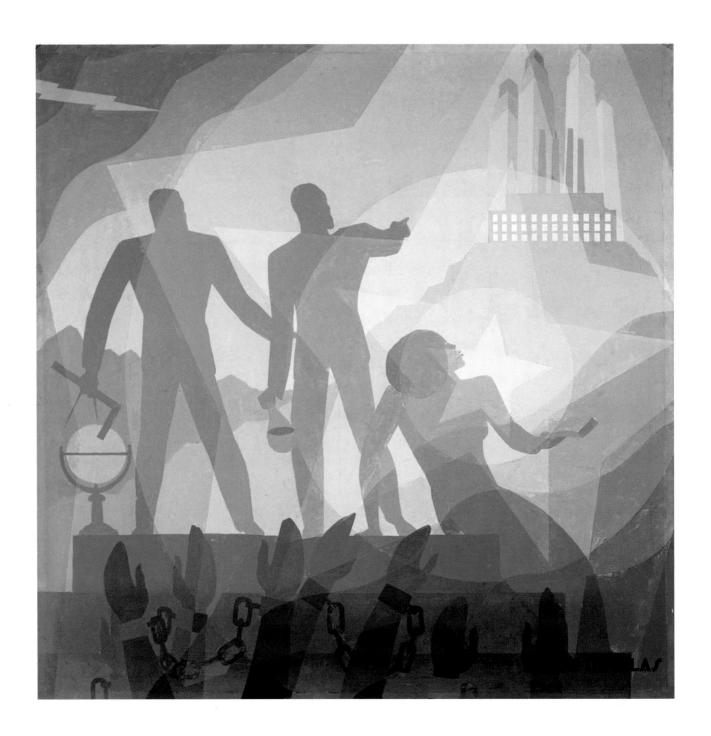

18 **Aaron Douglas**
Aspiration, 1936

LIKE THE GYPSY'S DAUGHTER OR BEYOND THE POTENCY OF JOSEPHINE BAKER'S EROTICISM

ANDREA D. BARNWELL

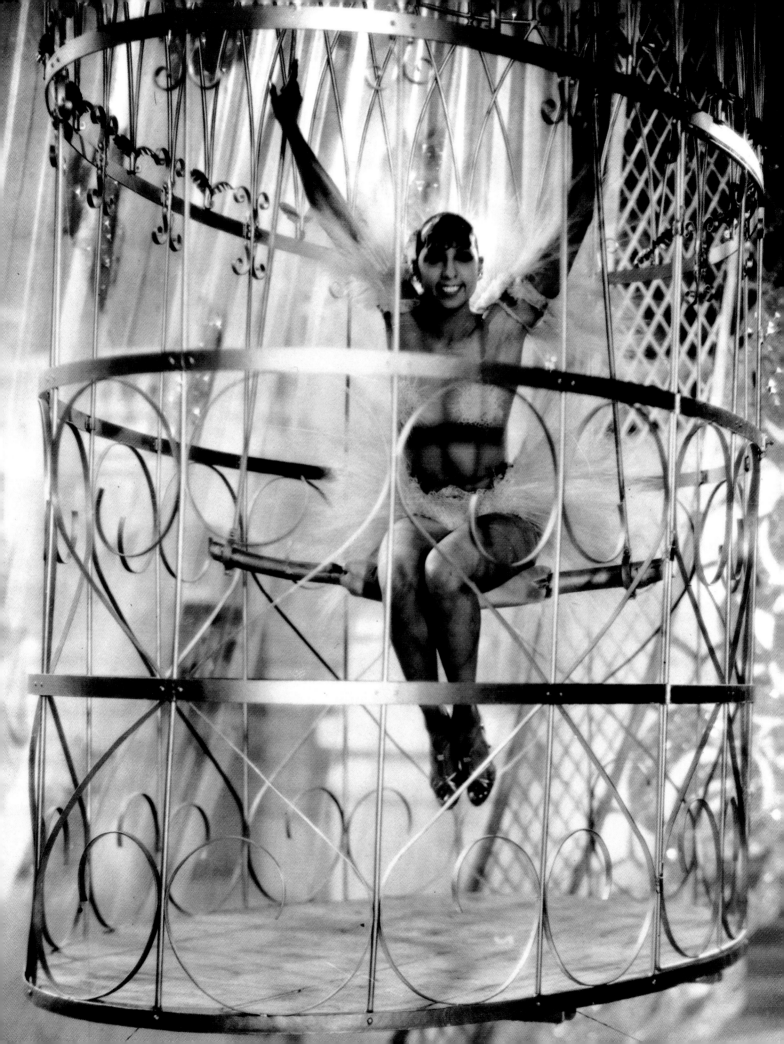

Fatou, a native girl, bare-breasted and clad in a skirt of rubber bananas, slithers down the limb of a jungle tree and encounters a white explorer who lies asleep and dreaming under his mosquito net. Scantily dressed black men provide the ambience for this setting by singing softly and beating drums. As Fatou shimmies, the bananas jiggle, as if imitating the erect phallus of the explorer, who is awoken by her call to the wild. She offers herself, withdraws the offer, offers again, draws back again and bursts into laughter. As she dances, her suggestive movements animate and exacerbate the explorer's desiring imagination.

By donning the festoon of bananas, Fatou appeals to the fatigued explorer's desire to unwrap, taste and devour, presenting herself *and* the bananas as available for his post-nap snack. Following such a sampling, however, the explorer, confident in his perceived superiority, would remember that neither the banana peel nor the native girl were worthy of safeguarding and they would, therefore, be pushed aside as refuse.

Josephine Baker's 1926 performance as Fatou in *La Folie du Jour* enacted and elicited the Parisian audience's fantasy and lust for African women. This performance and subsequent ones must be examined within the context of a complex web of economic, political, visual and ideological constructs that shape European concepts of 'the self' and 'the other'.

The complex psychoanalytic and sexual relationships between the the colonizer and the colonized have been theorized extensively. In colonialist discourse, colonized peoples often exist as an anonymous collective of natural, cultural and sexual resources. This rhetoric had serious repercussions regarding attitudes concerning the black female body, as seen in its use of literary allusions and *double entendres* (such as 'penetration' and 'conquering the interior').[1] In *True France: The Wars Over Cultural Identity, 1900–1945*, Herman Lebovics explains that France's perceived superiority – as articulated via colonial discourse – as well as its territorial and economic success were promoted and disseminated through political oratory, public monuments, the arts and through all levels of French society.[2]

These perceptions were fresh in the minds of many people in 1920s Paris.

Josephine with Joe Alex
performing *La Danse Sauvage*
from *La Revue Nègre* at Théâtre
de Champs-Elysées, Paris, 1925
Courtesy of Bryan Hammond

Despite her origins in St Louis, Missouri, Josephine Baker's black skin signified particular characteristics which were associated with the primitive. These perceptions, coupled with Baker's performances, fueled the wildest fantasies in the minds of many Parisians. Although representations of Baker as Fatou are perhaps her most celebrated images, confining Baker to the realm of a performer who was solely preoccupied with satisfying colonial fantasies does not acknowledge her self-agency, autonomy or ability to influence European perceptions of African women. The 1930s marked the beginning of Baker's transformation, from the so-called primitive dancing girl in music halls, to a glamorous song stylist of refined love ballads, performing in elegant nightclubs, theaters, and on film.

Both of Baker's 1930s films, *Zou Zou* (1934) and *Princesse Tam Tam* (1936), seem to have been created specifically for her to mimic and enact her real-life transformation. (Baker, her husband Pepito Abatino and his brother collaborated on the writing, directing and financing of both projects.) As the only woman of African ancestry to command multi-dimensional roles such as these – as opposed to typecast native girls in banana skirts – Baker challenged and exceeded colonial expectations for black female performers.

In 'Uses of the Erotic: The Erotic as Power' Audre Lorde explains that women distrust the power that rises from their deepest and non-rational knowledge and, furthermore, that women so empowered are dangerous.[3] However, despite its volatile strength,

> ... the erotic offers a well of replenishing and provocative force to the woman who does not fear its revelation, nor succumb to the belief that sensation is enough.[4]

In a scene in *Zou Zou,* Zou Zou takes center stage as her brother Jean adjusts a theater floodlight. While on stage, alone, she delights herself by creating an interplay between her body and her shadow cast on the stage curtain. By making shadow puppets, high kicking, doing the splits and dancing the Charleston she basks in the pleasure of her body's potential and her ability to create an interaction between the corporeal and that which is projected. She attracts the attention of her brother, another stage hand, the producer and the director, who are conducting auditions; the importance of her performance, however, transcends the invasive male gazes.[5] Though she is certainly aware of the men's curious and longing stares, Zou Zou's own enjoyment is her motivation. Her personal thrill is only interrupted when her eyes finally meet those of the spectators; she acknowledges their stares, stops performing and flees from the stage. The sheer joy and personal pleasure of creating this display, evident from her laughter and expressions, are significant elements often neglected in discussions of Baker's performances. By demonstrating her conscious decision to please herself she defies colonialist expectations that attempt to confine her to the realm of the plastic.[6]

The most dramatic example of Baker's impulse to perform occurs, however, in *Princesse Tam Tam*. Baker plays Alwina, a Tunisian shepherd girl who is transformed into an exotic princess. In a scene towards the end of the film, Alwina is a guest at Maharajah Datane's party. As she watches the performers he has hired for the occasion, she is so moved by the music and the incessant drum beat that she runs on to the stage, ripping off her evening gown, and begins to dance. The energy of her motions, her talent and the contrast between her dancing and that of the hired performers make her the highlight of the party. Like Zou Zou (and Baker in real life), who

engages in spectacle for her own pleasure, Alwina is motivated by her desire to dance and enjoy the music regardless of who is watching.

Baker's dancing in *Princesse Tam Tam* may correspond with colonial ideas of African women's savage rhythm, but her transformation from a perceived state of wretchedness to a glamorous woman who charms and enchants nearly everyone she meets has parallels not only with Zou Zou but with her own transformation from grotesque wild African (in the eyes of her audience) to celebrated performer.[7]

Although many people celebrate Baker's career, many could argue that her initial success was achieved at the expense of her integrity and the principles of African-Americans. These opposing views are part and parcel of the debate between African-American writers, philosophers and artists who disagreed on how black figures, physiognomies and lifestyles should be depicted.[8] In a 1925 letter to Langston Hughes, Aaron Douglas contends that black peoples' self-representations will not all be glorious and/or positive. Douglas writes,

> ... our problem is to conceive, develop, establish an art era ... Let's bare our arms and plunge them deep deep through the laughter, through pain, through sorrow, through hope, through disappointment, into the very depths of the souls of our people and drag forth material crude, rough, neglected. Then let's sing it, dance it, write it, paint it ... Let's create something transcendentally material, mystically objective, Earthy. Spiritually earthy. Dynamic.[9]

Douglas's comments encapsulate the difficult but important task of reconsidering Baker's controversial artistry and reception in its entirety. To consider her early performances in isolation is to ignore the most telling aspects of her career: talent and transformation.

Baker's talents, motivated by self-agency, are the force that compels us to revisit her performances, writings and films again and again. The interplay between her self-produced images and those created by others complicates, and often detracts from, her self-agency as a performer. Caricature-like images such as those included in *Le Tumulte Noir* (Paul Colin's 1927 series of lithographs, which portray Baker as animalistic) have the potential to fascinate and repulse simultaneously. In many ways, especially considering her willingness to pose for images such as this, they seem to offer a counterpoint to her self-agency. In the exaggerated image of Baker in a cage, for example, Colin depicts her, limbs akimbo and obviously shades darker then her actual complexion. In addition Colin takes artistic licence and represents Baker's physique not as it appears but much more shapely, as if it is conforming to his own aesthetic ideal of the African female form. More disturbingly, she bears an uncanny likeness to the monkey that Colin depicts in the same series. The images, which seem to recall performers in blackface, are obvious impositions rather than accurate depictions. They may be read as degrading images that seal Baker in the realm of the animalistic and entrapped. Her performances, however, especially her later roles in film, provide direct contrasts to these representations. In this lithograph it becomes evident that she is caged though the cage does not restrain her. She metaphorically bends the bars; the imposed cage does not restrict her, and representations such as this do not prohibit her transformation.

Many people claim to have created Josephine Baker: Paul Colin declared that he had 'invented' her;[10] Jacques Charles, the producer and director who assisted with

Paul Colin
from *Le Tumulte Noir, c.*1927
lithograph
Schomburg Center for Research in
Black Culture, Art & Artifacts Division,
The New York Public Library, Astor,
Lenox and Tilden Foundations
© ADAGP, Paris and DACS, London 1997

La Revue Nègre (Baker's explosive 1925 début in Paris), claimed that he directed the audience's attention to her on the opening night;[11] Paul Poiret, the designer who begged her to wear his gowns, maintained that he converted her from a savage to a princess.[12] These individuals may have supplied her with finances and material goods. Baker, however, was always the principal agent of her reception, compelling her audience to examine the binary oppositions she created: the savage emerging as elegant, snack meaning skirt, caramel-colored skin depicted black, eroticism as the foundation for empowerment, Fatou foretelling Zou Zou.

Baker's transformation in Paris is a significant component in the history of black women artists and performers, a history that includes Edmonia Lewis, Loïs Mailou Jones, Miriam Makeba and Barbara Chase Riboud, who migrated in order to (re)create themselves. From a dancer/comedian in New York's Plantation Nightclub in 1925, Baker became Zou Zou and later lieutenant in France's Women's Auxiliary Air Force, earning the Légion d'Honneur in 1961. Like the gypsy's daughter,[13] Baker lived a migratory life to create situations where she could realize her personal aspirations despite defined boundaries. During these travels she was constantly transforming herself through such accouterments as wigs, plumes, birdcages, evening gowns and banana skirts.[14] Like the gypsy, forced to travel and acquire survival skills, Baker mastered the art of transformation to such perfection that it seemed an inter-generational character trait. As the epitome of a woman who utilized self-agency in order to attain personal satisfaction, Baker was recreation and reconceptualization personified. This ability to metamorphose secures and implants her standing as the ultimate self-propelled icon of renaissance, within and beyond the boundaries of Harlem's rebirth.

Notes

1. For additional information on the sexual perceptions of the primitive, please consult Marianna Torgovnick, *Gone Primitive: Savage Intellects, Modern Lives*, University of Chicago Press, Chicago, 1990, pp. 3–41, Lola Young, *Fear of the Dark: 'Race', Gender and Sexuality in the Cinema*, Routledge, New York, 1996, pp. 38-83, and Sander Gilman, *Difference and Pathology: Stereotypes of Sexuality, Race and Madness*, Cornell University Press, Ithaca, 1985.
2. Herman Lebovics, *True France: The Wars Over Cultural Identity, 1900–1945*, Cornell University Press, Ithaca, 1992, p. viii.
3. Audre Lorde, 'Uses of the Erotic: The Erotic as Power', *Sister Outsider: Essays and Speeches*, Crossing Press, Freedom, 1984, p. 53.
4. *Ibid.*, p. 54.
5. For information on the impact of desire and the male gaze please consult Laura Mulvey's *Visual and Other Pleasures*, Indiana University Press, Bloomington, 1989.
6. Other scenes in *Zou Zou* that underscore Baker's transition from a typecast primitive to a multi-dimensional character include her singing 'C'est lui' in a stunning evening gown; being escorted by an entourage of Frenchmen in tuxedos; her celebrated performance in the birdcage, wearing an elegant costume of strategically placed white plumes; and the conclusion, which features Baker dressed in a most fashionable fur hat and wristlets.
7. Earlier, in another (less dramatic) scene, Alwina demonstrates that she performs for her own fulfilment when she goes to a sailors' bar. Mesmerized by the music, she performs and, predictably, everyone delights in her performance. A separate yet interesting topic that deserves exegesis is the inability of Baker's characters to sustain fulfilling romantic relationships.
8. For more information on this discussion, please consult Alain Locke's *The New Negro*, Atheneum, New York, 1970; James Porter's *Modern Negro Art*, Arno Press, New York, 1969; Albert Boime's *The Art of Exclusion: Representing Blacks in the Nineteenth Century*, Smithsonian Institution Press, Washington D.C., 1990; and Romare Bearden's 'The Negro Artist's Dilemma', in *Critique: A Review of Contemporary Art*, November 1946, vol. I, no. 2, pp. 16–22.

9. Aaron Douglas in a letter to Langston Hughes, 21 December 1925. Langston Hughes Papers, James Weldon Johnson Memorial Collection of Negro Arts and Letters, Beinecke Rare Book and Manuscript Library, Yale University, New Haven, Connecticut. The section of this letter (featured in Richard Powell's *The Blues Aesthetic: Black Culture and Modernism*, The Washington Project for the Arts, Washington D.C., 1989, p. 24) and its relationship to primitivism was discussed during Richard J. Powell's seminar entitled 'Topics in the Art of the United States: Harlem Re/Naissance' at Duke University during the Fall of 1996.

10. Jean-Claude Baker and Chris Chase, *Josephine: The Hungry Heart*, Random House, New York, 1993, p. 114.

11. Phyllis Rose, *Jazz Cleopatra: Josephine Baker in Her Time*, Doubleday, New York, 1989, p. 5.

12. *Ibid.*, p. 9.

13. In *Josephine: The Hungry Heart* (op. cit., p. 80) Jean-Claude Baker and Chris Chase compare Baker to the woman in Tennessee Williams's *Camino Real*, who was 'reborn a virgin every time the moon rose'.

14. Baker included an autobiographical prose poem in a small book entitled *Joséphine Baker vue par la presse française*, which acknowledges her opinion about her transformation. She writes:

> ... They said I was homely
> That I danced like an ape
> Then I was less homely – Cosmetics
> I was hooted
> Then I was applauded
> ... I am moral
> They said I was the reverse ...
> I sing and dance still – Perseverance ...

Baker's poem was printed in English in the African-American newspaper, *The Chicago Defender*, on 10 October 1931 in a section entitled 'Atta Girl, Jo'.

PAUL ROBESON AND THE PROBLEM OF MODERNISM

JEFFREY C. STEWART

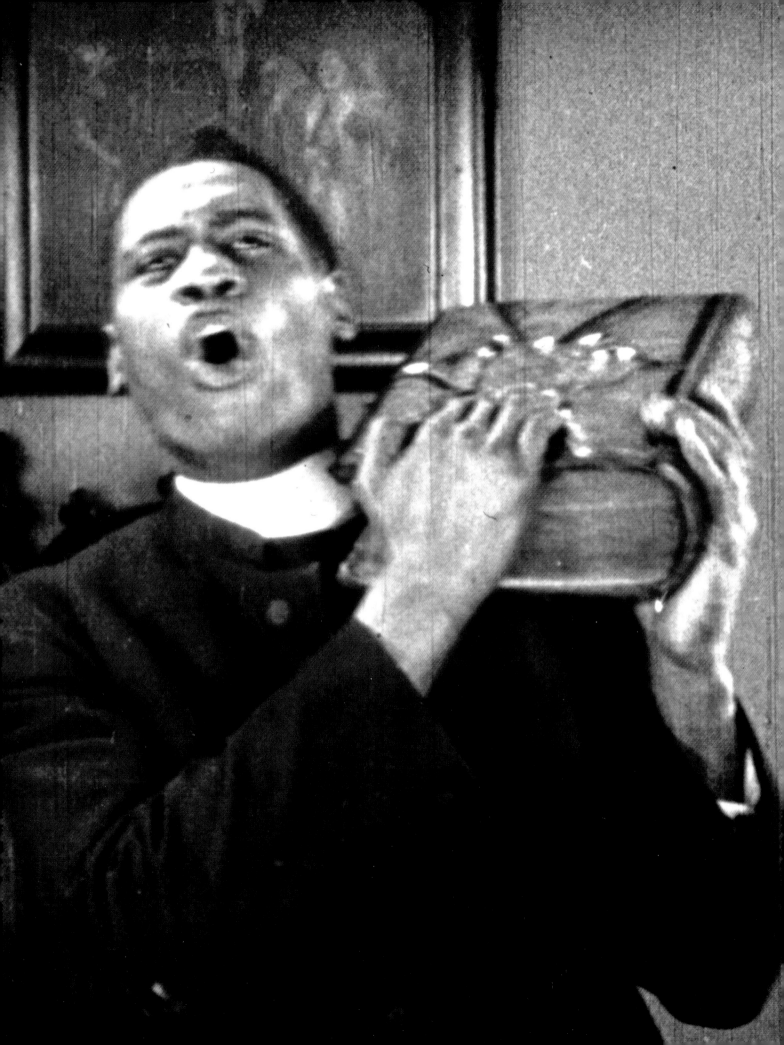

Modernism is a tricky word when used in association with the Harlem Renaissance. Modernism most often refers to the rebellious artistic and literary movements of the late-nineteenth and early-twentieth-century Europeans and white Americans, whose sense of alienation from the rise of the corporate industrialized state was reflected in the breakdown of the representational and the familiar in literature and art.[1] But modernism is also linked to more sociological processes, usually termed modernity: social forces such as industrialization, urbanization, secularization and commodification, and technological innovations such as photography and film that reflect the rise of the machine age in Western Europe and America.[2] It is because of these social forces and technological innovations that America is usually thought to have reached modernity in the 1920s – the Model A, the rise of motion pictures, the radio, etc. – but it is because of modernism that the Harlem Renaissance, according to many commentators, emerged as a distinctive African-American literary and artistic movement in the 1920s.[3] This argument is made rather explicitly in George Hutchinson's recent book, *The Harlem Renaissance in Black and White*.[4] When we add to this Houston Baker's argument, in *Modernism and the Harlem Renaissance*, that modernism in African-American culture is voiced by an imagined community or nationalism in turn-of-the-century literary forms, the scope for what is and is not modernism widens considerably.[5] Yet several factors have prevented the African-American from fitting neatly into the white American narrative of modernism or modernity in American life, and a brief look at the Harlem Renaissance and the career of Paul Robeson, one of its most talented prodigies, may help to explain why.

My impression of the limitations of the usual sense of modernism comes from Raymond Williams's posthumously published book, *The Politics of Modernism*, in which he shows how modernism has been a way of elevating one part of an enormously complex and varied constellation of social forces and movements around the turn of the century.[6] By privileging the artistic and literary rebellions of the late nineteenth and early twentieth century, modernist theorists usually validate the primacy of the art object as the center of any aesthetic interpretation and consider the social, political and economic underpinnings of cultural productions as marginal. For black intellectuals what that has meant is that one is forced to look at African or African-American art in these terms; and if it is not spare, pristine, highly formalized and elitist – then it is not modern, not important, and not to be valued. This is essentially Houston A. Baker's point. But Baker constructs a competing modernism, one that redefines, again, what is important and thereby marginalizes that which is not in an effort to recapture for the Harlem Renaissance the prestige associated with the term. In other words, the real modernism must be black and must be a nationalist discourse. Challenging this view in his book *The Harlem Renaissance in Black and White*, George Hutchinson argues that the Harlem Renaissance was modernist and laudably redefines the original notion of modernism to include not only the literary but also the broader philosophical and anthropological writings of William James, John Dewey, Franz Boas and Horace Kallen, which launched cultural pluralism and made it the reigning ideology of twentieth-century liberalism. Here, at least, in Hutchinson's reformulation, the really distinctive characteristic of Harlem Renaissance modernism was that it was an *interracial* cultural strategy for transforming America into an ethnic 'pluriverse' – an argument that surfaces more in the writings of W.E.B. Du Bois, Alain Locke and Charles S. Johnson than in the writings of their mentors, James, Boas and Robert Park. But Hutchinson's formulation ignores those black cultural formations of the 1920s that are not interracial, that were developed solely for a black audience and linked directly

Previous page:
Paul Robeson as Reverend Jenkins
in *Body and Soul*, 1924
Directed by Oscar Micheaux
Courtesy of George Eastman House,
New York

to a segregated social formation lived by the majority of African-Americans during that period. Even more importantly, such a definition of Harlem Renaissance modernism ignores the issues of control over the ownership and production of knowledge and culture in the 1920s. Du Bois and Johnson, for example, edited the magazines *The Crisis* and *Opportunity*, respectively, which published most of Harlem's poetry, fiction and visual illustration, but they operated at the behest of largely white organizations with whom both editors had problematic relationships. More broadly, black intellectuals such as Du Bois and Locke did not interact with James and Boas as cultural or social equals; and neither did Paul Robeson, despite his sometimes affectionate collaborations with Eugene O'Neill and Carl Van Vechten. A system of white vetting of black intellectuals and artists ensured that when the writers or actors veered too far outside of the parameters of white modernist enthusiasm, the black recipients of white patronage often found themselves abandoned. That experience spawned what I would call the 'double consciousness' of Harlem Renaissance modernism, that is the experience of feeling oneself at one moment an artist, qua artist, à la modernism, with considerable inflated social status, and then a Negro, to paraphrase Du Bois.[7] The lived experience of modernism for many African-American intellectuals and artists in the 1920s included the sense that if one violated the prescriptions of modernist discourse, if one dared to foreground the historical and contemporary oppression of peoples of color in one's notion of culture, then one fell out of the loop. Paul Robeson's struggle to create a career reveals much about the problem of modernism facing a black artist and about why, in the 1930s, he broke with the modernist notion of culture to begin an analysis of the global reach of racism and imperialism.

Let us start with a film, *Body and Soul* (1924), made by the independent black film-maker Oscar Micheaux, and the first film that Robeson appeared in.[8] Developed for, and marketed to, an all-black audience, this film tells the story of a black criminal, played by Robeson, who escapes from jail, poses as a minister and takes advantage of a black community, especially a young woman, whose God-fearing mother cannot accept her daughter's assertions that 'Reverend Jenkins' is a drunk, a faker and a rapist. This film is modern because it breaks with the 'Black Victorian' expectation that black people always present a positive image of themselves in their art – a position in the 1920s best expressed by Du Bois that 'all art is propaganda for or against the race' – and instead provides a searing self-critique of the folly of the black community, especially its over-confidence in black ministers, whom Micheaux was known to dislike.[9] The film is modern in a formal sense: it uses dream sequences and flashbacks, and it cuts between scenes to create not only movement in the story but also the sense that one is part of the community portrayed. The film is also modern for what it takes on: it is one of the first (if not *the* first) films to contain an African-American rape scene (a black man violating a black woman); it powerfully portrays the intergenerational conflict between old and 'New Negroes', the principal conflict of the Harlem Renaissance; and it deconstructs the black self-help ideology with a deep and unrelenting irony. For example, a portrait of Booker T. Washington hangs on the mother's wall, but the film shows how feeble Washington's vision of the black independent businessman has become when the 'black businessman' (so captioned in the film) is a crooked liquor salesman and gambling-parlor owner. Another scene reveals the irony of the 'hooping and howling' preaching of the black ministry; Jenkins's exuberant preaching is fueled by alcohol, which he drinks secretly under the podium. Even though Jenkins is an escaped criminal, it is astonishing that Micheaux was able to get away with such a devastating critique of the ministry. The viewer needs little

imagination to grasp the movie's not too subtle point – that most ministers are exploiters of their communities. But what is exceptional is Micheaux's casting of Robeson in a double role as two brothers – Jenkins, the criminal masquerading as a minister, and Sylvester, the budding inventor – for it stresses the point, absent from the more celebrated Eugene O'Neill play, *The Emperor Jones*, that not all black men are evil.[10] As Sylvester, Robeson steps forward to ask for the daughter's hand in marriage when she has become pregnant by Jenkins. Even here, Micheaux uses the model of the good black man to make another critique of the black community. When Sylvester makes his offer, he is rejected by the mother because he does not have enough money; while there are good Negro men, their ultimate valuation by the community is based on materialism rather than character.

This film does not even appear in George Hutchinson's index to his book because it does not conform to Hutchinson's thesis that what was important about the Harlem Renaissance was that it was interracial. The omission of the film reinscribes a familiar narrative in the history of black culture in America – that nothing existed prior to the discovery of black themes by Columbus-like whites – but, more seriously, the conceptualization that Harlem Renaissance modernism was interracial implies that there was not an indigenous modernist movement within the black community. *Body and Soul* interrupts that narrative by showing that the modernism within the black community was a movement committed to breaking with the tradition of respectability, – of always 'putting the best foot forward' in the arts to convince whites that blacks were equal – and, instead, uses the arts as a self-critical mirror on the black community. Nor does the film fit easily in the frame that Houston Baker constructs in *Modernism and the Black Renaissance*. Here Baker analyzes the literature leading up to and including Alain Locke's *The New Negro: An Interpretation* to argue that the modernism of the black renaissance consists of the literary 'sounds' of an 'imagined community' or nationalism among African-Americans in the 1920s.[11] *Body and Soul* is certainly a film about an autonomous black community and yet the film goes beyond nationalistic consciousness to expose, as Frantz Fanon would put it, the 'pitfalls of national consciousness' for the black community.[12] In a way, *Body and Soul* is a narrative on race as false consciousness: skin color is not a reliable barometer of character or morality. In this sense, *Body and Soul* moves beyond the concerns of race and nation to address a community that listens to its youth, listens closely to the 'sounds' of malignancy even among its own.

The reality, however, is that Robeson could never have been a star of the Harlem Renaissance if he had relied exclusively on parts in plays and films written by poorly financed African-American producers like Micheaux. As with many other successful 'New Negroes' of the 1920s, Robeson had to practice another brand of double consciousness – to keep one foot in black modernism until he could gain enough support from the white modernists to lever himself into a career as a crossover artist. And to enter that world the talented black performer had to be 'discovered' or vetted by white playwrights and artists, and act or otherwise participate in Negro productions written or created by artists that were not really modernist in the radical aesthetic sense of late-nineteenth and early-twentieth-century modernism in Europe and America. Why?

The reason is not hard to find for the Negro was never considered part of the machine age: indeed, in the popular myth of John Henry, the Negro is eulogized precisely because he resists modernity.[13] In order to enter modernist discourse the African-American had to do so as the primitive. In Robeson's first major play, for

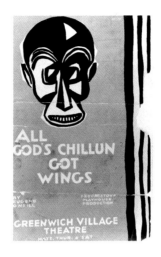

Poster of *All God's Chillun Got Wings*, 1924
The New York Public Library

example, *Taboo* (written by the white woman, Mary Wiborg), he plays first a lazy African-American from Louisiana and then an African king, honored by his regal robes in the American production, demeaned and humiliated by his tawdry garb in the London version.[14] A noble savage in New York and then a savage buffoon in London. In both cases the Negro becomes interesting to moderns only through a maneuver that imprisons him in his primitive past. When Eugene O'Neill cast Robeson in the play *All God's Chillun Got Wings*, a modern love story between a black man and a white woman, the poster for the production depicted an African mask. In the title role of the 1924 production of The *Emperor Jones* (O'Neill decided to stop using Charles Gilpin, the originator of the role, because he had become too uppity), Robeson, though initially an assimilated African-American, succumbs to a primitive fear of witch doctors.[15] Robeson's other major acting role of the 1920s, as Jim singing 'Old Man River' in *Show Boat*, casts him as a lazy southern darkie, whose resistance to work is part of his charisma as a preindustrial figure.[16] That role, and others such as John Henry in the 1940 play of that name by Roark Bradford (Bradford stated that Paul Robeson *was* John Henry) suggests that romanticism is a far more accurate genre for the literature of the movement than modernism.[17] For what distinguished white usages of Robeson's talents in the 1920s and 1930s was a symbolic return to the past, a past in which the pre-industrial, pre-modern qualities of the Negro were both romanticized and envied by the white author or viewer.

Romanticism also characterizes the frame in which much of the 'New Negro' literary and dramatic efforts of the 1920s most easily fits: films, unlike Micheaux's, that were intended primarily for a white or educated African-American audience. The dominant narrative of the Harlem Renaissance was nostalgia, especially for those, like Robeson's father, who had participated in the Great Migration that brought hundreds of thousands of African-Americans out of the South into northern cities during the 1910s and 1920s. In that move north, the dominant refrain was a longing for the South, a note that is overwhelming in Jean Toomer's *Cane*, the short fiction of Rudolph Fisher, and in the short stories and novels of Zora Neale Hurston.[18] Much of this writing is pre-realism rather than post-realism, as in the literary modernism of the late nineteenth century that is so often regarded as the model for the black movement of the 1920s. What is at issue here is nothing less than what W.B. Yeats and others searched for in the Irish Renaissance – a romantic re-engagement with a folk tradition that is still within reach historically and emotionally for an educated generation of cosmopolitans.[19] Here Robeson uniquely embodies the dominant note of the Harlem Renaissance, for his enormous success in the 1920s comes as a concert singer of the spirituals, music of the nineteenth century, rather than as a singer of the blues or jazz of the 1920s.[20] White and black romantic constructions of the Negro's cultural identity dominated in the Harlem Renaissance, and those forms that were most successful were those that blended both.

And this is not surprising. The 1920s was a transitional period in American history for African-Americans socially, economically and politically, one in which the locus of black presence is shifting northward and urbanward, thereby remapping the African-American landscape and the American perception of what blackness means in American culture.[21] Negro history inevitably remains in the subconscious of America's most creative white people and the South remains in the subconscious of the recent black migrant.

Of course for Hutchinson and other critics of the Harlem Renaissance the exploration of a deeply malignant persona is what makes Eugene O'Neill's *The*

Emperor Jones the archetypal modernist drama of the 1920s.[22] The play narrates the story of how an African-American Pullman porter gains control of the indigenous population of a Caribbean island (one 'that has not yet been self-determined by white Marines') through brutality and terror, but plagued by voodoo spells, dreams and hallucinations, he is eventually assassinated by the island's witch doctor for his crimes against the people.[23] *The Emperor Jones* has been and can be read many ways – as a narrative on what Marcus Garvey's rule in a mythical little Africa would really come to; as a critique of Americanism imported into the Caribbean; and as a commentary on the 'Black As Other', not only in America but also in adopted homelands like Haiti. But many black intellectuals, both in the 1920s and later in histories of the Harlem Renaissance, have criticized the play, although as Hutchinson argues persuasively, some African-American intellectuals such as Alain Locke and Montgomery Gregory, the organizer of the Howard Players, loved the play, especially with Gilpin in the lead role.[24] But when the play was presented on stage in Harlem during the 1930s and Emperor Jones became fearful of the 'ha'nts' in the forest, Langston Hughes recalled that those in the Lafayette Theatre audience laughed and screamed to the actor: 'Them ain't no ghosts, fool! ... Why don't you come on out o' the jungle – back to Harlem where you belong?'[25] That was, in fact, a message that could have been delivered directly to the playwright. For *The Emperor Jones* was directed towards a white audience or at least an audience that thought about African-American identity in Victorian and primitivist categories.

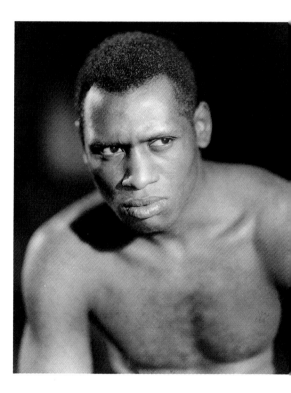

Paul Robeson in Eugene O'Neill's play *The Emperor Jones* at the Ambassadors Theatre, London, September 1925
photograph: Sasha
The Hulton Getty Picture Collection

The Emperor Jones was certainly modernist in terms of its complex approach to its central character, Jones, who is driven by complicated impulses – conscious desires to be free, to rise above his station, to be respected, but also unconscious needs to control, abuse, and perhaps be loved by, others. But the play remains problematical in that it maps this identity with a Haitian primitivism that replicates the same Victorian racial dichotomies of white man/rational, black man/irrational that are endemic to nineteenth-century colonialism. That Jones, a conniving, coldly calculating, supremely rationalist and rationalizing ruler would suddenly become paralyzed by superstition and fear of ghosts at the end of the play is preposterous simply from the standpoint of plausible character development and is believable only if the audience draws upon its Victorian notions of black people as ultimately superstitious and irrational, no matter how sophisticated they may appear to be. Without such primitivist notions of blackness, the Harlem audience just laughed. Like many other modernist projects of the 1920s, *The Emperor Jones* inevitably fell back into portraying black people within the Victorian categories that post-modernism would challenge.

Why were such modernist liberals as Eugene O'Neill unable to break with the Victorian racial construction of black identity? In part it was related to the fact that another modernist, Sigmund Freud, had also reified primitivist categories when he argued in *Totem and Taboo* (published in English in 1918) that primitive peoples had preserved a connection with unconscious and spiritual impulses in their daily lives. Literary modernists of the 1920s who wished to portray such 'deep' feelings naturally turned to Africa and African-Americans as part of modernism's romantic attempt at recovering a kind of consciousness – seeing spirits and ghosts, for example

Carl Van Vechten
Billie Holiday (1915–59),
23 March 1949
silver gelatin print
Library of Congress, Washington D.C.
Joseph Solomon, as Executor of the
Estate of Carl Van Vechten

– that had been lost by most civilized men.[26] In Jones, O'Neill fused what would normally be considered two separate identities – that of a white conqueror and a black primitive – in one character, and by having the character succumb to self-destruction, O'Neill suggested his critique of Western mentality. But O'Neill narrated his critique only through a kind of blackface: he projected the drama of self-destruction on to the black man who adopts the values, ironically, of Western capitalism – greed, ruthless individualism, unrelenting self-promotion, to the detriment of the larger community, the Caribbean black people on the Emperor's island. It does not take much imagination to realize that Eric Lott's analysis of the motivation behind nineteenth-century blackface (which O'Neill donned for one play) – that the white actor in blackface, here a white writer for our purposes, could act out as a black person those qualities or issues he could not take responsibility for as a white man – applies to O'Neill's play.[27] The play narrates the history of exploitation in the Caribbean, but without any reference to the history of colonialism that engendered that exploitation. Modernism tended to silence the historical and social context of the conflicts in modernity, and announce the central drama of the twentieth century as essentially an internal psychological conflict, in which whiteness was not implicated. But imagine, for a moment, that the character of Emperor Jones had been written as a white man: that would have made a revolutionary and more psychologically provocative play!

To do so, however, would mean to repudiate the privilege that O'Neill and other so-called modernists of the Harlem Renaissance were not ready to relinquish. We see a similar pattern in Carl Van Vechten, Robeson's other patron of the mid-1920s, who was the single most important figure in publicizing Robeson as a singer of the spirituals, a man who gave white people tours of Harlem, who wrote one of the best novels of the period, *Nigger Heaven*, and who epitomized in his personality, at least, a modernist boulevardian.[28] Van Vechten not only encouraged Robeson in his study of the spirituals but also in his discovery of Africa. But rather than a modernist, Van Vechten was a romanticist with an Oscar Wildean aestheticism: in his photographs he would pose African-Americans with African artifacts – an African mask, for example, in his photograph of Billie Holiday – as if the viewer could tease out the transatlantic connections. As long as Robeson was content to play the primitive for European and American romantics, he could enjoy social freedom, associate with whites in conditions of relative social equality and was an appropriate subject for Van Vechten. But when Robeson began to question the imperialistic and capitalistic roots of racism, when he became associated with Communism and anti-racist activism, and when he began to commit himself to creating an alternative to the exploitative system of labor and race that existed in mid-twentieth-century America, Van Vechten, for one, dropped him.[29]

Finally, it is worth looking at what happened when black and white romanticism came together, rather disastrously, in the film *Sanders of the River*. As Martin Duberman, Robeson's biographer, writes: 'early in the summer of 1934, the Korda [Alexander and Zoltan] brothers offered him the role of the African chief Bosambo in a film they were planning based on Edgar Wallace's book *Sanders of the River*.'[30] Robeson jumped at the chance because of his increasing interest in the study of Africa and in identifying himself as an African. He thought he had found a dignified

African role to play, in part because of the willingness of the Kordas to include footage collected in Africa that showcased African folkways. As in *Body and Soul* Robeson's character, Bosambo, is an escaped criminal, but this time a good-hearted one who becomes the benevolent chief of his tribe under the tutelage of Sanders, an English commissioner. Bosambo approaches 'Sandy' to get his help against his enemy, King Mofolaba, the 'Bad African King', a slave trader who wants to drive the British out of Africa. Sanders takes on Bosambo as a collaborator through whom 'Sandy' can more easily collect taxes for the British. The two African kings maintain an uneasy peace until Sandy decides to return to England and two unscrupulous British traders spread the rumor 'Sandy is dead. There is no law any more.' In the scenes that follow, the natives become 'restless', war dances erupt, even the elephants, hyenas and giraffes become distraught, simply because an English commissioner has left. When the inevitable showdown comes between Bosambo and Mofolaba, it is Sandy who must rescue Bosambo from death at the hands of his adversary and re-establish peace among the Africans. Although the Kordas must have thought of their film as modern – it portrays a close relationship between a white man and an African; contains a scene where one Englishman defends the Africans against charges that they are 'savages'; and shows Africans willing to adopt English ways in their march towards peace and prosperity – there are images of African women dancing bare-breasted, witch doctors whipping up the natives into a fever pitch and African men climbing trees like monkeys. It reads as a stereotype today, and apparently did so in 1935. When Robeson saw the edited film he was aghast at how completely the film reified the notion that English colonialism was good because it brought peace to warring African tribes. Robeson stated afterwards that the film had been recut to glorify imperialism, suggesting that there were no such elements in the scenes in which he acted.[31] But there are too many scenes in which Robeson participates to make that explanation completely satisfactory. One of the most embarrassing episodes takes place near the end of the film. Sandy is about to leave and one of the African kings states, 'We love one another now, and you know why, Lord Sandy? Because we know that if we don't, you will punish us,' to which Sandy replies, 'That's right.' Robeson is standing right next to him when the king articulates the ideology of African dependency.

There could be several explanations for Robeson's naivety in this instance. He wanted the film to be different and to rise above the cheap characterizations of Africa and African folkways in popular media, and he believed that the Kordas, who shot footage on location in Africa, had been true to his vision. In addition, I believe that Robeson's enthusiasm for a film that would show African dances, dress and social practices eclipsed the film's narrative, particularly the ways in which the Kordas reworked Edgar Wallace's story so that it ultimately glorified British colonial admin-istration.[32] This interest in the anthropological was part of the black romanticism of the Harlem Renaissance and after the filming Robeson began to realize how inadequate that Harlem Renaissance ideology – whether we call it modernism or romanticism – was for him, as a black man, self-conscious about the influence his cultural produc-tions would have. Modernism as it had germinated in the 1920s and in regard to the African-American had failed to destroy white privilege or European colonialism, and it had not created the social formation in which cultural productions funded by white capital could imagine an alternative post-colonial world for people of African descent. Robeson realized that simply pursuing his art and displaying his talent – and trusting white American and British directors because they treated him nicely – would not result in movies and performances that would honor the black experience. He learned

that he could not escape the reality of race distinction by going abroad or confining himself to his art. Precisely at the moment in his life when he benefited the most from the commodification of the primitive on stage and in film, his frustration with the limits of his role as an actor in modernist projects grew.

In the 1930s Paul Robeson moved out of the black modernist nationalism of the 1920s and the white primitivist modernism of Greenwich Village to fashion a new identity for himself as a black artist who was an activist leader of a global cultural and political movement. It was partly because Robeson was a performing artist that his struggle and failure to craft what he saw as authentic representations of the black experience forced him into a confrontation with the economics of cultural production that radicalized him. That struggle pointed up his own dependency on romantic white patronage and opened his eyes to the ways in which he and his art were used to advance the racial propaganda he rejected. Yes, interracial modernist artistic productions made it possible for a small segment of the black middle class to live more integrated and aesthetically rich lives; but the structures of racism and colonialism remained, and their power was veiled by the illusion that creating works of art transformed the economic and social conditions that underlay them. Try as he might, Robeson's collaborations with white modernists ended up reproducing the very structures of domination that he wished to overthrow. Disillusioned with the limits of the modernist artistic space, Robeson moved out into a political space in which he could challenge the social formations of racism and colonialism. He would later argue that a fundamental transformation of American society and international capitalism was

necessary if the world was to be made safe for democracy. His contribution would be to extend the notion of culture beyond the modernist frame and, in so doing, point the way towards the Direct Action Movement of the 1950s and the Black Arts Movement of the 1960s.

Notes

I wish to thank Gilbert Morris for conversations on this subject and Fath Davis Ruffins for reading and making comments on an early draft of this essay. I also wish to thank Marta Reid Stewart for her support during the writing of this essay.

1. Although there are exceptions, most of the theorizing in relation to the Harlem Renaissance has borrowed more from literary than visual art notions of modernism. Two early and remarkably clear articles on the subject are Harry Levin 'What Was Modernism?', *Massachusetts Review* I, August 1960, pp. 609–30, and Robert Martin Adams 'What Was Modernism?', *Hudson Review* 31, Spring 1978, pp. 19–38. A veritable 'renaissance' of scholarly writing on modernism seems to be occurring. Consider Fredrick Jameson, *Theory of Culture*, Y. Hameda, Tokyo, 1994; Bonnie Kime Scott, *Refiguring Modernism*, Indiana University Press, Bloomington, 1995; Joseph N. Riddel, *The Turning Word: American Literary Modernism and Continental Theory*, University of Pennsylvania Press, Philadelphia, 1996; Carola M. Kaplan and Anne B. Simpson, eds., *Seeing Double: Revisioning Edwardian and Modernist Literature*, St. Martin's Press, New York, 1996; Andrew Hewitt, *Political Inversions: Homosexuality, Fascism, & the Modernist Imaginary*, Stanford University Press, Stanford, 1996; Jack Selzer, *Kenneth Burke in Greenwich Village: Conversing with the Moderns, 1915–1931*, University of Wisconsin Press, Madison, 1996; Terri A. Mester, *Movement and Modernism: Yeats, Eliot, Lawrence, Williams, and Early Twentieth-Century Dance*, University of Arkansas Press, Fayetteville, 1997; Daniel R. Schwartz, *Reconfiguring Modernism: Explorations in the Relationships between Modern Art and Modern Literature*, St. Martin's Press, New York, 1997; David Weir, *Anarchy and Culture: the Aesthetic Politics of Modernism*, University of Massachusetts Press, Amherst, 1997; and Joyce Piell Wexler, *Who Paid for Modernism: Art, Money, and the Fiction of Conrad, Joyce, and Lawrence*, University of Arkansas Press, Fayetteville, 1997, among many others. For recent investigations of modernism in the visual arts and the Harlem Renaissance, see Richard J. Powell, *The Blues Aesthetic: Black Culture and Modernism*, Washington Project for the Arts, Washington, 1989, and Amy Helene Kirsche, *Aaron Douglas: Art, Race, and the Harlem Renaissance*, University Press of Mississippi, Jackson, 1995.
2. Raymond A. Williams, ed.,*The Politics of Modernism: Against the New Conformists*, with an introduction by Tony Pinkney, Verso, London, 1989, and Peter Wagner, *A Sociology of Modernity: Liberty and Discipline*, Routledge, London & New York, 1994.
3. For a discussion of modernity in relation to the United States, see Alan Trachtenberg, *The Incorporation of America: Culture and Society in the Gilded Age*, Hill & Wang, New York, 1982, especially pp. 38–69, 182–234; Robert Sklar, *Movie-Made America: A Cultural History of American Movies*, Random House, New York, 1975.
4. George Hutchinson, *The Harlem Renaissance in Black and White*, Oxford University Press, London and New York, 1996. Nathan Irvin Huggins's *Harlem Renaissance* (Oxford University Press, New York, 1971) is the classic comparative analysis of the Harlem Renaissance in relation to American and European modernism.
5. Houston A. Baker, *Modernism and the Harlem Renaissance*, University of Chicago Press, Chicago, 1987.
6. Raymond A. Williams, op. cit.
7. W.E.B. Du Bois, 'Of Our Spiritual Strivings', *The Souls of Black Folk* (1903) in *W.E.B. Du Bois Writings*, The Library Press of America, New York, 1986, p. 364.
8. Martin Bauml Duberman, *Paul Robeson*, Alfred A. Knopf, New York, 1988, p. 77. See also Donald Bogle, *Blacks in American Films and Television: An Encyclopedia*, Garland Publishing, Inc., New York & London, 1988, pp. 32–33.
9. For discussion of Black Victorianism, see Jeffrey C. Stewart, 'Alain Locke and Georgia Douglas Johnson: Washington Patrons of Afro-American Modernism', in David McAleavey, ed., *Washington and Washington Writing*, Center for Washington Area Studies, George Washington University, Washington, 1986; and Fath Davis Ruffins, 'Mythos, Memory, and History: African American Preservation Efforts, 1820–1990', in Ivan Karp, Christine Mullen Kreamer and Steven D. Lavine, eds, *Museums and Communities: The Politics of Public Culture*, Smithsonian Institution, Washington and London, 1992, pp. 513–21. For Du Bois's discussion of art and propaganda, see 'The Criteria of Negro

Art', *Crisis* 32, October 1926, pp. 290–97. Micheaux's attitude towards ministers is noted in Donald Bogle, op. cit. p. 33.

10. Eugene O'Neill, *The Emperor Jones, 'Anna Christie', The Hairy Ape*, Vintage Books, New York, 1995, pp. 3–41.

11. Alain Locke, *The New Negro: An Interpretation*, Albert and Charles Boni, New York, 1925. For discussion of 'imagined community', see Benedict Anderson, *Imagined Communities: Reflections on the Origins and Spread of Nationalism*, Verso, London and New York, 1996.

12. Frantz Fanon, *The Wretched of the Earth*, translated by Constance Farrington and with a preface by Jean-Paul Sartre, Grove Press, New York, 1963, pp. 148–205.

13. Guy B. Johnson, *John Henry: Tracking Down a Negro Legend*, AMS Press, New York, 1969.

14. Program for *Taboo*, 1922, Theatre Collection, New York Public Library for the Performing Arts.

15. Joel Pfister, *Staging Depth: Eugene O'Neill and the Politics of Psychological Discourse*, University of North Carolina Press, Chapel Hill, 1995, p. 134.

16. Martin Bauml Duberman, op. cit., p. 114. Duberman quotes J.A. Rogers, a correspondent for the *Amsterdam News,* as repelled by 'the character of Joe's being simply another instance of the "lazy, good-natured, lolling darkey" stereotype "that exists more in white men's fancy than in reality."'

17. Roark Bradford, 'Paul Robeson is John Henry', *Collier's Magazine*, 13 January 1940. Frank Kermode offers another interpretation of the relation of primitivism to modernism in 'Modernism, Postmodernism, and Explanation', in Elazar Barkan and Ronald Bush, eds, *Prehistories of the Future: The Primitivist Project and the Culture of Modernism*, Stanford University Press, Stanford, C.A., 1995, pp. 357–72. I agree with Kermode's identification of modernism with dissociation of sensibility and disillusion with explanation in modern literature, and a resultant preference for descriptive forms of writing. But I also see modernism as implying a recognition of the constructed nature of human experience, without any explanatory givens such as God, nature, etc., to relieve man and woman of the terrible responsibility to create his or her world, as Jean-Paul Sartre argued in *Being and Nothingness* (Grammercy Books, New York, 1994). As such, to embrace the primitive is not so much a part of modernism as a reaction to modernist consciousness and thus a desire to return to or bond with that which is perceived as wholly given, i.e. the primitive as a creature of instinct, nature, spiritual forces, indeed any givenness that precludes the awareness of the constructed nature of all human essence and agency. This maneuver is romantic not only in that it longs for a past that can never be returned to, but also because, as James Clifford suggests (in *The Predicament of Culture: Twentieth Century Ethnography, Literature, and Art*, Harvard University Press, Cambridge, 1988), such 'primitivism' is largely imagined, a mapping of pre-modern mentality that is misrepresentative and misperceived.

18. Jean Toomer, *Cane*, with an introduction by Darwin T. Turner, Liveright, New York, 1975; Rudolph Fisher, 'Vestiges: Harlem Sketches', in Alain Locke's *The New Negro: Voices of the Harlem Renaissance*, with an introduction by Arnold Rampersad (1925), Atheneum, New York, 1992 edition, pp. 75–84; Zora Neale Hurston, 'Spunk', in Alain Locke, op. cit. pp. 105–11.

19. I am indebted to Gilbert Morris, with whom I have had several conversations this year, for this observation. For more on Yeats, see Uta von Rienersdorff-Paczensky und Tenczin, *W.B. Yeats's Poetry and Drama Between Late Romanticism and Modernism: an Analysis of Yeats's Poetry and Drama*, P. Lang, New York, 1997.

20. Martin Bauml Duberman, op. cit., pp. 77–82.

21. For the Great Migration and its interpretation, see Jeffrey C. Stewart, *1001 Things Everyone Should Know About African American History*, Doubleday, New York, 1996, pp. 52–60 and '(Un)Locke(ing) Jacob Lawrence's Migration Series' in *Jacob Lawrence: The Migration Series*, with an introduction by Elizabeth Hutton Turner, The Phillips Collection and the Rappanhannock Press, Washington, D.C., 1993, pp. 41–51.

22. George Hutchinson, op. cit., pp. 194, 309.

23. Joel Pfister, op. cit., pp. 129–32.

24. George Hutchinson, op. cit., pp. 193-94.

25. Langston Hughes, *The Big Sea*, 1940, quoted in Joel Pfister, op. cit., pp. 131–32.

26. Joel Pfister, op. cit., *passim.*

27. Eric Lott, *Blackface Minstrelsy in the American Working Class*, Oxford University Press, New York, 1993.

28. Jervis Anderson, *This Was Harlem: A Cultural Portrait, 1900–1950,* Farrar, Straus, Giroux, New York, 1982, pp. 212–20.

29. Martin Bauml Duberman, op. cit., p. 235.

30. *Ibid.*, p. 178.

31. *Ibid.*, p. 179.

32. *Ibid.*, p. 180. Robeson's interest in Africa in the 1930s is chronicled on pages 173 to 178.

MODERN TONES

PAUL GILROY

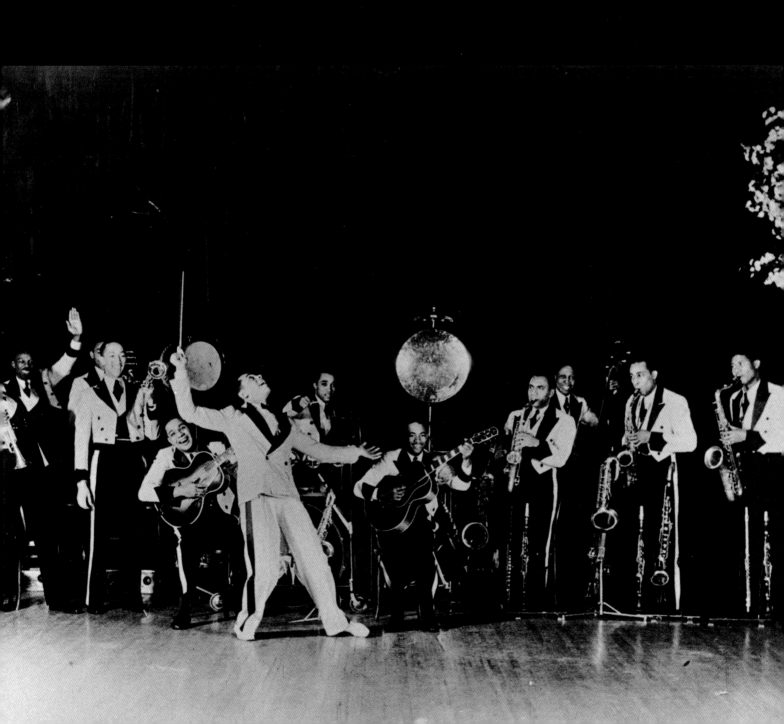

It has been observed that enslaved Africans were first coerced into the monumental edifice of Western culture through a doorway provided by the Christian church. The part that their musical creativity has played since then, in making that confinement endurable and negotiating ways out of it, has been less extensively commented upon. Tracking attitudes to black musics – sacred, secular and profane – through debates about modernity and aesthetic modernism is a difficult task because modern aesthetics have not just mirrored the principles of racial differentiation produced in other fields of equally-specialised but less innocent knowledge. Modern aesthetics repeatedly produced and sanctioned the spurious truths of an unjust racial order. Blacks, 'negroes', appeared regularly in writing about the nature and essence of Western art. Racial difference was repeatedly cited where critics pondered the inability of non-Europeans to produce legitimate and therefore authentic art. These distinctions were often, though by no means always, expressed in the opposition between primitive and civilised. They became central to modern specifications of exactly what art should comprise.[1]

Black modernism, to which music was central, presents an interesting repudiation of these compromised aesthetic schemes. It was 'initialised' by the catastrophic violence of slavery that kept its progenitors at a distance from literacy and logo-centric selfhood, and shaped by the creative musical opportunities that were offered as partial compensation for forced exile from the world of writing. These characteristics should make it obvious that the distinctive patterns of culture and communication found in the transnational web of the modern black atlantic would not be dominated by literature. It may be less obvious that the black atlantic's world of sound would be so actively and consistently counterposed to the world of texts and that it would sometimes conscript the visual arts into struggles against the power of racialised rationality and imagination invested in writing and print technology.

When, in our own century, black music joined temporarily with modernist visual arts under the banners of the sensuous and the immediate it became an important source of resistance against definitions of art, to which the opposition between races – re-expressed as conflict between a primitive child and a rational adult – was integral. The music was only able to furnish important analogies for other types of artistic creation – cubism, surrealism – because of the relative ease with which black feeling could be traded as a cultural commodity in a new market. Negrophobia and negrophilia were mutually entangled in some surprising patterns.[2] Harlem became an imaginary repository of transgressive feeling to many far-flung affiliates of the avant-garde. Josephine Baker and her peers were distinguished emissaries conducting these fantasies into the inner sanctum of European decadence. To the new remote audiences for whom American Harlem was an unproblematic extension of African tribalism, foregrounding music did little to disrupt their enthusiasm for the exotic and the instinctive. Black musics were enthusiastically reduced to those racial qualities alone. As the musics travelled, they registered the processes of dissemination in their own attenuated forms. Some commentators went so far as to suggest that a distinctive Parisian school of jazz-playing was developing alongside that practised in New York. European critics began to write about the music seriously and respectfully but without always appreciating its historic ties to black America.

It is not long since Harlem displaced London as home to the largest African-descended population outside Africa. Alain Locke's introduction to *The New Negro* spelled out some of the implications of that fateful change for the future development of black cultural life in the century of the 'color line'. Harlem would find a new role as the capital of a black world. It would localise aspirations towards nationhood even

Previous page:
Cab Calloway and his Orchestra, New York City, 1933
photograph: P. Vacher/Jazz Index

if a thoroughgoing alternative nationality was impracticable. From its first imaginings this work of cultural and political reconstruction was marked by conflict over its scope. Would it be something more than a narrowly American operation? Harlem, the great black metropolis, could nurture the life of an emergent people, provide a crucible for their cosmopolitan consciousness and their historic obligations, both to their own special nature and to the wider world. Harlem would form the majestic kernel of a novel modern enterprise, bringing new life to the race after the slumbers of New World slavery and the catastrophic shock of adaptation to impoverished life in America's cities. However, as putative capital of the black world, it would have to be recognised as having significant ties to populations in other parts of the world. These groups were bonded together not by some conveniently automatic mechanism of race consciousness but by a novel sense of blackness as a hemispheric, indeed planetary, phenomenon. Precisely that spirit was being fostered in a truly global city by the growing forces of anti-colonial nationalism and anti-imperial communism as well as the foolish, petty and irrational workings of the system of white supremacy itself, which had been underlined by the Great War and its sorry aftermath for the black Americans who had taken part in it.[5] The influential presence of returnees from the war in Europe underlined the fact that Harlem would have to do more than national duty. It would be the head, if not exactly the heart, of black America, but it was also to be a space for the intellectual and cultural reconstruction of black life on an emphatically *transnational* scale. The non-American and occasionally anti-American aspects of this historic change were confirmed by the number of West Indians arriving in Harlem in the first quarter of the twentieth century. Later Marcus Garvey's movement for black self-determination would supply an angry voice and a timely militaristic style to the unprecedented political and cultural forces formed in this urban confluence of peoples and interests. Locke, working in the afterglow of an intellectual encounter with his Harvard tutor Josiah Royce, as well as three years spent at Oxford and two more in

120 James VanDerZee
Marcus Garvey in a UNIA Parade,
1924

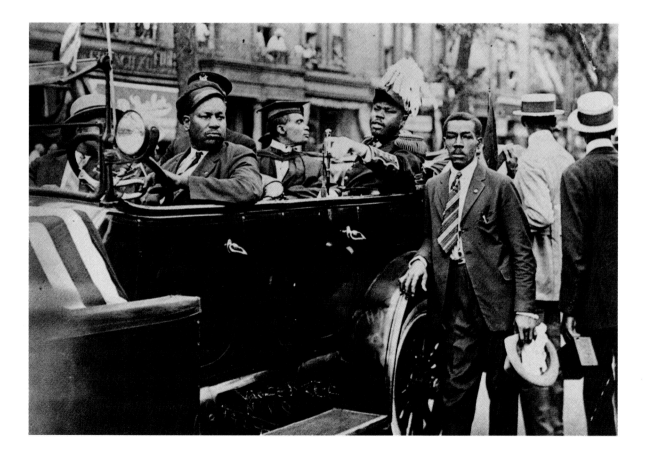

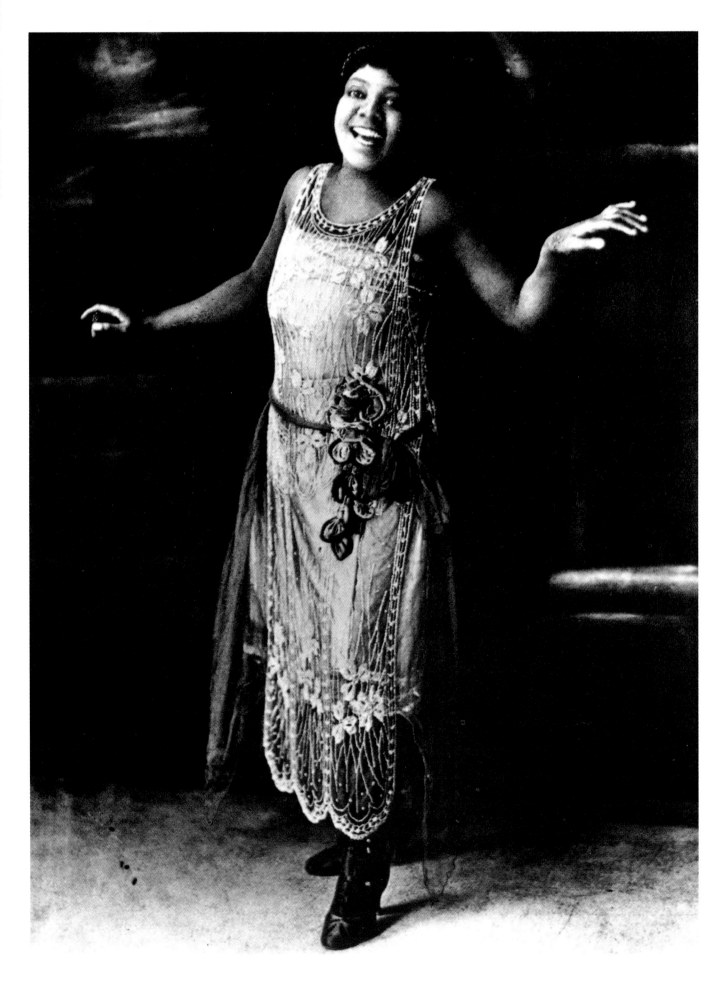

Berlin, saw Harlem as a 'province'.[4] The centripetal effects that it offered would have ethical and aesthetic significance to complement their obvious political import.

However attractively the noble goal of cultural and communal consolidation was framed by the African-American elite, it was hard to square with the messy, conflictual and chaotic character of urban life. The city's growth created new Harlemites not only from the West Indies but from the South and other rural areas. That rich and volatile mixture yielded no pure, seamless or spontaneous articulation of black America's world-historic, national spirit. There was only an unstable blend for which Garvey's dynamic Ethiopianism would provide a contradictory expression in the political field. The cultural content of Garveyism was not critical, cosmopolitan or revolutionary. The Garveyites' martial music, pomp, costume and spectacular ritual represented a sustained attempt to quell, discipline and perhaps eviscerate a disorderly, black population. Their drilled uniformity invited Harlemites to measure up to the exalted behavioural and moral standards demanded by the obligation to reshape men, women and families en route to a comprehensive rebuilding of race and nation. Whatever their triumphs and qualities, work done by Garvey and his followers repudiated many of the defining qualities of a spontaneous 'low down and dirty' folk culture in favour of a commitment to racial uplift via the process of building and moulding character.

For the most part, as Garvey's political foes, the more respectable apostles of the 'New Negro' were only reluctantly bonded to their opponents' vision by seriousness, bourgeois propriety and an enthusiasm for complete rupture with the oppressive patterns of the past.[5] Their revolution led towards a different goal in which blacks would be reconciled to class and status hierarchies and other intraracial inequalities rather than having those divisions dissolved in the unanimity of shared and reified racial difference. Theories about black art and culture played a significant role in producing this outcome. There was a sharp divergence between those who emphasized that black music was a folk form in transition towards varieties of high cultural expression that could demonstrate the overall worth of the race, and others who saw it instead as a sophisticated urban and cosmopolitan phenomenon of an inescapably modernist type. The former view found confirmation in a reading of spirituals, while the latter turned instead towards jazz. Locke's sense of the divisions within black music and the politics of its interpretation bears detailed scrutiny.[6] In progress towards the elevated destination of classical form, authentic folk styles unfolded in a marvellous pattern absolutely analogous to that found in the most orthodox accounts of European cultural development. On the other hand, the authority of jazz in the cultural scheme of things was compromised by its inescapably hybrid character. Notwithstanding its energy, jazz, 'sometimes for the better, sometimes not', was becoming 'progressively even more composite and hybridized'.[7] This evaluative split marks the axis of conflict visible, above all, along the lines of class that divided the respectable from the disreputable. This, too, had cultural consequences. Who would be the custodians of the racial spirit, the guardians of the distinctive heritage that would be the awe-inducing gift of black folk, black Americans, to the modern world? Would it be the uneducated blues-loving poor for whom their music was, above all, a matter of instinct, the conservatory-trained elite who conserved, filtered and rearticulated an ignoble racial heritage, the hedonistic jazzers seduced by the transgressive syncretism of gloriously inauthentic uptown life; or the mandarins whose sage observations were imagined to be capable of reconciling all these incompatible operations?

However the tensions between these different analyses of black music were

to be resolved, all proceeded from the same remarkable assumption. All parties saw a new place for music as the central source of cultural value. In jazz, where the departures from traditional forms were most marked and invigorating, J.A. Rogers discerned an even more significant development. In almost the same moment that T.W. Adorno first diagnosed black popular music as reified, regressive and therefore complicit with fascism,[8] from a more intimate location, Rogers suggested that a democratic spirit resided in its 'mocking disregard for formality'. The new spirit of joy and spontaneity, he continued, 'may itself play the role of reformer'. Rogers's important insight had been bought at the price of accepting a view of jazz as an exotic and primitive force, 're-charging the batteries of civilisation' with new vigour. Today it may be more useful to read those elements of his argument as an inessential, decorative concession to the temper of the times that does not compromise his central thesis:

> '... in spite of its present vices and vulgarisations, its sex informalities, its morally anarchic spirit, jazz has a popular mission to perform. Joy, after all, has a physical basis. Those who laugh and dance and sing are better off even in their vices than those who do not.'[9]

Voices on all sides of the dispute about the value and meaning of black music appear to have accepted the proposition that even if music was not itself a means of restoration and rebirth, it could provide a useful gauge from which the developmental progress of the race might be read off. It is here that music begins to be imagined as a creative model for the visual arts and a blueprint for novelists and poets.

It should be no surprise that the need for music-making to function at the core of the 'New Negro's' new culture required that the relationship between the music and the new technologies of its production and dissemination be obscured. The spell of spontaneity and the glamour of immediacy would both be destroyed by attention to the emergence of the music industry, the power of the phonograph or the constraining effects of the recording process that dispatched the seductive sounds of Harlem on their global travels. The mediation of racial creativity by technology was minimised just as the long hours of practice and study that lay behind the stylised simulation of spontaneity were systematically concealed. This music had to be apprehended as an organic feature of black life that could be conjured up without effort. It was to be as resistant to regulation and self-conscious thought as the teeming jungle that supplied its governing trope. The synergy released by the combination of discrepant forms – high and low, vulgar and exalted, European, Caribbean and American – would itself be systematically played down as the hybrid character of the music was repressed and denied lest its composite form compromise the political claims that its glorious presence brought to voice.

Since then the desire to make music into the medium of cultural rebirth and to hear in it the characteristic signature of racial genius has been a recurrent feature of thinking about black culture. Positioning black music in this way was, it seems, a significant element in bringing that very result about. Music accordingly became the centre of black culture in a new and distinctly modern way. Although black art had separated itself from black life, music remained a potent means to link the new era to the simpler unfreedoms that had preceded it. It was the power of the music, after all, that had named the epoch 'The Jazz Age'.

Notes

1. 'How often we hear it said that a European Beauty would not please a Chinese or even a Hottentot, in so far as the Chinaman has quite a different conception of beauty from the Negro, and the Negro in turn from the European, and so forth. Indeed, if we look at the works of art of those non-European peoples ... they may appear to us as the most gruesome idols, and their music may sound as the most horrible noise ...', G.W.F. Hegel, *Introductory Lectures on Aesthetics*, translated by B. Bosanquet (1886), Penguin Books, 1993, p. 50.

2. James Clifford, 'Negrophilia', in Denis Hollier, ed., *A New History of French Literature*, Harvard University Press, 1989, pp. 901–8.

3. W.E.B. Du Bois, 'The Black Man In The Great War', *The Crisis*, June 1919; Arthur E. Barbeau and Henri Florette, *The Unknown Soldiers: African-American Troops In World War 1*, Temple University Press, 1974.

4. Josiah Royce, 'Provincialism', in *The Social Philosophy of Josiah Royce*, Stuart Gerry Brown, ed., Syracuse University Press, 1950, pp. 49–69.

5. '... by the evidence and promise of the cultured few, we are at last spiritually free, and offer through art an emancipating vision to America', Alain Locke, 'Negro Youth Speaks', in *The New Negro* (1925) Athenaeum, New York, 1968, p. 53.

6. Alain Locke, *The Negro and His Music*, Associates in Negro Folk Education, Washington, D.C., 1936. Reprinted by Arno Press and the *New York Times*, 1969.

7. Alain Locke, 'Who and What is Negro?', in *Opportunity*, 20, 1942, p. 39.

8. In his magisterial work *Different Drummers: Jazz In The Culture of Nazi Germany*, (Oxford University Press, 1992), the Canadian historian of fascism, Michael Kater, has pointed out that Adorno enthused over the Nazi regime's introduction of controls on jazz. See Adorno's 'Abscheid vom Jazz', in *Europäische Revue*, 9, 1933, p. 315.

9. J.A. Rogers, 'Jazz At Home', in *The New Negro*, op.cit., p. 223.

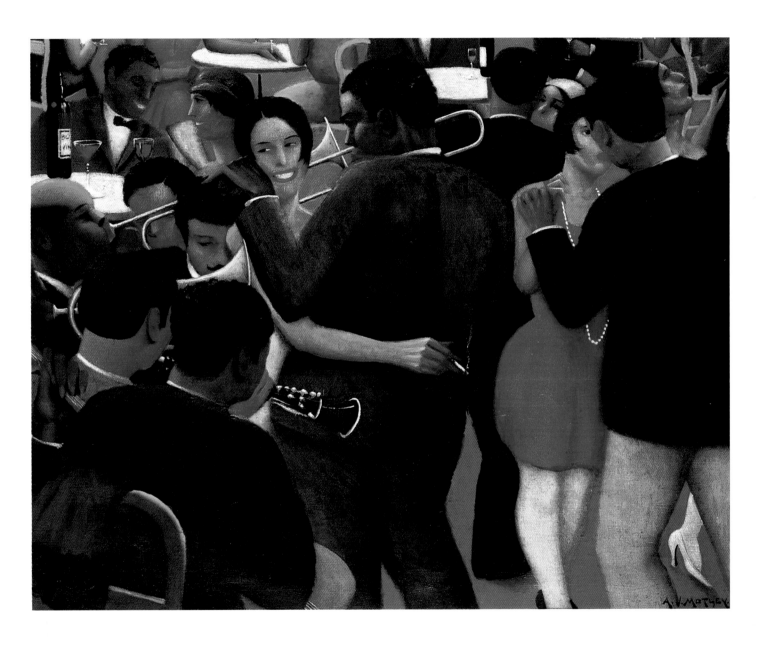

87 **Archibald J. Motley Jr**
Blues, 1929

86 **Archibald J. Motley Jr**
Cocktails, c. 1926

90 **Archibald J. Motley Jr**
Brown Girl After the Bath, 1931

88 **Archibald J. Motley Jr**
Jockey Club, 1929
Schomburg Center for Research in Black Culture, Art & Artifacts Division,
The New York Public Library, Astor, Lenox and Tilden Foundations
photograph: Manu Sassoonian

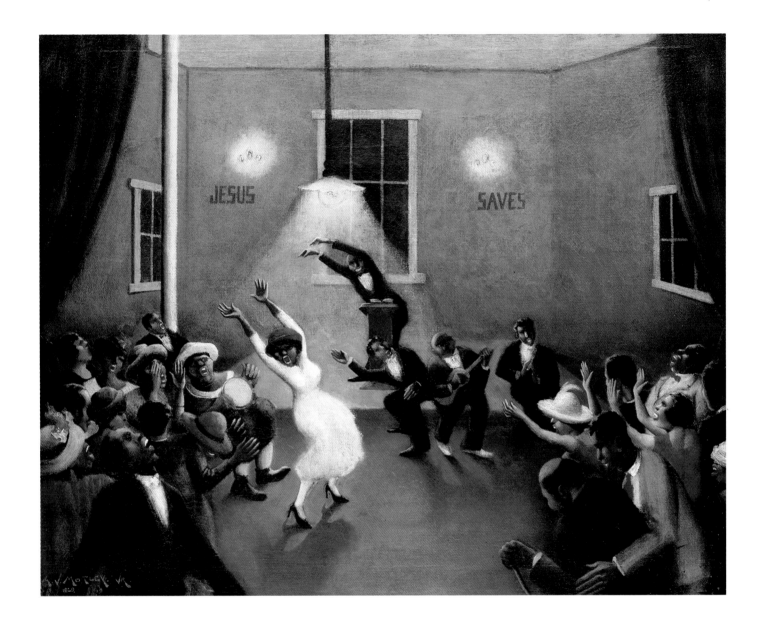

89 **Archibald J. Motley Jr**
Tongues (Holy Rollers), 1929

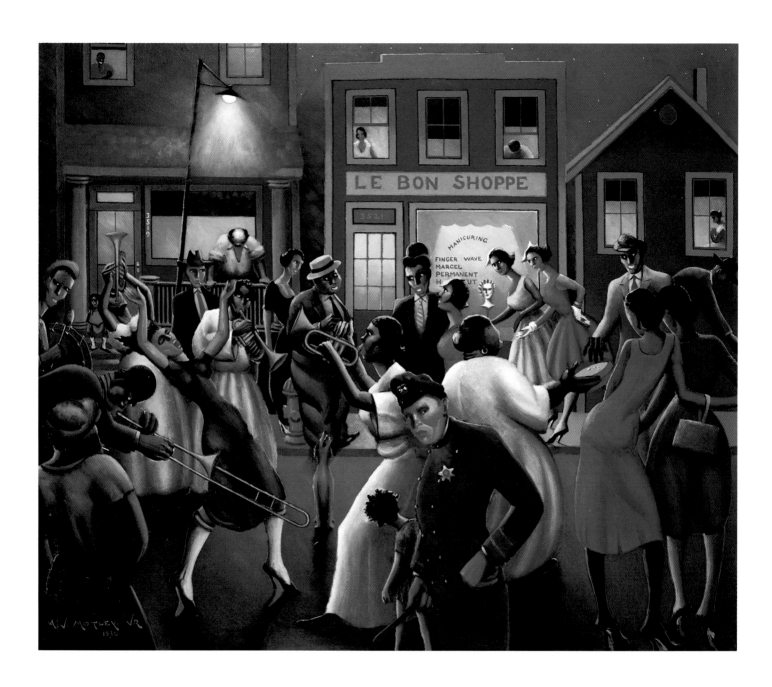

92 **Archibald J. Motley Jr**
Saturday Night Street Scene, 1936

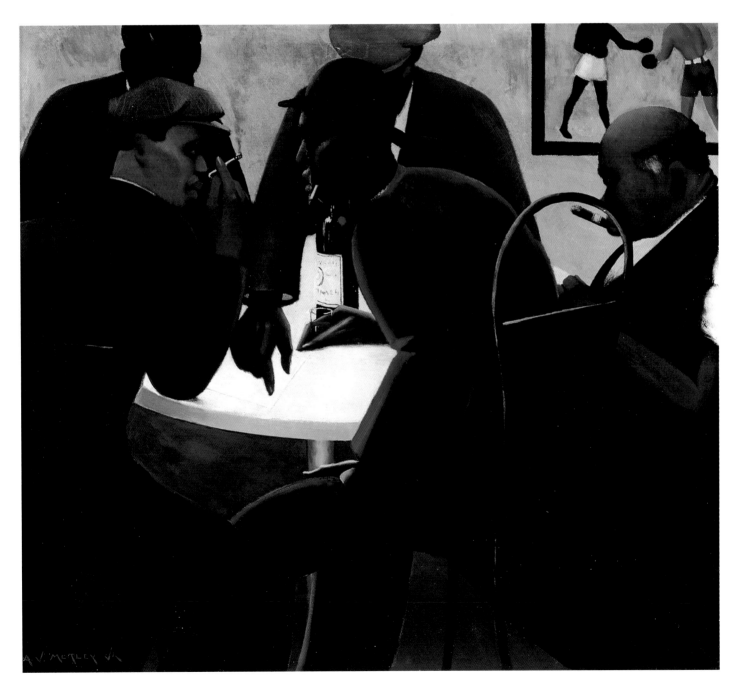

91 **Archibald J. Motley Jr**
The Plotters, 1933

22 **Walker Evans**
42nd Street, 1929

23 **Walker Evans**
Citizen in Downtown Havana, 1932

106 **Augusta Savage**
Gamin, 1930
Schomburg Center for Research in Black Culture, Art & Artifacts Division,
The New York Public Library, Astor, Lenox and Tilden Foundations
photograph: Manu Sassoonian

21 **Sir Jacob Epstein**
Portrait Bust of Paul Robeson (1898–1976), 1928

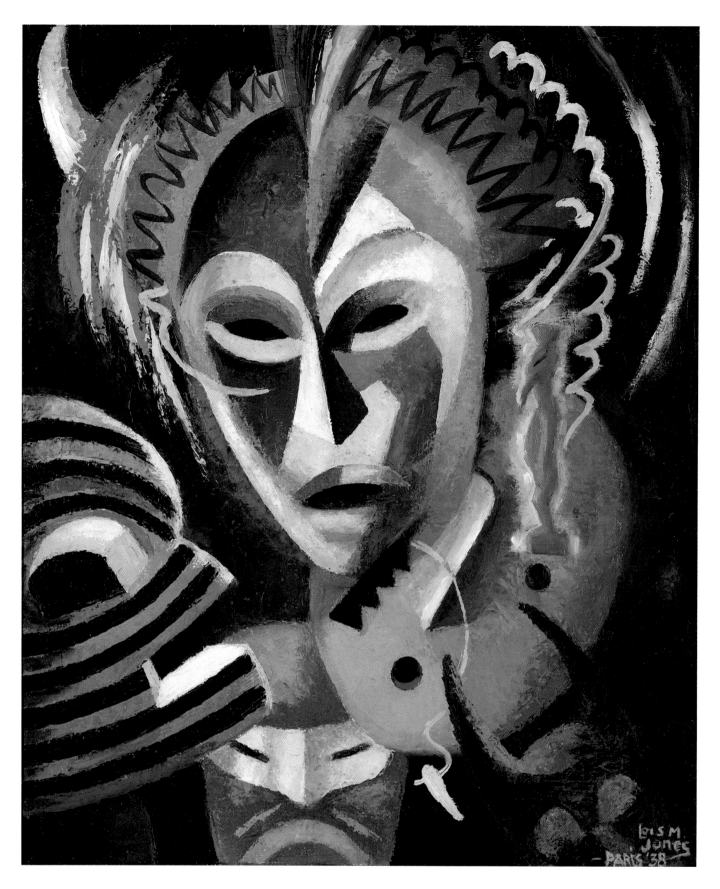

39 **Loïs Mailou Jones**
Les Fétiches, 1938

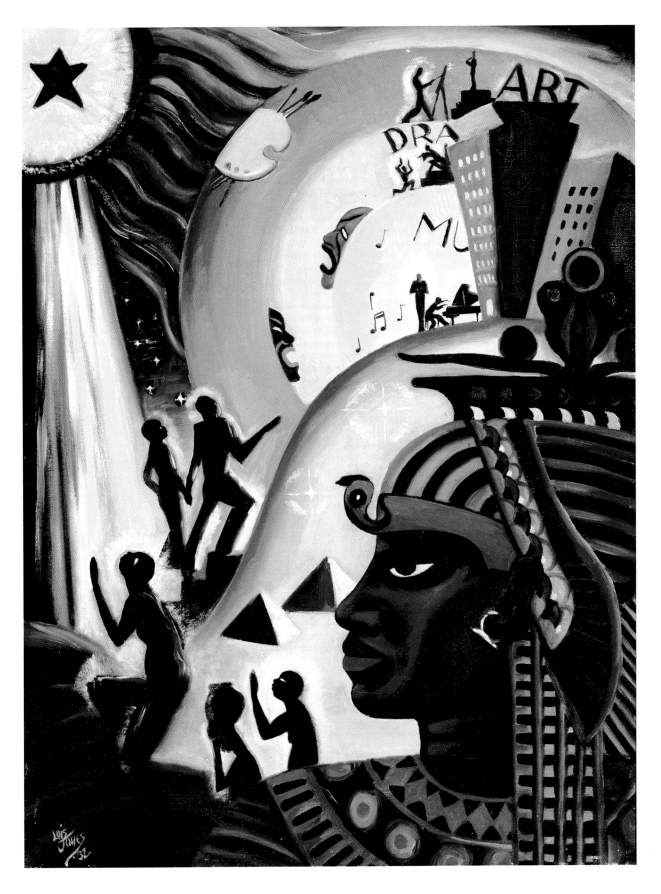

38 **Loïs Mailou Jones**
The Ascent of Ethiopia, 1932
Milwaukee Art Museum. Purchase, African-American Art Acquisition Fund,
matching funds from Suzanne and Richard Pieper, with additional support
from Arthur and Dorothy Nelle Sanders

131 **Carl Van Vechten**
Bessie Smith (1894–1937), 3 February 1936

130 **Carl Van Vechten**
Zora Neale Hurston (1891–1960), 3 April 1935

35 **William H. Johnson**
Portrait Study No. 16, c. 1930

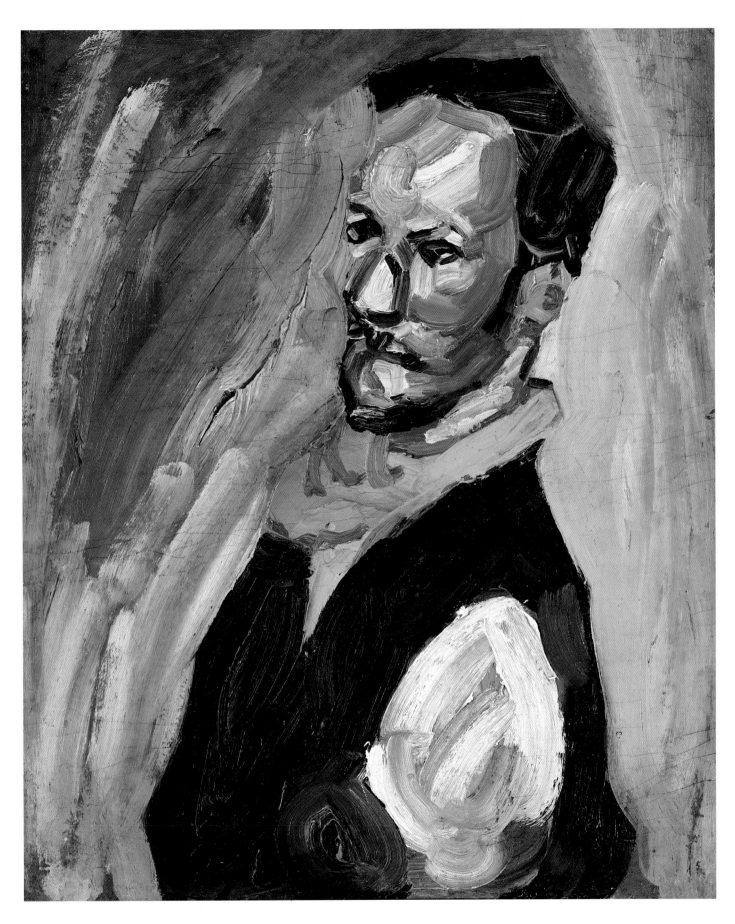

37 William H. Johnson
Self-Portrait with Bandana, c. 1935–1938

36 **William H. Johnson**
Portrait of a Boy, c. 1935–1938

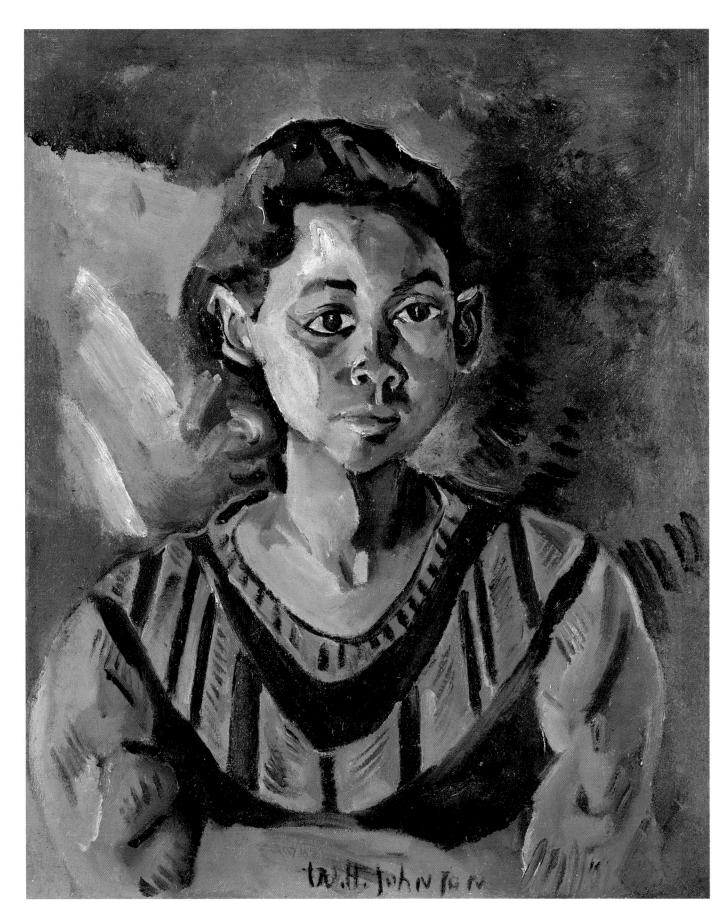

34 **William H. Johnson**
Little Girl, c. 1930

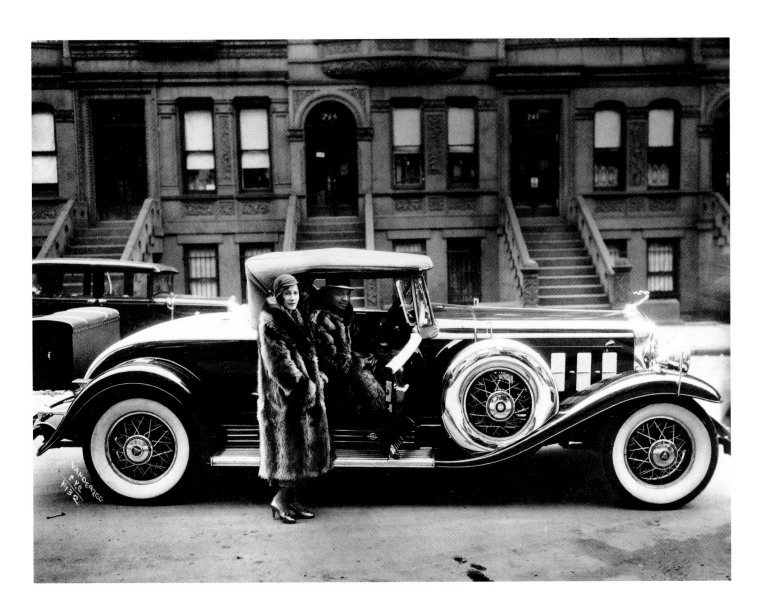

129 **James VanDerZee**
Couple, Harlem, 1932

115 **James VanDerZee**
The VanDerZee Men, Lenox, Massachusetts, 1908

128 **James VanDerZee**
Self Portrait, 1931

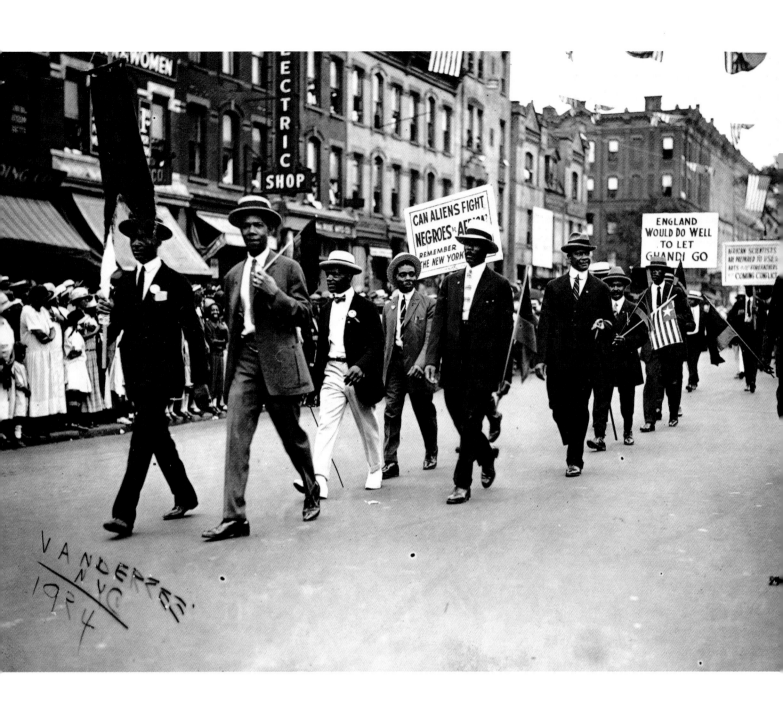

121 James VanDerZee
Protest Parade, 1924

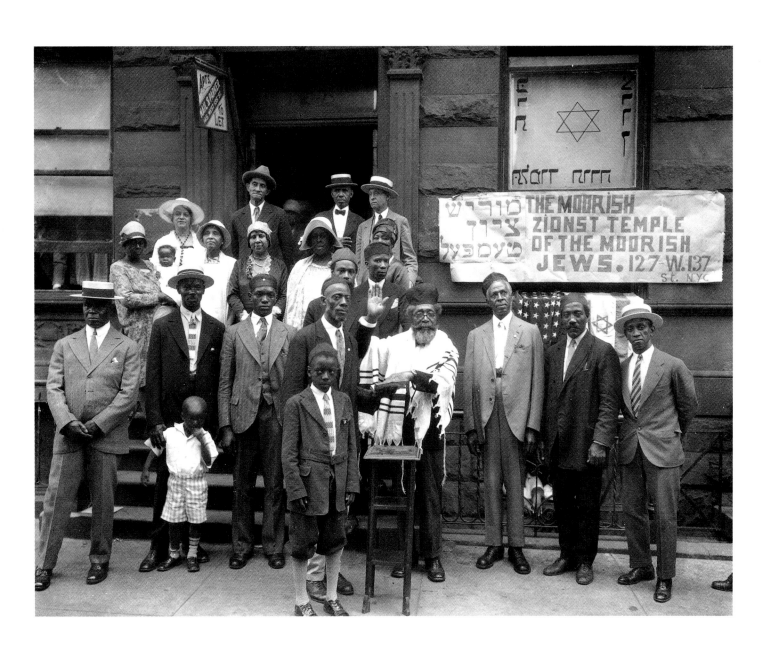

127 **James VanDerZee**
Black Jews, Harlem, 1929

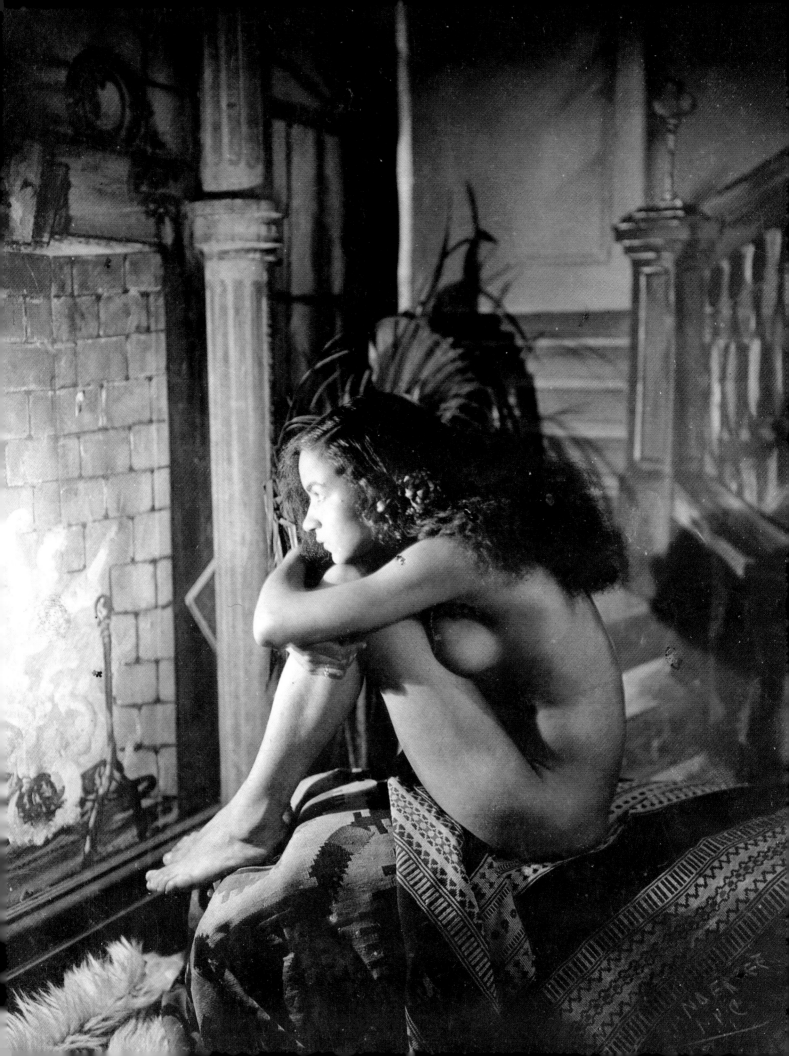

119 **James VanDerZee**
Nude, Harlem, 1923

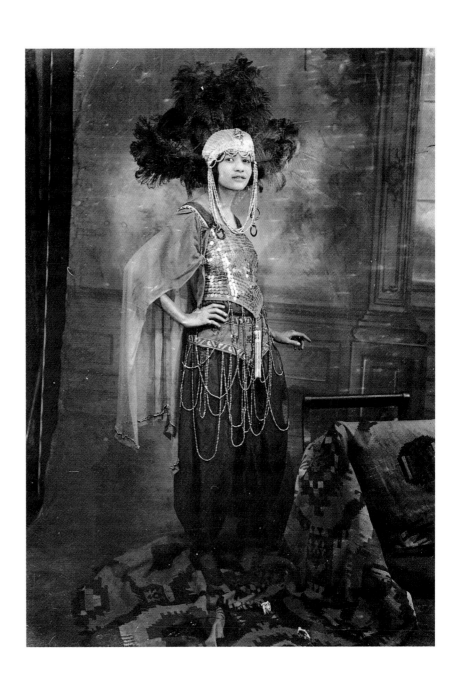

122 **James VanDerZee**
Dancer, Harlem, 1925

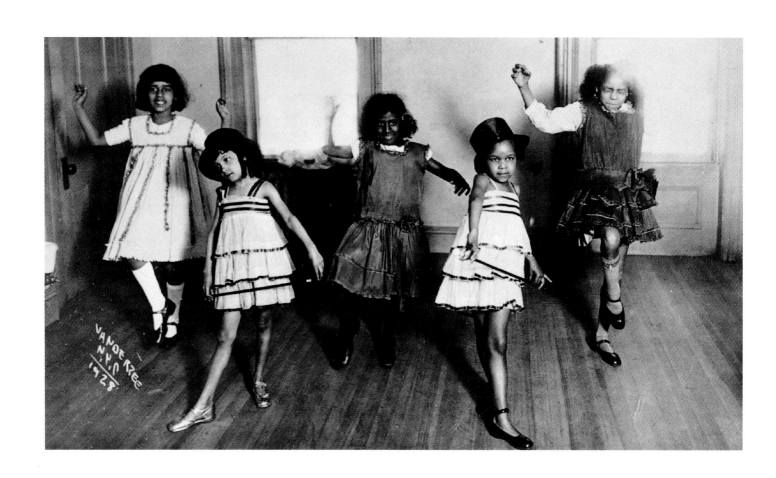

125 **James VanDerZee**
Dancing School, 1928

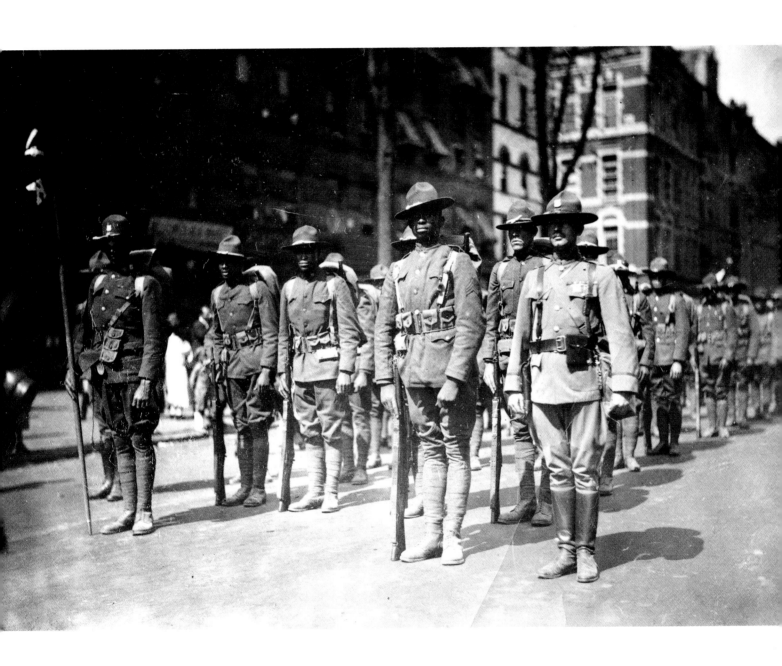

118 **James VanDerZee**
Victory Parade of 369th Regiment, 1919

126 **James VanDerZee**
The Barefoot Prophet, 1929

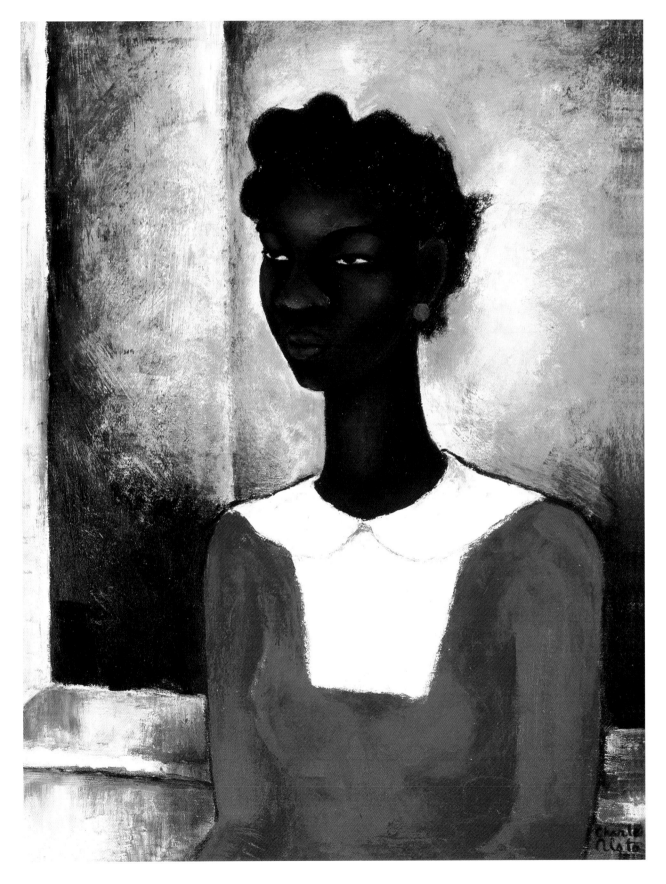

1 **Charles Alston**
Girl in a Red Dress, 1934

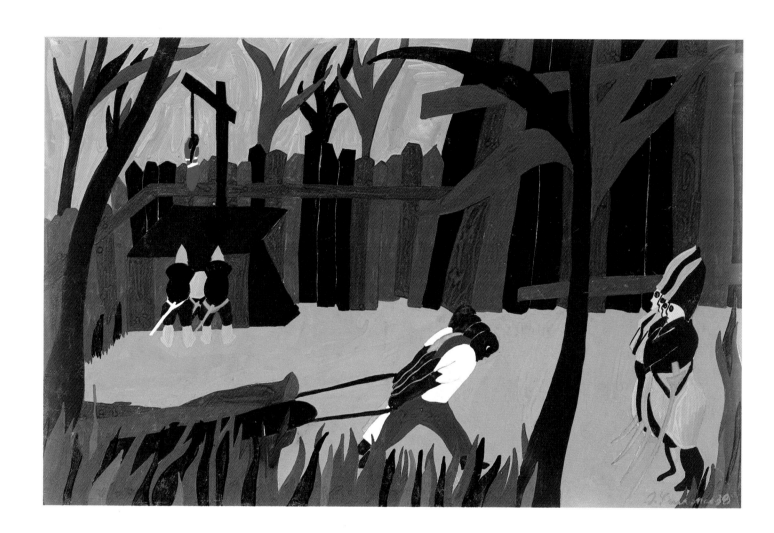

41 **Jacob Lawrence**
Toussaint L'Ouverture Series, 1937–38
No. 2: *Mistreatment by the Spanish soldiers caused much trouble on the island and the death of Anacancam a native queen, 1503*
gouache on paper, 27.9 x 48.3 cm
Aaron Douglas Collection, The Amistad Research Center, Tulane University, New Orleans, Louisiana

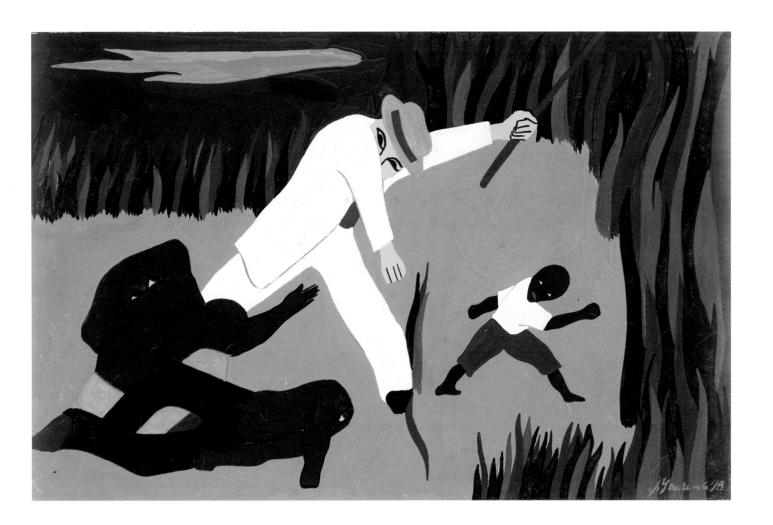

46 Jacob Lawrence
Toussaint L'Ouverture Series, 1937–38
No. 7: *As a child, Toussaint heard the twang of the planter's whip and saw blood stream from the bodies of slaves*
gouache on paper, 27.9 x 48.3 cm
Aaron Douglas Collection, The Amistad Research Center, Tulane University, New Orleans, Louisiana

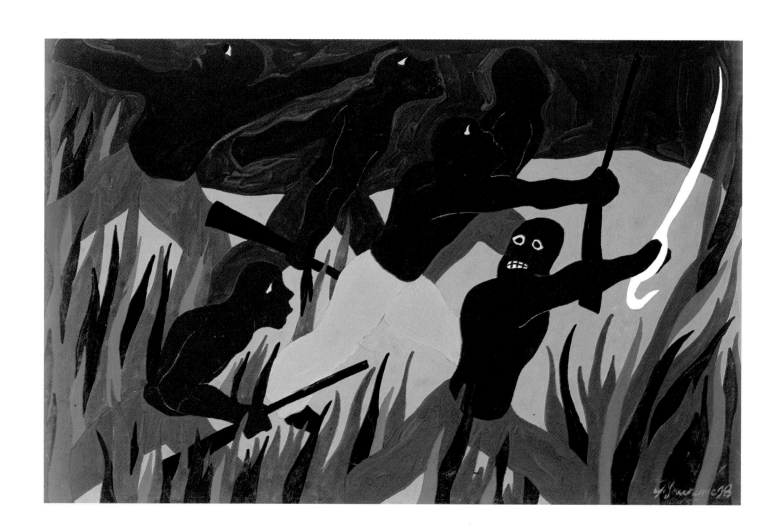

51 **Jacob Lawrence**
Toussaint L'Ouverture Series, 1937—38
No. 12: *Jean Francois, first Black to rebel in Haiti. Toussaint did not believe that the time was right for rebellion*
gouache on paper, 27.9 x 48.3 cm
Aaron Douglas Collection, The Amistad Research Center, Tulane University, New Orleans, Louisiana

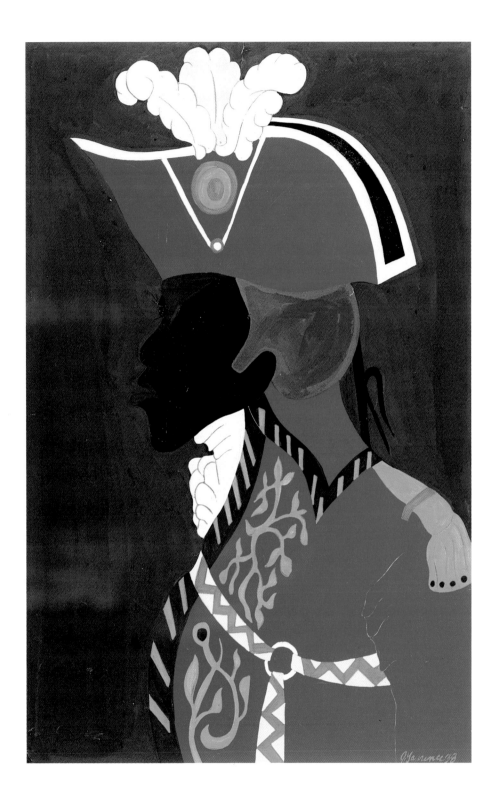

59 Jacob Lawrence
Toussaint L'Ouverture Series, 1937—38
No. 20: *General Toussaint L'Ouverture*
gouache on paper, 27.9 x 48.3 cm
Aaron Douglas Collection, The Amistad Research Center, Tulane University, New Orleans, Louisiana

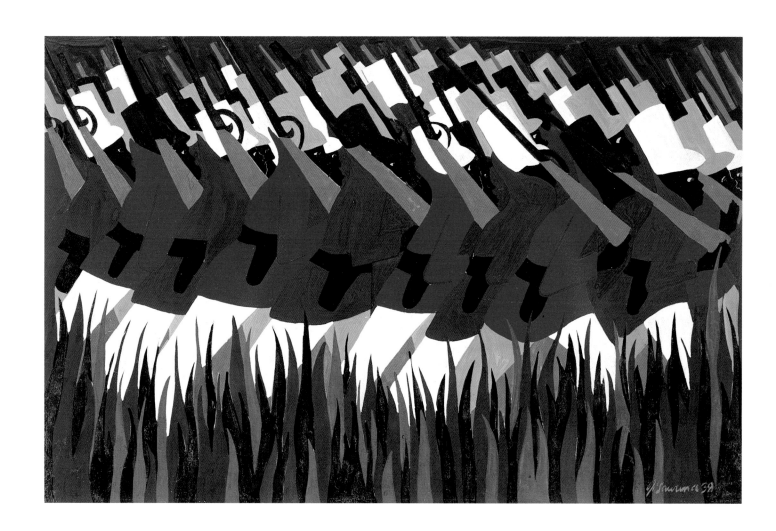

62 **Jacob Lawrence**
Toussaint L'Ouverture Series, 1937–38
No. 23: *General L'Ouverture collected forces at Marmelade, and on October 9, 1794, left with 500 men to capture San Miguel*
gouache on paper, 27.9 x 48.3 cm
Aaron Douglas Collection, The Amistad Research Center, Tulane University, New Orleans, Louisiana

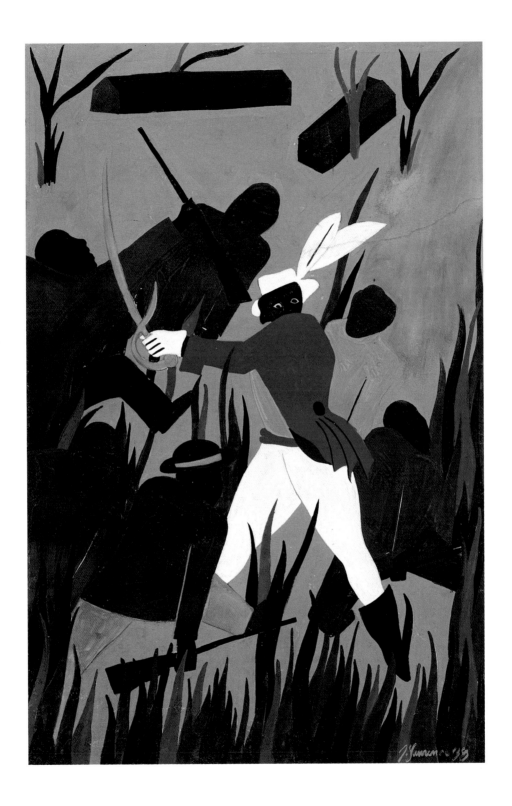

64 **Jacob Lawrence**
Toussaint L'Ouverture Series, 1937—38
No. 25: *General Toussaint L'Ouverture defeats the English at Saline*
gouache on paper, 27.9 x 48.3 cm
Aaron Douglas Collection, The Amistad Research Center, Tulane University, New Orleans, Louisiana

69 **Jacob Lawrence**
Toussaint L'Ouverture Series, 1937–38
No. 30: *Napoleon Bonaparte begins to look on Haiti as a new land to conquer*
gouache on paper, 27.9 x 48.3 cm
Aaron Douglas Collection, The Amistad Research Center, Tulane University, New Orleans, Louisiana

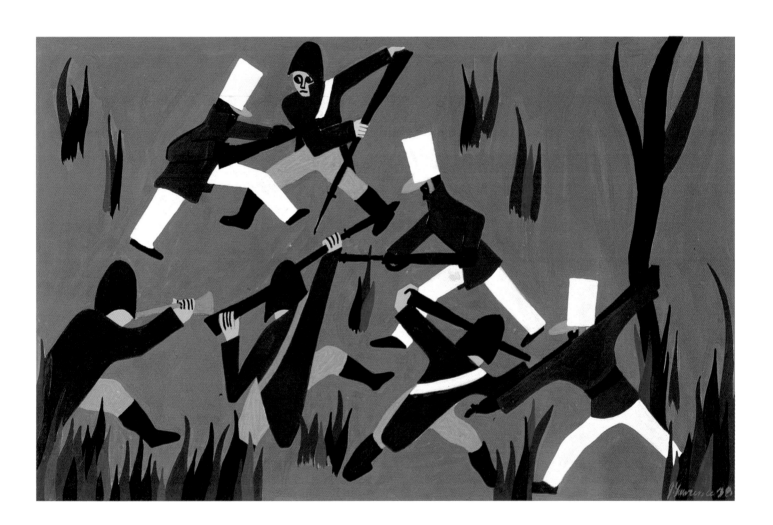

76 **Jacob Lawrence**
Toussaint L'Ouverture Series, 1937–38
No. 37: *Toussaint is taken to Paris and imprisoned in the dungeon of the Castle Joux August 17, 1802*
gouache on paper, 27.9 x 48.3 cm
Aaron Douglas Collection, The Amistad Research Center, Tulane University, New Orleans, Louisiana

152

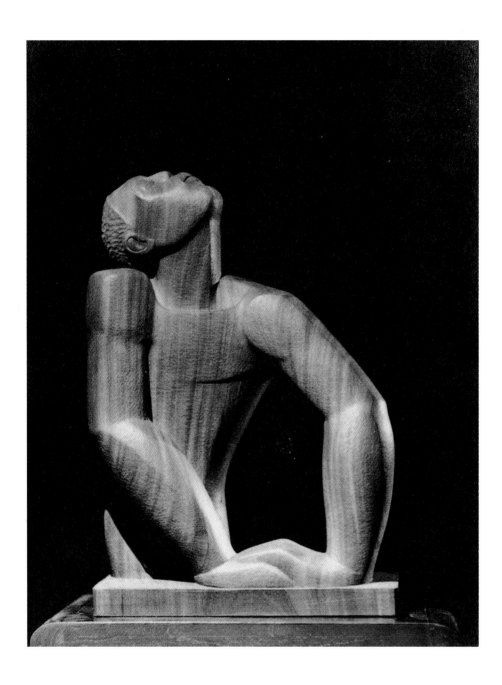

Edna Manley
Negro Aroused, 1935
mahogany, 63.5 cm high
National Gallery of Jamaica
photograph: Denis Malcolm Gick © Estate of the Artist / Edna Manley Foundation

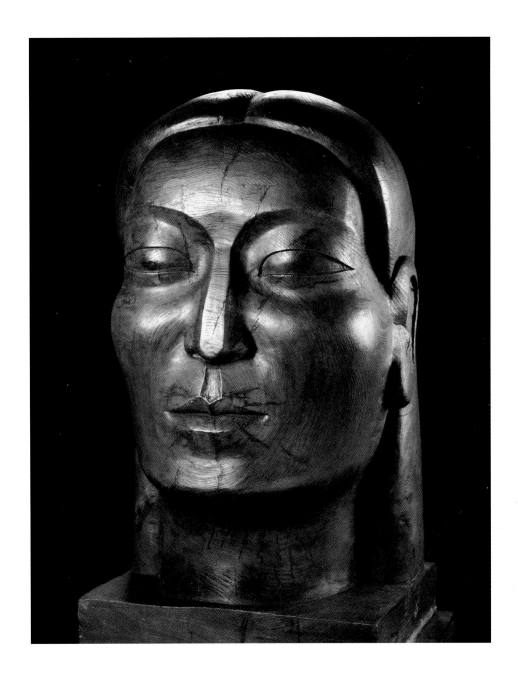

84 **Ronald C. Moody**
Midonz (Goddess of Transmutation), 1937

STILL

MARTINA ATTILLE

After Doris Ulmann's death in 1934, some 7,000 glass negatives were destroyed to reduce the 'bulk' of the collection. Negatives for many of her portraits of Gullah plantation workers in South Carolina were among those destroyed before the Ulmann collection was shipped to the University of Oregon in Eugene. 'Those responsible for the selection of negatives to be saved had been more closely associated with the photographer in the context of her Appalachian work and assigned less importance to the photographs from South Carolina.'[1]

Doris Ulmann's photographs of black people document the faces of people in the African Diaspora, faces made even more intensely beautiful by the literary alchemy of all those authors, including Jean Toomer, Toni Cade Bambara, James Baldwin, Toni Morrison, William Faulkner, Maya Angelou, Alice Walker and Thulani Davis, who lived, loved and even fled the real and mythic regions of the United States of America indicated by 'The South'. Isn't it interesting that during the period in which Ulmann so devotedly arranged and framed her subjects for camera, in anticipation of their disappearance amidst the general bustle of New World immigration, the rise of jazz music already testified to the energy with which Africans had taken flight from racist Southern institutions to take their chances elsewhere? Josephine Baker knew she was free when in 1925 she saw the Statue of Liberty sink on the horizon as she sailed to Paris with La Revue Nègre, a troupe of 25 black Americans.

It's so easy, in Ulmann's work, to mistake art for essence. That is, to mistake the artistry of the photographer for the essentialism of her carefully composed subjects. A staunch pictorialist, working against modernist enthusiasms, Ulmann and her husband, Dr Charles H. Jaeger, joined the Pictorial Photographs of America, an organisation formed in 1916 with Clarence H. White as its first president. Her work preceded the documentary engagement of photographers like Dorothea Lange, Gordon Parks and Walker Evans, who brought a sharper light to a broader American landscape caught in the harsh political realities of a deep economic and social depression.

When I first looked through the images in *The Darkness and The Light, Photographs by Doris Ulmann*[2] I was looking for romance, and my desires spilled over into a search, a meditation on this business of African Diaspora. And it is still a searching gaze that is gratified by the appearance and reappearance of black individuals in the various and many images Ulmann has bequeathed, quite different from my strained scrutiny of work by J.T. Zealy, who produced daguerreotypes of slaves on a South Carolina plantation in 1850.[3]

There is a shifting movement evident in Ulmann's arrangement and rearrangement of sitters and in her repeated experiments with standard tableaux. 'Doris Ulmann worked with great deliberation and care. Every picture was composed. She never used a light-meter. "I am the light-meter" she would say. Neither of her cameras had a shutter. She would remove the lens-cap, count, replace it. In the course of a full working day she would make a maximum of 20 exposures.'[4] In contrast to the more generic portraits of New York society made back in her New York home at 1000 Park Avenue, Ulmann created pastoral theatre out of her vision of rural innocence in a period of dynamic urban change.

'Dancing the Charleston on the stage of the Paris music hall, Josephine Baker brought the vogue for Harlem to Europe,

Previous page:
113 Doris Ulmann
Head Portage, South Carolina,
1929–30

Doris Ulmann with her tripod, c. 1933
Division of Special Collections and
University Archives, University of Oregon

where it was transformed into *Le Tumulte Noir*.'[5] Zora Neale Hurston made it to New York in 1925 and headed back South in her Chevrolet coupé from 1928 to 1930 on an extended field trip, completing *Mules and Men* in 1929 (published in 1935), and a Guggenheim Fellowship covered her study of magic practices in the West Indies from 1936 to 1938. By 1932 Louis Armstrong was making his first trip to Europe. Doris Ulmann died at the age of 50 in New York City, 28 August 1934. 'Miss Ulmann always asked her subjects what they did in the way of work and if they liked working. "How do you like your job?" '[6] Her sitters look polite. In any case, her letters reveal that she found the Gullah people of the South Carolina coast strange and self-conscious.

Rockin' Chair, recorded by Louis Armstrong in New York in 1929, captures a deep lingering nostalgia, spiked with self parody. Listen to almost anything from the years of his early success, note especially anything that sounds like transportation and leaf through Doris Ulmann's portraits of the 'types' she so passionately sought. Time warps under the strain of disjunction. But then time is available for poetic interpretation. Mark well writer Ntozake Shange's divination, 'the slaves who were ourselves', in *Sassafrass, Cypress and Indigo* and the creation of the character Nana Peazant in Julie Dash's film *Daughters of the Dust*. It's partly about negotiating a contemporary past across the distance of amnesia and death. A touch morbid, perhaps, but quite vital to language, which is a profound reality in itself.

Southern ghosts linger for those with memories.

It is possible, however, for an outsider, a tourist, to drive through Greensboro, North Carolina, without a pause for thought of civil rights activists Joe McNeil, Junior Blair, Frank McCain and David Richmond sitting at a Woolworth lunch-counter. I managed it, but later these things have a way of catching up with you.

> 'I was talking about time. It's so hard for me to believe in it. Some
> things go. Pass on. Some things just stay. I used to think it was my
> rememory. You know. Some things you forget. Other things you never
> do. But it's not. Places, places are still there.'[7]

Why does Hannah's dream of a wedding[8] have the same meaning in an African/American context as it does in an African/Caribbean/British context? Death.

Transatlantic: London, Heathrow, to North Carolina, via Philadelphia, 1992. Artist Sonia Boyce and I reflect on the frequency of popular reportage on murders that take place between lovers, the specificity of the killing action and the varying levels of involvement with the corpse. We speculate on whether the actions of the murderer are determined by a particular pathology in the relationship, which then determines whether to stab, stamp, smother or eat the body. We go on to talk about faith, but that's another story.

The South of popular imagination, a hating place, has been Billy Holiday's *Strange Fruit*, Nina Simone's *Mississippi Goddam*, but some of Ulmann's photographs reveal, and Zora Neale Hurston's field research records, that black people who live in the stasis of ritual can maybe remember something that those of us who have migrated up, over and on, are wary of forgetting: the rituals of remembrance and the need to reinvent ourselves, transform ourselves, periodically aestheticising notions of self and community.

Anyway, it's not only 'The South', as in the southern states of the United States below the Mason-Dixon Line, but also the South, which is the Caribbean and

Europe – I'm looking for essence, essentialism, a narrative to ward off the forgotten, in a mythic territory where the dream of a wedding means death and the dream of rivers means freedom. Romance.

So, Sonia and I get on an overnight Amtrak from Greensboro, North Carolina, to Atlanta, Georgia, and head for the Romare Bearden exhibition at the High Museum.[9] *Conjure Woman* was a series of images that would come to mind months later when I would stifle a laugh at Sonia Boyce's question to Veronica Ryan at the Camden Arts Centre in London. 'Are you familiar with the term "to conjure"?' The question seemed strange declared in front of an audience in a public gallery. To my mind, questions like that were to be reserved for private speculation, quiet exchanges about ritual. A charged subject, too close to primitive to gain respect in European modernist contexts. But in any case, there in the Atlanta High Museum was a selection of paintings, totally amazing, photograph paintings, images spliced and cut open, which said something about being of African descent.

As with Ibo Landing, used as a narrative device by both American film-maker Julie Dash[10] and British film-maker Ngozi Onwurah,[11] there exists a symbolic system with which to negotiate epic ethereal spaces, including resurrection from the dead and a connectedness to those who went some other place through death.

> 'This female conjurer is a conduit for the spiritual powers and knowledge of Africa. She represents the African Diaspora. She is an herbalist, a diviner, a priestess who manipulates unseen, unfamiliar forces that heal or destroy. Her mysterious persona and penetrating gaze denote her traditional stature and power in society and her significance in the culture of African-Americans. Symbolising primal power, the conjurer is found in the rural South and the urban North.'[12]

I stifle my furtive excitement when Sonia Boyce asks Veronica Ryan if she is familiar with the term 'to conjure' because the answer is important but inevitably fragmented and contingent.

Two years later I was in New York making studio visits and making new introductions. Iké Udé would say: 'Modern art to me, ironically being Nigerian and being African, modern art is ultimately African art. From Picasso, Giacometti, Modigliani etc., the list goes on, to Basquiat, to myself. We all are from African schools. All modern artists are from African schools.' I would respond: 'Would you say that the idea that African art is at the basis of modern art is a view that is widely accepted, or not?' He concluded: 'The fact remains, glaringly. It's simply a fact, whether one agrees or one doesn't agree. A fact remains a fact.'[13]

Identification is the issue, and finding routes to identification and perspective systems is the work in hand. I haven't forgotten Doris Ulmann in all this. 'Doris Ulmann attended the Clarence White School of Photography, and there in two years learned how to manage the camera and how to mix and employ her chemicals. But basically she was self-taught, for she was a genuine artist and, as such, had to find her own way.'[14] Her photographs taken during chauffeur-driven field trips, accompanied by her maid, are part of an opus open to a kind of immersion, a conjuring process, for remaking and transforming the modernist vernacular, 'to paint it black', as artist Lubaina Himid would indicate.[15]

Doris Ulmann involved herself totally in the photographic process. I am conscious of my avoidance of Ulmann the person, though my curiosity is inclined to her

broken marriage, her good taste in clothes, her eating habits and her personal rather than her professional relationship to Julia Peterkin, owner of the Lang Syne Plantation, South Carolina. Peterkin invited Ulmann to photograph the Gullah people who worked on her farm, a collaboration that resulted in *Roll, Jordon, Roll*.[16] Her privileged lifestyle is attractive too. But I am drawn into Ulmann's images in an effort to identify, as intimately as I dare, with evidence of something being played out between the photographic *imaginary* and the subjects who present themselves for the plate camera. 'Between a coherent history and a history of rupture may lie another address to the past: a writing shot through with desire, and which may remain as fragmentary and devoid of destination as desire itself.'[17]

Doris Ulmann did not set out on her photographic excursions with anthropometer, callipers, goniometer and other tools of the field anthropologist, measuring body parts, heads and skulls, facial and cranial angles. She was looking for 'types', black and white, that represented the 'American character', at a time when science and art must have been chattering about theories of racial determinism or even about Adolf Hitler's *Mein Kampf*, published in 1925. The significance of these theories would not have been lost on Doris Ulmann's social class.

Notes

1. David Featherstone, *Doris Ulmann, American Portraits*, University of New Mexico Press, Albuquerque, 1985, p. 49.
2. *The Darkness and the Light, Photographs by Doris Ulmann*, Aperture Inc., New York, 1974.
3. Jeanne Moutoussamy-Ashe, *Viewfinders: Black Women Photographers*, Dodd, Mead & Company, New York, 1986, p. 5.
4. John Jacob Niles, 'Doris Ulmann: As I Remember Her', in *The Appalachian Photographs of Doris Ulmann*, The Jargon Society, Penland, N.C., 1971, p. 103.
5. Cheryl A. Wall, *Women of the Harlem Renaissance*, Indiana University Press, Bloomington & Indianapolis, 1995.
6. *The Appalachian Photographs of Doris Ulmann*, op. cit.
7. Toni Morrison, *Beloved*, Chatto & Windus, London, 1987, p. 35.
8. Toni Morrison, *Sula*, Picador (in association with Chatto & Windus), 1991, p. 78.
9. *Memory and Metaphor: The Art of Romare Bearden 1940–1987*, a touring exhibition organised by the Studio Museum in Harlem.
10. Julie Dash, *Daughters of The Dust*, 1992.
11. Ngozi Onwurah, *Welcome To The Terrordome*, 1994.
12. Sharon F. Patton, 'Memory and Metaphor: The Art of Romare Bearden 1940–1987' in *Memory and Metaphor: The Art of Romare Bearden 1940–1987*, The Studio Museum in Harlem and Oxford University Press, New York, 1991.
13. 23 February 1994, New York City.
14. *The Appalachian Photographs of Doris Ulmann*, op. cit.
15. *HYSTERIA: A Symposium of Women's Art History in an Age of Mapping*, Tate Gallery, Liverpool, 1991.
16. Julia Peterkin and Doris Ulmann, *Roll, Jordon, Roll*, Robert O. Ballou, New York, 1933. Limited edition of 350 with copper-plate gravure reproductions released in 1934.
17. Andrea Fisher, *Let Us Now Praise Famous Women: Women Photographers for the US Government 1935–1944*, Pandora Press (Routledge & Kegan Paul Ltd), London, 1987, p. 126.

HARLEM ON OUR MINDS

HENRY LOUIS GATES JR

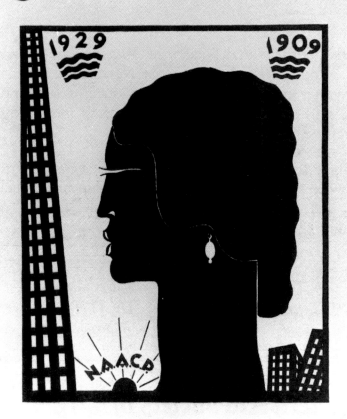

'The real fever of love for the place will begin to take hold upon him. The subtle, insidious wine of New York will begin to intoxicate him. Then, if he is wise, he will go away, *any* place – yes, he will even go over to Jersey. But if he be a fool, he will stay and stay on until the town becomes all in all to him; until the very streets are his chums and certain buildings and corners his best friends. Then he is hopeless, and to live *elsewhere* would be death. The Bowery will be his romance, Broadway his lyric, and the Park his pastoral, the river and the glory of it all his epic, and he will look down pityingly on all the rest of humanity.'

Paul Laurence Dunbar

'It was loving the City that distracted me and gave me ideas. Made me think I could speak its loud voice and make the sound human. I missed the people altogether.'

Toni Morrison

Since the earliest decades of this century, the lure of Harlem has captivated the imagination of writers, artists, intellectuals and politicians around the world. Stories are legion of African-American and African pilgrims progressing to Manhattan then plunging headlong into the ultimate symbolic black cultural space – the city within a city, the 'Mecca of the New Negro' (as Alain Locke put it in 1925) – that Harlem became in the first quarter of the twentieth century. Fidel Castro's recent pilgrimage uptown, recalling to mind his famous sojourn at the Hotel Teresa in 1960, is only the most recent of a long line of such pilgrimages into America's very own heart of darkness. The list of pilgrims is long and distinguished, and includes such varied notables as Max Weber and Carl Jung, Federico García Lorca and Octavio Paz, Zora Neale Hurston and Langston Hughes, Kwame Nkrumah and Wole Soyinka, Marcus Garvey and Malcolm X, Ezekiel Mphalele and Nelson Mandela. I could go on and on. 'Harlem was like a great magnet for the Negro intellectual,' Langston Hughes wrote, 'pulling him from everywhere. Once in New York, he had to live in Harlem.' Harlem was not so much a *place* as a state of mind, the cultural metaphor for black America itself.

Harlem, as a site of the black cultural sublime, was invented by writers and artists who were determined to transform the stereotypical image of Negro Americans at the turn of the century away from their popular image as ex-slaves, defined as members of a race inherently inferior – biologically and environmentally unfitted for mechanized modernity and its cosmopolitan forms of fluid identity – into an image of a race of culture bearers. To effect this transformation, a 'New Negro' was called for – quite urgently, many black intellectuals felt – and this New Negro would need a nation over which to preside. And that nation's capital would be Harlem, that realm north of Central Park, centered between 130th Street and 145th.

It was Booker T. Washington who first hoped to institutionalize the cultural and political force of this New Negro. Writing in 1900, Washington enlisted several of his fellows (including his nemesis, W.E.B. Du Bois) to imagine a 'New' Negro, unfettered by the racist burdens of the past – a past characterized by two-and-a-half centuries of slavery and nearly a half-century of disenfranchisement, peonage, Black Codes, and Jim Crow, not to mention the vicious assault on Negro freedom and political rights depicted in literature, in the theatre, on the vaudeville stage and throughout the

Previous page: **Aaron Douglas**
The Crisis, May 1929

popular visual arts, in the form of a blanket of demeaning stereotypes of deracinated, ugly, treacherous and hauntingly evil Sambo images. Families could encounter these images throughout their homes in 1900: on their alarm clocks, on their egg cups or tea cosies, napkin rings or place mats at breakfast, in parlor games, advertisements in magazines and US government postcards. Such an onslaught of stereotypes – reinforced subliminally in advertisements and on trade cards, and overtly in pulpits on Sunday and even in the law – demanded resistance and an organized response. 'We must turn away from the memories of the slave past,' Washington would insist at the beginning of the new century, no doubt with this proliferation of negations of black humanity in mind. 'A New Negro for a New Century', he argued, would be the answer.

This New Negro movement, which took at least three forms before Alain Locke enshrined it in the Harlem Renaissance in 1925, took its artistic inspiration from citizens across the Atlantic in Europe. First, in the early 1890s, Dvořák declared the spirituals to be America's first authentic contribution to world culture and urged classical composers to draw upon them to create *sui generis* symphonies. A decade later, Pablo Picasso stumbled across 'dusky Manikins' at an ethnographic museum and for-ever transformed European art, as well as Europe's official appreciation of the art from the African continent. Picasso's *Les Demoiselles d'Avignon* – the signature paint-ing in the creation of Cubism – stands as a testament to the shaping influence of African sculpture and to the central role that African art played in the creation of modernism. The Cubist mask of modernism covers a black Bantu face. African art – ugly, primitive, debased in 1900; sublime, complex, valorized by 1910 – was transformed so dramatically in the cultural imagination of the West, in such an astonishingly short period, that the potential for the political uses of black art and literature in America could not escape the notice of African-American intellectuals, especially Du Bois, himself educated in Europe and cosmopolitan to the core, and Alain Locke, Harvard-trained, a Rhodes scholar at Oxford in 1906 and thereafter a student of aesthetics in Germany in the heady years of the modernist explosion. If European modernism was

Right: **Aaron Douglas**
Forest Fear (Flight)
(from *Emperor Jones* series), n.d.
woodcut, 22.9 x 16.5 cm
Personal collection of Valena
Minor Williams

Far right: **Aaron Douglas**
Defiance (from *Emperor Jones*
series), n.d.
woodcut, 22.9 x 16.5 cm
Personal collection of Valena
Minor Williams

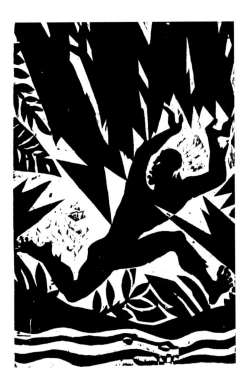

truly a mulatto, the argument went, then African-Americans would save themselves politically through the creation of the arts. The Harlem Renaissance, in so many ways, owes its birth to Euro-African modernism in the visual arts. This Renaissance, the second in black history, would fully liberate the Negro – at least its advanced guard.

The first African-American renaissance took place at the turn of the century. Writing in 1901, the black Bostonian, William Stanley Braithwaite (a distinguished critic and poet), argued that 'We are at the commencement of a "negroid" renaissance ... that will have as much importance in literary history as the much spoken of and much praised Celtic and Canadian renaissance.' Writing at the end of a full decade of unprecedented literary production by black women (who published a dozen novels and edited their own literary journal between 1890 and1900) and at a moment when the poet Paul Laurence Dunbar, the novelists Pauline Hopkins and Charles Chesnutt, and the essayists W.E.B. Du Bois and Anna Julia Cooper were at the height of their creative powers, a critic in the *AME. Church Review* in 1904 declared the birth of 'The New Negro Literary Movement', likening it, as had Braithwaite, to the Celtic renaissance.

The second, and most famous, renaissance was known as the Harlem, or New Negro Renaissance. This renaissance was well underway by 1925, nurtured by Alain Locke, who edited a special issue of *Survey Graphic Magazine* in March of that year ('Harlem: Mecca of The New Negro') to be followed by a 446-page anthology entitled *The New Negro: An Interpretation*, replete with illustrations by the German designer Winold Reiss and the African-American artist Aaron Douglas. Writers such as Langston Hughes, Jean Toomer, Countee Cullen, Jessie Fausett and Zora Neale Hurston – the fundaments of the black canon today – came of age here, leading the *New York Herald Tribune* to announce in 1925 that America was 'on the edge, if not already in the midst, of what might not improperly be called a Negro renaissance.' Locke also

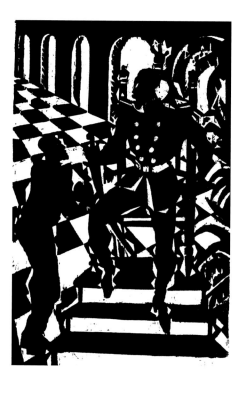

Far left:
Aaron Douglas
Bravado (from *Emperor Jones* series), n.d.
woodcut, 22.9 x 16.5 cm
Personal collection of Valena Minor Williams

Left:
Aaron Douglas
Surrender (from *Emperor Jones* series), n.d.
woodcut, 22.9 x 16.5 cm
Personal collection of Valena Minor Williams

liked the term: part one of his anthology is called 'The Negro Renaissance'. Locke even urged young black visual artists to imitate the European modernists who were so heavily influenced by sub-Saharan African art. 'By being modern,' Locke declared, with no hint of irony, 'we are being African.'

The third renaissance was the Black Arts Movement of the 1960s and early 1970s. Defining itself against the Harlem Renaissance, and deeply rooted in black cultural nationalism, the Black Arts writers saw themselves as the artistic wing of the Black Power movement. Writers such as Amiri Baraka, Larry Neal and Sonia Sanchez saw black art as functional; the function in question was the political liberation of black people from white racism. Constructed on a fragile foundation of the overtly political, this renaissance was the most short-lived of all. Yet many of the artists who have come of age since 1987 were shaped or deeply influenced by this period.

A decade later, however, black writers and artists, musicians, dancers and actors would enter a period of creativity unrivaled in American history. The signs of cultural vibrancy are unmistakable: in dance (Bill T. Jones and Judith Jamison); in literature (Toni Morrison and Terry McMillan, Walter Mosley and John Edgar Wideman); August Wilson in drama; Rita Dove in poetry; public intellectuals such as Cornel West, Greg Tate and Lisa Jones; artists such as Martin Puryear and Lorna Simpson; Anthony Davis and Thulani Davis in opera; jazz musicians such as Wynton Marsalis and Cassandra Wilson; Hip-Hop artists such as Public Enemy, De La Soul and Queen Latifah; film-makers such as Spike Lee, Julie Dash, John Singleton – the list is stunningly long. From television to op-ed pages, from the academy to the poetry slam, never before have so many black artists and intellectuals achieved so much success in so very many fields.

The current renaissance is characterized by a specific awareness of previous black traditions, which these artists echo, imitate, parody and revise, self-consciously, in acts of 'riffing', 'signifying' or even 'sampling'. As the jazz and opera composer Anthony Davis puts it, 'There are three different strains in the black music revolution today – classical jazz (such as Wynton Marsalis), avant jazz (such as Anthony Braxton), and the fusion of Hip-Hop and jazz (such as the compositions of Steve Coleman).' What each shares, however, Davis continues, 'is a common attempt to rediscover the past.' Davis's opera *Malcolm X* is a prime example. 'What this is, is a renaissance of post-modernism, and post-modernism, in America, is quintessentially black,' he concludes.

'Renaissances' are acts of cultural construction, attempting to satisfy larger social and political needs. And the African-American post-modern renaissance – in its openness, its variety, its playfulness with forms, its refusal to follow preordained ideological lines, its sustained engagement with the black artistic past – is no exception. Its artists seem as determined to define their work freely within a black tradition as they are to consolidate a black presence within America's corporate cultural institutions. Given the sophistication of so much of this art, and given its demonstrated power to turn a profit, it is highly likely that the achievements of this renaissance will be the deepest, the longest-lasting and the most appreciated by the larger American society.

What lessons from the Harlem Renaissance of the 1920s and 1930s can we draw upon to critique today's black post-modern renaissance? Much has been made of the Harlem Renaissance's putative faults and purported limitations – an overdependence on white patronage and a pandering to debased white tastes in the form of primitivistic

depictions of black sensuality and hedonism in the literature, art, music and dance of the period. We can debate these claims and even accept some (with enormous qualifications) as true, despite the fact that *all* artists are dependent upon patronage, and all 'renaissances' especially so, and despite the fact that the literature created during the Harlem Renaissance – especially the poetry of James Weldon Johnson, Langston Hughes and Sterling Brown, the fictions of Jean Toomer and Zora Neale Hurston – drew upon African-American vernacular traditions of music and oral traditions to create *sui generis* African-American modernist forms that today, three-quarters of a century later, are judged to be canonical by even the most conservative keepers of the American canon. What is more, the literature created proved to be the fertile ground from which such writers emerged as Richard Wright, Ann Petry, Ralph Ellison, James Baldwin, Gwendolyn Brooks, Amiri Baraka, Alice Walker and Toni Morrison, to list just a few who use the Renaissance writers as their silent second texts. In Morrison's case, she turned to the Renaissance itself as the setting for her last novel, *Jazz*.

What *does* seem curious about the Harlem Renaissance is that its creation occurred precisely as Harlem was turning into the great American slum. The death-rate in Harlem was 42 per cent higher than in other parts of the city. The infant mortality rate in 1928 was twice as high in Harlem as it was in the rest of New York. The tuberculosis death-rate was four times as high as that among the white population. The unemployment rate, according to Adam Clayton Powell Jr, was 50 per cent. There was no way to romanticize these conditions, despite the valiant attempts of Locke and his fellows to do so. Even James Weldon Johnson, one of the most politically engaged of all the Renaissance writers, wrote *Black Manhattan* in 1931 to create the fiction of Harlem as a model of civility and black bourgeois respectability, rather than as an example of the most heinous effects of urban economic exploitation and residential segregation. For Johnson, Harlem was 'exotic, colorful, sensuous; a place of laughing, singing, and dancing; a place where life wakes up at night.' Moreover, he continued, 'Harlem is not merely a Negro colony or community, it is a city within a city, the greatest Negro city in the world. It is not a slum or fringe, it is located in the heart of Manhattan and occupies one of the most beautiful and healthful sections of the city.' Alain Locke, always an optimist and called 'the press agent of the New Negro' by Charles Johnson, declared Harlem to be the cultural capital of the black world: 'Without pretense to their political significance, Harlem has the same role to play for the New Negro as Dublin had for the New Ireland or Prague for the New Czechoslovakia. Harlem, I grant you, isn't typical – but it is significant, it is prophetic.'

The Harlem of literature and the Harlem of socio-economic reality were as far apart as Bessie Smith was from Paul Whiteman. The valorization of black rhythm, spontaneity, laughter and sensuality – all keywords when discussing depictions of blacks by blacks at the time – contrasted starkly with Harlem's squalor and the environmental or structural delimitations upon individual choices such as those finally depicted in Richard Wright's *Native Son*, published in 1940, in part as a reaction *against* what Wright felt to be the Renaissance writers' bohemian decadence.

The Renaissance's fascination with primitivism, one could argue, has today found a counterpart in three arenas of representation: the reconstruction of the institution of slavery, the valorization of vernacular expressive cultural forms as a basis for a post-modern art and the use of a lyrical voice-of-becoming in fictions that depict the

emergence of black female protagonists with strong, resonant voices and self-fashioned identities. Subjects to be avoided previously – such as slavery, vernacular linguistic forms and the female tale of the transcendence and emergence of the self – have all emerged like the return of the repressed as dominant themes in African-American literature. What remains to be explored, however, in the written arts of *this* renaissance, are the lives and times of the grandchildren of the Bigger and Bessie Thomases of *Native Son*, which, by and large, have been of interest primarily to young black film-makers, but which far too often seem to be caught in the embrace of a romantic prim-itivism, navigating us through the inner city more for sexual titillation than for social critique. Given the stark statistics describing the nightmare reality of black inner-city life – one in three black men between the ages of 20 and 29 in prison, on probation, on parole; 46 per cent of all black children born at or beneath the poverty line – one is forced to wonder where this generation's Bigger Thomas is. Until this subject matter finds a voice as eloquent as that of the newly emergent and aspiring middle-class black self, today's renaissance runs the risk of suffering the sorts of critique that we leveled against the Harlem Renaissance seven decades ago.

Perhaps it is no accident that the most interesting rendering of this tension between the myth of Harlem and its social reality is to be found *not* in a text produced in that period but in Toni Morrison's *Jazz*, set in Harlem in 1926. What Morrison succeeds in doing here is to create a protaganist whose fate is as shaped by her environ-ment as by her actions, in a curious kind of stasis or equilibrium that seeks to resolve the tension between the naturalism of Richard Wright and Ann Petry, on the one hand, and the lyrical modernism of Jean Toomer, Zora Neale Hurston and Ralph Ellison on the other. 'Word was', Morrison's narrator tells us, 'that underneath the good times and the easy money something evil ran the streets and nothing was safe – not even the dead.' It is here, in this novel, that the Harlem Renaissance finally finds its most sophisticated voice *and* its critique, the newest renaissance grounding itself in the mirror of the old, bridging that gap between the shadow and the act, the myth and the reality, between the fiction and the fact. Morrison's ultimate message would seem to be a warning that it is only when our artists today 'speak its loud voice and make that sound human,' avoiding 'missing the people altogether,' in all their complexity that *this* renaissance can claim to be the renaissance to end all renaissances. Much depends on whether we get it.

A CHRONOLOGY OF VISUAL ART AND CULTURE, 1919–1938

1919

● Printmaker and painter James Lesesne Wells leaves Jacksonville, Florida, and arrives in New York where he attends the National Academy of Design.
● Jamaican sculptor Edna Swithenbank (Manley) arrives in London where she attends several art schools.
● The spectacle of the all-black 369th Regiment marching up New York's Fifth Avenue, in a grand celebration of the end of the First World War, captures the imaginations of many artists, intellectuals and activists.
● A wave of white-on-black violence and racial disturbances across the United States prompts the visceral designation 'the Red Summer'.
● Oscar Micheaux's first film, *The Homesteader*, is released in Chicago.
● Claude McKay's poem *If We Must Die* is published.
● W.E.B. Du Bois organises the Pan-African Congress in Paris.
● The National Association for the Advancement of Colored People (NAACP) organises a conference on lynchings and publishes *Thirty Years of Lynchings in the United States 1889–1919*.
● Henry Ossawa Tanner's paintings are exhibited in The Group of American Artists in New York.

1920

● Oscar Micheaux's second film, *Within Our Gates*, premieres at the Vendome Theatre in Chicago. Micheaux's films *The Brute* and *Symbol of the Unconquered* are released later in the year.
● After being discharged from the army, painter Palmer C. Hayden settles in New York where he enrols in classes at Columbia University.
● After studying art at the National Academy of Design in New York, graphic artist and jazz musician Albert Alexander Smith moves to Europe.
● Eugene O'Neill's *The Emperor Jones* is produced, starring Charles Gilpin.
● Marcus Garvey's First International Convention of the Negro Peoples of the World is held at Madison Square Garden, New York.
● Meta Vaux Warrick Fuller's sculpture is exhibited at the Pennsylvania Academy of the Fine Arts.

1921

● Sculptor Augusta Savage leaves Tallahassee, Florida, and arrives in New York where she attends Cooper Union.

● Painter and educator James V. Herring establishes the Department of Art at Howard University in Washington, D.C.

● An exhibition of works by Negro artists is held at the 135th Street Branch of the New York Public Library.

● The Museum of Fine Arts in Boston exhibits recent archaeological finds from ancient Nubia and Axum (cultures that dominated Egypt, and the Horn of Africa in particular, during the twenty-fifth and twenty-sixth dynasties).

● Artist William H. Johnson enters the National Academy of Design.

● The musical revue *Shuffle Along*, by musicians Eubie Blake and Noble Sissle, introduces audiences to an entirely novel way of seeing black performers.

● Oscar Micheaux completes two films: *The Gunsaulus Mystery* and *Deceit*.

● Paul Robeson makes his theatrical début in Mary Hoyt Wilborg's *Taboo*.

1922

● Richard Samuel Roberts opens his photographic studios in Columbia, South Carolina.

● Sculptor Nancy Elizabeth Prophet leaves Providence, Rhode Island, for Paris where she attends the Ecole des Beaux Arts and exhibits regularly in the Salons d'Automne.

● The Tanner Art League holds a large exhibition of Negro artists at Dunbar High School, Washington, D.C.

● Artist Albert Alexander Smith begins his role as chronicler of black history with his portrait of the Martiniquan novelist René Maran (the winner of France's prestigious Prix Goncourt) for the cover of the magazine *The Crisis*.

● Sculptor Edna Manley arrives in Kingston, Jamaica, with her husband, Norman Manley, and her son.

● Augusta Savage creates a bust of Marcus Garvey, founder and leader of the Universal Negro Improvement Association.

Right: **Edna Manley**
Market Women, 1936
wood, 40.6 cm high
Courtesy of Spelman College, Atlanta
© Estate of the Artist / Edna Manley Foundation

● Oscar Micheaux releases four films this year: *Son of Satan, Uncle Jasper's Will, The Virgin of the Seminole* and *The Dungeon*.

● The Boston Public Library holds a special exhibition of visual arts and literature by Negroes.

● James Weldon Johnson's anthology, *The Book of American Negro Poetry*, is published.

● King Oliver's Creole Jazz Band takes up residence in Chicago where the young Louis Armstrong joins them.

● In Washington, D.C., the Howard Players perform *Genefrede*, a play about Toussaint L'Ouverture.

● Meta Vaux Warrick Fuller's *Ethiopia Awakening* is exhibited in the *Making of America* exposition in New York.

1923

● *Opportunity*, the National Urban League's 'Journal of Negro Life', is first published, providing an outlet for black artists and illustrators.

● Graphic artist Miguel Covarrubias leaves Mexico City and arrives in New York. Within months of his arrival he is one of the city's leading illustrators.

● Painter Henry Ossawa Tanner is awarded the Legion of Honour by the French government.

● Although initially admitted to the Fontainebleau School of Fine Arts Summer School for American Architects, Painters and Sculptors, Augusta Savage is later denied admittance because of her race.

● Jean Toomer's poem *Cane* is published.

● Bessie Smith makes her first recordings of *Downhearted Blues* and *Gulf Coast Blues*.

1924

◉ Sculptor Richmond Barthé moves from Bay St Louis, Mississippi, and settles in Chicago to attend the School of the Art Institute.

◉ The Barnes Foundation – a cultural institution devoted to art education – opens in Merion, Pennsylvania. Among the original works of art used by the Foundation in its education programme are selected carvings from West and Central Africa.

◉ Howard University professor, philosopher and 'New Negro' patriarch Alain Locke publishes 'A Note on African Art' in *Opportunity* magazine.

◉ James VanDerZee embarks on a series of photographic assignments featuring Marcus Garvey and the activities of the Universal Negro Improvement Association.

◉ Publisher Alfred A. Knopf introduces Carl Van Vechten to Walter White, Assistant Secretary for the NAACP, which initiates Van Vechten's serious exploration of contemporary black culture.

◉ After a ten-year hiatus the Philadelphia painter Laura Wheeler Waring returns to Paris to study for a year at the Académie de la Grande Chaumière.

◉ Miguel Covarrubias's illustrations of black entertainers are featured in *Vanity Fair* magazine.

◉ Oscar Micheaux completes the films *Birthright* and *Body and Soul*, the latter starring Paul Robeson.

1925

◉ Designer Winold Reiss is contracted to design and illustrate a special issue of *Survey Graphic*, entitled 'Harlem: Mecca of the New Negro'. His solo exhibition, *Representative Negroes*, opens at the 135th Street branch of the New York Public Library.

◉ Painter Archibald J. Motley Jr exhibits his radical and provocative study of black cabaret life, *Syncopation*, in the *Art Institute of Chicago's Annual Exhibition*. It receives an award.

◉ Miguel Covarrubias illustrates Langston Hughes's first book of poetry, *The Weary Blues*.

◉ Miguel Covarrubias creates the set designs for the musical production *La Revue Nègre*, which opens in Paris and introduces audiences to the African-American dancer Josephine Baker.

◉ Painter, graphic artist and muralist Aaron Douglas arrives in New York and eventually studies art with Winold Reiss. He begins to illustrate and design the covers of *Opportunity* and *The Crisis* magazines.

◉ As a result of his sympathy with Howard University student protesters, Alain Locke is dismissed from his teaching position, which fortuitously provides him with the time and flexibility to help shepherd New York's burgeoning Negro arts movement. He is reinstated at Howard University in 1927.

◉ Alain Locke edits and publishes *The New Negro: An Interpretation*. Winold Reiss and Aaron Douglas are among the artists whose works are featured in this volume.

◉ Countee Cullen's first volume of poetry, *Color*, is published.

◉ Labour leader A. Philip Randolph founds The Brotherhood of Sleeping Car Porters in Harlem.

◉ Zora Neale Hurston becomes editor of *The Spokesman*.

1926

◉ Aaron Douglas and Langston Hughes collaborate on a portfolio of drawings and poems on the theme of 'the blues', published by *Opportunity* magazine and the National Urban League.

◉ Aaron Douglas (along with artist Richard Bruce Nugent) illustrates the short-lived arts and literary journal, *Fire!!*

◉ Aaron Douglas is commissioned by *Theatre Arts Monthly* to illustrate scenes from Eugene O'Neill's play *The Emperor Jones*.

◉ The leftist monthly, *New Masses*, is published, providing an artistic outlet for artists such as Miguel Covarrubias and James Lesesne Wells.

◉ Aaron Douglas designs advertisements for Carl Van Vechten's novel *Nigger Heaven*.

◉ Miguel Covarrubias travels to Havana, Cuba, where he observes Afro-Cuban religious rituals and dance. Covarrubias later travels to Paris where he meets many artists, performers and writers.

◉ Miguel Covarrubias illustrates composer W.C. Handy's book *Blues*.

◉ Thomas Munro and Paul Guillaume publish *Primitive Negro Sculpture*, one of the first critical studies of African art and its influences on Western art to be published in the United States.

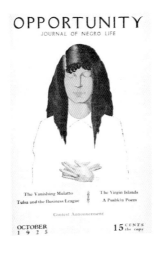

OPPORTUNITY
JOURNAL OF NEGRO LIFE

The Vanishing Mulatto The Virgin Islands
Tulsa and the Business League A Pushkin Poem

Contest Announcement

OCTOBER 15 CENTS
1 9 2 5 the copy

Left:
Aaron Douglas
Opportunity, October 1925

Below:
123 **James VanDerZee**
Swimming Team, Harlem, 1925
photograph, 6 x 23.5
Schomburg Center for Research in
Black Culture, The New York Public
Library

1927

⬤ Following her electrifying performance at the Folies Bergère, dancer Josephine Baker is widely photographed, featured in product advertisements throughout France and portrayed by artists Paul Colin, Alexander Calder, Tsuguharo Foujita, Henri Laurens, Kees van Dongen, Georges Rouault and Marie Laurencin.

⬤ Oscar Micheaux releases three films: *The Conjure Woman*, *The Devil's Disciple* and *The Spider's Web*.

⬤ The Harmon Foundation holds the first of its annual art exhibitions featuring works by African-Americans.

⬤ Palmer C. Hayden, winner of the Harmon Foundation's gold award in fine arts, eventually leaves New York for a year of independent study in Paris. He remains there until 1932.

⬤ William H. Johnson leaves New York for a year of independent study in Paris. He remains there until 1929.

⬤ Although awarded a fellowship by the Italian-American Society to attend the Royal Academy of Fine Arts in Rome, Augusta Savage is forced to decline because of insufficient finances.

⬤ Langston Hughes's *The Negro Artist & The Racial Mountain* is published.

⬤ The Savoy Ballroom opens in Harlem with Fletcher Henderson and his orchestra.

⬤ Josephine Baker's Folies Bergère performance is captured on film.

⬤ Palmer C. Hayden exhibits at the Galerie Bernheim-Jeune in Paris.

⬤ William H. Johnson exhibits at the Student and Artist Club in Paris.

⬤ Aaron Douglas illustrates Countee Cullen's *Caroling Dusk*, Langston Hughes's *Fine Clothes to the Jew*, Charles S. Johnson's *Ebony and Topaz*, James Weldon Johnson's *God's Trombones*, and Alain Locke's and Gregory Montgomery's *Plays of Negro Life*.

⬤ Jean Renoir's film *Sur un air de Charleston* – starring Renoir's wife, Catherine Hessling, and the black vaudevillian Johnny Hudgins – premieres in Paris.

⬤ In spite of filing for bankruptcy this year, Oscar Micheaux produces two films: *The Broken Violin* and *The Millionaire*.

⬤ Winold Reiss visits the Penn Community School on the South Carolina Sea island of St Helena, where he produces about 16 portraits of its black inhabitants.

⬤ The Blondiau Theatre Arts Collection of African Art is exhibited at the New Art Circle Gallery in New York.

⬤ Laura Wheeler Waring is awarded the gold award in fine arts from the Harmon Foundation, while painter William Edouard Scott is awarded the gold medal.

⬤ Miguel Covarrubias's book *Negro Drawings* is published.

⬤ *Le Tumulte Noir*, Paul Colin's portfolio of lithographs chronicling Josephine Baker and the jazz movement in Paris, is published.

⬤ *La Croisière Noire*, a film and exhibition based on a cross-continental tour of Africa (sponsored by the automobile manufacturer Citroën) opens at the Musée des Arts Décoratifs in Paris.

⬤ Sculptor Jacob Epstein arrives in New York for a three-month stay. While there he meets Carl Van

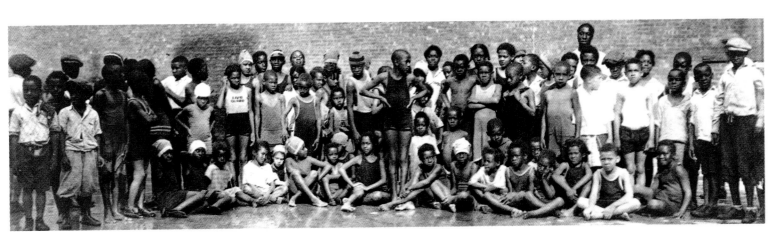

Above:
Alberta Hunter, 1934
Photograph: Max Jones Files / Redferns

Right:
85 **Archibald J. Motley Jr**
Woman Peeling Apples (Mammy) (Nancy), 1924
Schomburg Center for Research in Black Culture, Art & Artifacts Division, The New York Public Library, Astor, Lenox and Tilden Foundations
photograph: Manu Sassoonian

Vechten, Albert Barnes, Frank Crowninshield and Paul Robeson, who sits for a portrait bust.
● Aaron Douglas embarks on a long career as a muralist with *Jungle and Jazz*, his wall paintings for the Club Ebony in Harlem.
● Painter Hale Woodruff leaves Indianapolis, Indiana, and settles in Paris.
● *The Negro in Art Week* exhibition opens in Chicago, Illinois, and is sponsored by the Chicago Women's Club.
● *Mending Socks* by Archibald J. Motley Jr is voted the most popular work during its display at the Newark Museum's exhibition *Paintings and Watercolors by Living American Artists*.
● Aaron Douglas and Miguel Covarrubias (along with Langston Hughes, Zora Neale Hurston and 'New

Negro' patriarch Alain Locke) become protégés of the wealthy Park Avenue patron Charlotte Osgood Mason.
● Henry Ossawa Tanner is elected a full member of the National Academy of Design.
● Duke Ellington begins his residency at the Cotton Club.
● DuBose Heyward's novel *Porgy* is produced as a play and later as an opera, *Porgy & Bess* by George Gershwin.

1928

● Archibald J. Motley Jr exhibits at the New Galleries in New York; the exhibition is reviewed at great length in the *New York Times*.
● Miguel Covarrubias exhibits at the Valentine Gallery in New York.
● Aaron Douglas receives a fellowship to study art at the Barnes Foundation in Merion, Pennsylvania.
● Painter Loïs Mailou Jones is hired as the head of the art department at the Palmer Memorial Institute in Sedalia, North Carolina.
● For the next two years the Afro-Cuban sculptor Teodoro Ramos-Blanco studies at the Academy of San Alejandro in Rome. His sculpture *The Slave* wins an award at an exhibition in Seville, Spain.
● Charles S. Johnson resigns from the Urban League to head the Department of Social Sciences at Fisk University in Nashville, Tennessee.
● The Haitian anthropologist Jean Price-Mars publishes his influential book *Ainsi Parla l'Oncle*.
● Oscar Micheaux releases four films: *When Men Betray, Easy Street, Thirty Years Later* and *The Wages of Sin*.
● Richard D. Maurice releases his film *Eleven p.m.*
● The Colored Players release their film *The Scar of Shame*, directed by Frank Peregrini.
● Miguel Covarrubias illustrates singer Taylor Gordon's autobiography, *Born to Be*.
● Archibald J. Motley Jr wins the gold award in fine arts from the Harmon Foundation.
● Sculptor and graphic artist Sargent Claude Johnson wins the Otto H. Kahn Prize from the Harmon Foundation for his work in sculpture.
● Wallace Thurman edits and publishes *Harlem*, the successor to *Fire!!*
● Paul Robeson stars in *Show Boat* in London with Alberta Hunter.

1929

● Aaron Douglas illustrates the jacket cover of Wallace Thurman's novel, *The Blacker the Berry*.
● Aaron Douglas illustrates Paul Morand's book of short stories, *Black Magic*.
● Bessie Smith stars in the film *St. Louis Blues*, directed by Dudley Murphy.
● William H. Johnson returns to New York after living and painting in France for three years. Within months of his return he wins the Harmon Foundation's gold award in fine arts. His work is widely reviewed, he briefly visits friends and family members in his native South Carolina and again leaves the United States, this time for Denmark.
● King Vidor completes his film musical *Hallelujah*, starring Daniel Haynes and Nina Mae McKinney.
● The 'all colored' film musical *Hearts in Dixie* is released.
● *Black and Tan*, a musical short featuring Duke Ellington and his orchestra, is released.
● Sargent Claude Johnson wins the bronze award for sculpture from the Harmon Foundation.
● Edna Manley exhibits at the Goupil Gallery in London.
● Photographer Doris Ulmann travels to South Carolina to photograph black workers. These works are exhibited at the Delphic Galleries in New York.

● Archibald J. Motley Jr wins a Guggenheim Fellowship, allowing him to study in Paris for a year.
● James Lesesne Wells leaves New York to accept a teaching position in the Art Department at Howard University in Washington, D.C.
● Richmond Barthé receives a Julius Rosenwald fellowship, which encourages him to leave Chicago and settle in New York, where he attends the Art Students' League.
● Painter Malvin Gray Johnson wins the Otto H. Kahn Prize for painting from the Harmon Foundation.
● Augusta Savage is awarded fellowships by the Julius Rosenwald Foundation and the Carnegie Foundation, enabling her to travel to Paris and study at L'Académie de la Grande Chaumière.
● The stock market crash signals the beginning of the Great Depression.

1930

● Aaron Douglas is commissioned by Fisk University in Nashville, Tennessee, to create a series of murals in the campus library.
● Aaron Douglas is commissioned by the Sherman Hotel in Chicago, Illinois, to paint a mural, *Dance Magic*, in their College Room Inn.
● During a tour of Havana, Langston Hughes meets Cuba's most famous artist, the black sculptor Teodoro Ramos-Blanco.
● *Arts and Decoration* publish Clive Bell's article 'Negro Sculpture'.
● Augusta Savage meets Paulette Nardal, the Martiniquan editor of *La Revue du Monde Noir*, a Paris-based journal devoted to black culture.
● Oscar Micheaux produces *Daughter of the Congo*.
● James VanDerZee moves from his photography studio on West 135th Street to a former Chrysler automobile showroom on Seventh Avenue in Harlem.
● Loïs Mailou Jones accepts a teaching position in the Art Department at Howard University in Washington, D.C., and leaves Sedalia, North Carolina.
● Sculptor Nancy Elizabeth Prophet wins the Otto H. Kahn Prize from the Harmon Foundation.
● James V. Herring creates the Howard University Gallery of Art, the first gallery in the United States directed and controlled by African-Americans and one of the first to highlight African-American art.

● Paul Robeson stars in the experimental film *Borderline*, shot in Switzerland and produced by the Pool Group (Bryher, Kenneth Macpherson and the poet H.D.).

● Painter Jacob Lawrence and his family settle in Harlem.

● Marc Connelly's drama *Green Pastures* opens on Broadway.

1931

● Aaron Douglas's *Forge Foundry* is featured in the Paris-based journal *La Revue du Monde Noir*.

● Aaron Douglas is commissioned by philanthropist Alfred Stern to paint a mural for Bennett College in Greensboro, North Carolina. Douglas chooses as his subject the nineteenth-century abolitionist and black activist Harriet Tubman.

● Under the sponsorship of the Julius Rosenwald Foundation, William Edouard Scott travels to Port-au-Prince, Haiti, where he paints and teaches art for a year.

● The *Exposition Coloniale Internationale* opens in Paris, bringing critical attention to France's African and Caribbean colonies. Concurrent with the exhibition is the creation of the Museum of African and Oceanic Arts, with art-deco reliefs depicting aspects of black culture by sculptor Alfred Janniot.

● Kineton Parkes, a regular contributor to *Apollo* magazine, devotes several pages of his book *The Art of Carved Sculpture* to Edna Manley's most recent works.

● Aaron Douglas sails to Europe for a year of study in Paris, enrolling at L'Académie Scandinave and studying privately with Charles Despiau, Henri de Waroquier and Othon Frieze.

● Alain Locke's article 'The American Negro as Artist' is published in the *American Magazine of Art*.

● Hale Woodruff returns to the United States and accepts a teaching position at Atlanta University.

● Oscar Micheaux releases his film *Darktown Revue* and completes his first 'talking' film, *The Exile*.

● Artist and illustrator Prentiss Taylor begins a collaborative publishing venture with Langston Hughes and Carl Van Vechten. Their first project is the illustrated chap-book *The Negro Mother*.

● Upon her return to New York, Augusta Savage opens the Savage School of Arts and Crafts in Harlem, the first of several of her Harlem-based art schools.

● James Lesesne Wells is awarded the gold medal in fine arts from the Harmon Foundation.

● Richmond Barthé has his first solo exhibition at the Caz-Delbos Gallery in New York.

● James Weldon Johnson's history of Harlem, *Black Manhattan*, is published.

1932

● James Lesesne Wells exhibits at the Delphic Studios in New York.

● Following several months spent in Tunisia, William H. Johnson returns to Denmark where he exhibits his African-themed paintings and prints.

● Jacob Epstein acquires a masterpiece of Fang art at auction in Paris: the famous *Great Bieri* (formerly in the collection of Paul Guillaume).

● Carl Van Vechten buys a Leica camera and begins to photograph prominent African-Americans in earnest.

● Jazz musician Louis Armstrong is featured prominently in the musical short *A Rhapsody in Black and Blue*.

Left:
17 Aaron Douglas
Cover illustration for *Spark*, 1934
Schomburg Center for Research in
Black Culture, Art & Artifacts Division,
The New York Public Library, Astor,
Lenox and Tilden Foundations
photograph: Laurel Duplessis

Right:
*Loïs Mailou Jones in her Paris
studio*, 1937–38
© Loïs Mailou Jones

Twenty-two African-Americans sail for the Soviet Union to take roles in *Black and White*, a film about racial segregation in the American South.

Harlem in Heaven, a musical short featuring dancer Bill Robinson, is released.

Prentiss Taylor illustrates Langston Hughes's self-published play, *Scottsboro Limited*.

Jacob Lawrence begins art training at the Harlem Art Workshop under the direction of Charles Alston.

Oscar Micheaux releases his films *Black Magic*, *The Girl from Chicago*, *Veiled Aristocrats* and *Ten Minutes to Live*.

Nancy Elizabeth Prophet returns to the United States and joins the art faculty of Atlanta University shortly afterwards.

1933

Aaron Douglas creates a mural for the Harlem YMCA.

In collaboration with writer Julia Peterkin, Doris Ulmann publishes *Roll, Jordan, Roll*, a book about black folk-life in the southern United States.

Aaron Douglas exhibits at the Caz-Delbos Gallery in New York.

Photographer Walker Evans arrives in Havana, Cuba, on a photographic assignment.

The Field Museum of Natural History's Hall of Man opens in Chicago, with more than 100 bronzes by sculptor Malvina Hoffman.

James Lesesne Wells is appointed Director of the Harlem Art Workshop and Studio.

Dudley Murphy releases the film *The Emperor Jones*, starring Paul Robeson.

Archibald J. Motley Jr is included in an Art Institute of Chicago exhibition, in conjunction with *A Century of Progress International Exposition*.

Palmer C. Hayden wins the Harmon Foundation's Painting Prize for *Fétiche et Fleurs*. This is the fifth of the Foundation's art exhibitions selected by jurors, and its final one.

Edward Burra leaves London for New York where he stays for several months, spending a significant amount of time in Harlem.

The Public Works of Arts Projects and the Works Progress Administration's Federal Arts Projects begin, providing jobs and financial assistance for many American artists, including a significant number of African-American artists.

1934

Under the sponsorship of the Public Works Administration, Aaron Douglas is commissioned to create four murals for the 135th Street branch of the New York Public Library. Douglas calls his murals *Aspects of Negro Life*.

Aaron Douglas exhibits at the Caz-Delbos Gallery in New York.

British socialite Nancy Cunard assembles and edits the *Negro Anthology*, a massive, profusely illustrated volume on black culture.

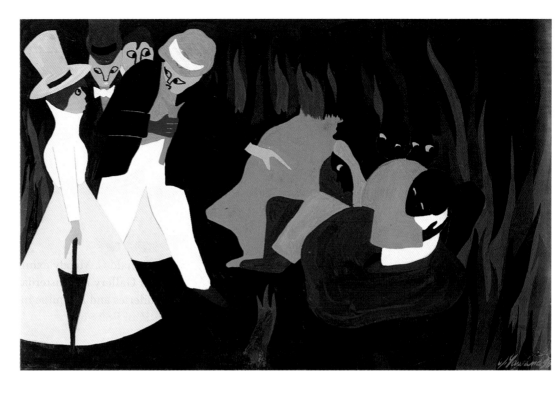

◉ In collaboration with the College Art Association, the Harmon Foundation establishes a travelling exhibition programme. The Foundation also produces and distributes a film documenting the activities of African-American artists.

◉ Romare Bearden, a young Harlem painter, publishes an article in *Opportunity* magazine criticising the Harmon Foundation's history of black cultural philanthropy and art patronage.

◉ *Four Saints in Three Acts* by Gertrude Stein and Virgil Thomson opens on Broadway with an all-black cast. Costumes and sets are designed by New York artist Florine Stettheimer.

◉ Fannie Hurst's novel *Imitation of Life* is made into a film, featuring two African-American actors, Louise Beavers and Fredi Washington.

◉ Following a visit to Haiti by President Franklin D. Roosevelt, the US Marines end their occupation of Haiti.

◉ Chicago illustrator Charles Dawson publishes *ABCs of Great Negroes*, a volume of linocut portraits.

◉ Josephine Baker's first sound film, *Zou Zou* (directed by Marc Allegret), is released in France.

◉ Paul Robeson and Nina Mae McKinney star in Alexander Korda's film *Sanders of the River*.

◉ Oscar Micheaux releases *Harlem after Midnight*.

◉ Malvin Gray Johnson dies in New York.

◉ Doris Ulmann dies in New York.

◉ Zora Neale Hurston's first novel, *Jonah's Gourd Vine*, is published.

1935

◉ A major riot in Harlem is triggered by protest against the discriminatory employment policies of white-owned stores in Harlem.

◉ Miguel Covarrubias illustrates Zora Neale Hurston's ethnographic study *Mules and Men*.

◉ Aaron Douglas is elected President of the Harlem Artists' Guild.

◉ A memorial exhibition for Malvin Gray Johnson is held at the Delphic Studios Gallery in New York.

◉ The Museum of Modern Art mounts the important exhibition *African Negro Art*.

◉ Josephine Baker's film, *Princesse Tam Tam* (directed by Edmond Greville), is released in France.

◉ George Gershwin's American folk opera, *Porgy and Bess*, premieres at the Alvin Theatre in New York.

◉ Carl Van Vechten holds his first exhibition of photographs in *The Leica Exhibition* at Bergdorf Goodman in New York.

◉ Oscar Micheaux releases *Lem Hawkin's Confession*.

◉ Paul Robeson and Hattie McDaniel appear in James Whales's film musical *Show Boat*.

◉ Archibald J. Motley Jr serves as artist-in-residence at Howard University in Washington, D.C.

◉ Jamaican sculptor Ronald C. Moody exhibits at the Adams Gallery in London.

◉ Bill Robinson's 'Mr. Bojangles' film career begins with *The Littlest Rebel*.

1936

● Jessie Owens makes history at the Berlin Olympics by winning four gold medals.

● Artist and art historian James A. Porter receives a Master's degree from New York University.

● Miguel Covarrubias moves back to Mexico City.

● A film version of Marc Connelly's play *The Green Pastures* is released.

● Jacob Lawrence is awarded a scholarship to the American Artists' School in New York.

● A play using Haiti as a setting opens at the Lafayette Theatre in Harlem: *Macbeth*, produced by John Houseman for the Harlem Unit of the Federal Theatre Project and directed by Orson Welles.

● Oscar Micheaux releases his film *Temptation*.

● Hale Woodruff travels to Mexico City where he studies mural painting with Diego Rivera.

● Aaron Douglas creates murals for the Hall of Negro Life at the Texas Centennial Exposition in Dallas, Texas. The *Exhibition of Fine Art Productions by American Negroes* is also held in conjunction with the Exposition.

● Richard Samuel Roberts dies in Columbia, South Carolina.

● Ronald C. Moody exhibits at the Walker Art Gallery in Liverpool.

● Paul Robeson stars in J. Elder Wills's film *Song of Freedom*.

1937

● Edna Manley exhibits her sculptures at the Jamaican Mutual Life Assurance Society in Kingston, Jamaica, and at the French Gallery in London.

● Aaron Douglas joins the faculty of Fisk University in Nashville, Tennessee.

● Loïs Mailou Jones travels to Paris for a year of study at L'Académie Julian.

● Ronald C. Moody is included in *Tropiques*, a group exhibition (with Henri Matisse, André Lhote, Raoul Dufy and others) at Galerie Billiet in Paris.

● Oscar Micheaux releases his film *Underworld*.

● Cedric Dover, a sociologist of English and East Indian ancestry, publishes *Half-Caste*, a study tracing the cultural contributions of mixed-race peoples (including African-Americans).

● At the instigation of photographer Louise Dahl-Wolfe, William Edmondson (a self-taught stone-carver from Nashville, Tennessee) is given a solo exhibition at the Museum of Modern Art. He is the first African-American artist to be given this opportunity.

● Paul Robeson stars in the film *King Solomon's Mines*, along with Cedric Hardwicke and Roland Young.

● Henry Ossawa Tanner dies in Paris.

1938

● Ronald C. Moody exhibits his sculptures at the Van Lier Gallery in Amsterdam and later at the Salon des Tuileries and L'Equipe in Paris.

● Paul Robeson stars in J. Elder Wills's film *Big Fella* and Thornton Freeland's film *Jericho*.

● Oscar Micheaux releases two films: *Gold's Stepchildren* and *Swing*.

● The African-American cultural spokesperson James Weldon Johnson is killed in an automobile accident.

● Another play with a Haitian setting and theme, *Haiti* (by William DuBois and starring Rex Ingram), opens at the Lafayette Theatre.

● Zora Neale Hurston publishes *Tell My Horse*, an anthropological study of Jamaican and Haitian culture.

● After eight years of living and working abroad, mainly in Denmark and Norway, William H. Johnson returns to the United States and settles in New York.

● Hale Woodruff completes two murals for the Savery Library at Talladega College in Talladega, Alabama.

● Charles Alston completes his *Magic and Medicine* murals for the Harlem Hospital in New York.

● Richmond Barthé completes his *Dance* reliefs for the Harlem River Houses in New York.

● Jacob Lawrence holds his first solo exhibition at the Harlem YMCA and completes his *Toussaint L'Ouverture* series.

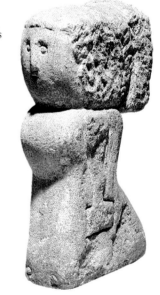

Right:
20 **William Edmondson**
Nurse, c. 1940

LIST OF WORKS

Measurements are in centimetres,
height x width

1 Charles Alston
Girl in a Red Dress, 1934
oil on canvas, 71 x 55.9
Collection of Harmon and Harriet
Kelley
© The Harmon and Harriet Kelley
Collection of African American Art

2 Richmond Barthé
The Blackberry Woman, 1932
bronze, 86 x 36.2 x 31.4
Whitney Museum of American Art,
New York. Purchase 32.71

3 Richmond Barthé
African Dancer, 1933
plaster, 110.5 x 43.3 x 37.3
Whitney Museum of American Art,
New York. Purchase 33.53
photograph © Whitney Museum
of American Art, 1997

4 Richmond Barthé
Feral Benga, 1935
bronze, 48.3 x 12.7 diameter
John P. Axelrod, Boston, Mass.

5 Richmond Barthé
Stevadore, 1937
bronze, 77.5 x 41.9 x 6.4
John P. Axelrod, Boston, Mass.

6 Edward Burra
Harlem, 1934
ink and gouache on paper,
79.4 x 57.1
Tate Gallery (purchased 1939)
© Tate Gallery, London, 1997

7 Edward Burra
Harlem, 1934
watercolour and bodycolour
on paper, 55.3 x 41.9
The Trustees, The Cecil Higgins Art
Gallery, Bedford
© Estate of Edward Burra, c/o Alex Reid
& Lefevre Ltd, 1997

8 Miguel Covarrubias
Rhapsody in Blue, c. 1927
mixed media, 68 x 78.5
Private Collection, Mexico, D.F.

9 Miguel Covarrubias
Lindy Hop, 1936
lithograph, 53.3 x 42.5
Michael and Teresa Grana

10 Miguel Covarrubias
Rumba, 1936
lithograph, 40.6 x 50.8
Michael and Teresa Grana

11 Aaron Douglas
Defiance (from *Emperor Jones*
series), n.d.
gouache on paper, 61.6 x 44.5
Aaron Douglas Collection, The Amistad
Research Center, Tulane University,
New Orleans, Louisiana

12 Aaron Douglas
*Surrender, Forest Fear (Flight),
Defiance, Bravado* (from *Emperor
Jones* series), n.d.
linoleum cuts, 22.9 x 16.5
Aaron Douglas Collection, The Amistad
Research Center, Tulane University,
New Orleans, Louisiana

13 Aaron Douglas / Langston Hughes
Portfolio, 1926
Five lithographs, each 40.6 x 29.2,
cover 49.5 x 33
Schomburg Center for Research in Black
Culture, Art & Artifacts Division, The New
York Public Library, Astor, Lenox and
Tilden Foundations

14 Aaron Douglas
*Aspects of Negro Life: An Idyll of
the Deep South*, 1934
oil on canvas, 152.4 x 353
Schomburg Center for Research in Black
Culture, Art & Artifacts Division, The New
York Public Library, Astor, Lenox and
Tilden Foundations
photograph: Manu Sassoonian

15 Aaron Douglas
*Aspects of Negro Life: From Slavery
Through Reconstruction*, 1934
oil on canvas, 152.4 x 353
Schomburg Center for Research in Black
Culture, Art & Artifacts Division, The New
York Public Library, Astor, Lenox and
Tilden Foundations
photograph: Manu Sassoonian

16 Aaron Douglas
*Aspects of Negro Life: The Negro in
an African Setting*, 1934
oil on canvas, 182.9 x 199.4
Schomburg Center for Research in Black
Culture, Art & Artifacts Division, The New
York Public Library, Astor, Lenox and
Tilden Foundations
photograph: Manu Sassoonian

17 **Aaron Douglas**
Cover illustration for *Spark*, 1934
conté pencil, 39 x 27.6
Schomburg Center for Research in Black
Culture, Art & Artifacts Division, The New
York Public Library, Astor, Lenox and
Tilden Foundations
photograph: Laurel Duplessis

18 **Aaron Douglas**
Aspiration, 1936
oil on canvas, 152.4 x 152.4
The Estate of Thurlow E. Tibbs Jr
© The Estate of Thurlow E. Tibbs Jr, 1936

19 **Aaron Douglas**
Into Bondage, 1936
oil on canvas, 153.4 x 153.7
In the Collection of The Corcoran Gallery
of Art, Washington D.C. Gift of Mr
Thurlow E. Tibbs Jr, The Evans-Tibbs
Collection

20 **William Edmondson**
Nurse, c. 1940
limestone, 29.8 x 7 x 17.8
John P. Axelrod, Boston, Mass.

21 **Sir Jacob Epstein**
*Portrait Bust of Paul Robeson
(1898–1976)*, 1928
bronze, 34.5 x 21.5 x 29.5
York City Art Gallery (purchased 1955)
© Estate of the artist, 1997

22 **Walker Evans**
42nd Street, 1929
silver print photograph on card,
c. 1932, 12 x 19.7
Collection of Vernon Pratt, Durham,
North Carolina
© Walker Evans Archive,
The Metropolitan Museum of Art

23 **Walker Evans**
Citizen in Downtown Havana, 1932
gelatin silver print, 17.9 x 9.7
Collection of Jock Reynolds and
Suzanne Hellmuth
photograph: Greg Heins, Boston
© Walker Evans Archive,
The Metropolitan Museum of Art

24 **Meta Vaux Warrick Fuller**
Ethiopia Awakening, n.d.
cast stone and plaster, painted,
33.7 x 8.3 x 8.9
Collection Meta Warrick Fuller Legacy,
Inc., Framingham, Mass.

25 **Palmer C. Hayden**
Untitled (Life passing before him),
n.d.
watercolour on paper, 36.8 x 24.8
John P. Axelrod, Boston, Mass.

26 **Palmer C. Hayden**
*The Lean Years of Paris
(Self-portrait, shaving)*, 1930
watercolour on paper, 45.7 x 31.8
John P. Axelrod, Boston, Mass.

27 **Palmer C. Hayden**
10th Cavalry Trooper, May 1939
oil on canvas, 50.8 x 77.5
Collection of George and Joyce Wein

28 **Malvina Hoffman**
Mangbetu Woman, 1930
bronze, 84 x 48 x 48
The Field Museum, Chicago, Illinois
photograph: M. Hoffman, negative
number MH14A
© The Field Museum, Chicago, Illinois

29 **Malvin Gray Johnson**
Negro Soldier, 1934
oil on canvas, 96.5 x 76.2
Schomburg Center for Research in Black
Culture, Art & Artifacts Division, The New
York Public Library, Astor, Lenox and
Tilden Foundations
photograph: Manu Sassoonian

30 **Malvin Gray Johnson**
Postman, 1934
oil on canvas, 76.2 x 76.2
Schomburg Center for Research in Black
Culture, Art & Artifacts Division, The New
York Public Library, Astor, Lenox and
Tilden Foundations
photograph: Manu Sassoonian

31 **Malvin Gray Johnson**
Self-Portrait, 1934
oil on canvas, mounted on canvas,
97.2 x 76.2
National Museum of American Art,
Smithsonian Institution. Gift of the
Harmon Foundation

32 **Sargent Claude Johnson**
Mask, 1930–35
bronze mounted on wooden base,
39.4 x 34.3 x 15.3
National Museum of American Art,
Smithsonian Institution. Gift of
International Business Machines
Corporation

33 **Sargent Claude Johnson**
Lenox Avenue, c. 1938
lithograph, 31.7 x 21.8
National Museum of American Art,
Smithsonian Institution. Transfer from
the D.C. Public Library

34 **William H. Johnson**
Little Girl, c. 1930
oil on canvas, 53.6 x 43.9
National Museum of American Art,
Smithsonian Institution. Gift of the
Harmon Foundation

35 **William H. Johnson**
Portrait Study No. 16, c. 1930
oil on canvas, 58.7 x 48.6
National Museum of American Art,
Smithsonian Institution. Gift of the
Harmon Foundation

36 **William H. Johnson**
Portrait of a Boy, c. 1935–1938
oil on burlap, 63.9 x 53.9
National Museum of American Art,
Smithsonian Institution. Gift of the
Harmon Foundation

37 **William H. Johnson**
Self-Portrait with Bandana,
c. 1935–1938
oil on burlap, 63.8 x 53.5
National Museum of American Art,
Smithsonian Institution. Gift of the
Harmon Foundation

38 **Loïs Mailou Jones**
The Ascent of Ethiopia, 1932
oil on canvas, 59.7 x 43.8
Milwaukee Art Museum. Purchase,
African-American Art Acquisition Fund,
matching funds from Suzanne and
Richard Pieper, with additional support
from Arthur and Dorothy Nelle Sanders
© the artist, 1997

39 **Loïs Mailou Jones**
Les Fétiches, 1938
oil on canvas, 53.3 x 64.8
National Museum of American Art,
Smithsonian Institution. Museum
purchase made possible by Mrs N.H.
Green, Dr R. Harlan and Francis Musgrave
© the artist, 1997

40–80 **Jacob Lawrence**
Toussaint L'Ouverture Series,
1937–38
41 panels: gouache on paper,
each 27.9 x 48.3
Aaron Douglas Collection, The Amistad
Research Center, Tulane University, New
Orleans, Louisiana

81 **Man Ray**
Noire et Blanche, 1926
gelatin silver print over-painted
with gouache, 21.9 x 27.6
Private Collection, New York

82 **Man Ray**
Untitled, c. 1935
photograph, 30.8 x 20.8
Collection L. Treillard, Paris

83 **Edna Manley**
Negro Aroused, 1935
bronze, 1982, 78 x 57 x 31.7
Wallace Campbell, Kingston, Jamaica

84 **Ronald C. Moody**
Midonz (Goddess of Transmutation),
1937
elm, 72 x 38 x 44.5
The Artist's Collection, courtesy
of Cynthia Moody
© Cynthia Moody

85 **Archibald J. Motley Jr**
*Woman Peeling Apples (Mammy)
(Nancy)*, 1924
oil on canvas, 82.5 x 71.1
Schomburg Center for Research in Black
Culture, Art & Artifacts Division,
The New York Public Library, Astor,
Lenox and Tilden Foundations
photograph: Manu Sassoonian
© Archie Motley

86 **Archibald J. Motley Jr**
Cocktails, c. 1926
oil on canvas, 81.3 x 101.6
John P. Axelrod, Boston, Mass.
© Archie Motley

87 **Archibald J. Motley Jr**
Blues, 1929
oil on canvas, 80 x 100.3
Collection of Archie Motley and Valerie
Gerrard Browne
© Archie Motley

88 **Archibald J. Motley Jr**
Jockey Club, 1929
oil on canvas, 65.4 x 81.3
Schomburg Center for Research in Black
Culture, Art & Artifacts Division, The New
York Public Library, Astor, Lenox and
Tilden Foundations
photograph: Manu Sassoonian
© Archie Motley

89 **Archibald J. Motley Jr**
Tongues (Holy Rollers), 1929
oil on canvas, 74.3 x 91.7
Collection of Archie Motley and Valerie
Gerrard Browne
© Archie Motley

180

LIST OF WORKS

90 Archibald J. Motley Jr
Brown Girl After the Bath, 1931
oil on canvas, 122.5 x 91.4
Collection of Archie Motley and Valerie
Gerrard Browne
© Archie Motley

91 Archibald J. Motley Jr
The Plotters, 1933
oil on canvas, 91.4 x 101.6
The Walter O. Evans Collection of
African-American Art (Travelling
Exhibition)
© Archie Motley

92 Archibald J. Motley Jr
Saturday Night Street Scene, 1936
oil on canvas, 91.4 x 106.7
Private Collection, LA. Courtesy of
Michael Rosenfeld Gallery, New York
© Archie Motley

93 Winold Reiss
Harlem at Night, c. 1924
ink on paper, 49.5 x 36.8
Collection of W. Tjark Reiss.
Courtesy of Shepherd Gallery
Reproduced with permission

94 Winold Reiss
*Elise Johnson McDougald
(1885–1971)*, c. 1924
pastel on board, 76.4 x 54.8
National Portrait Gallery, Smithsonian
Institution, Washington D.C. Gift of
Lawrence A. Fleischman and Howard
Garfinkle with a matching grant from the
National Endowment for the Arts
Reproduced with permission

95 Winold Reiss
Harlem Girl, I, c. 1925
pencil, charcoal and pastels on
heavy illustration board, 55.5 x 37.8
Museum of Art and Archaeology,
University of Missouri-Columbia.
Gift of Mr W. Tjark Reiss
Reproduced with permission

96 Winold Reiss
Harlem Girl with Blanket, c. 1925
pastel on paper, 74.9 x 49.5
Collection of W. Tjark Reiss.
Courtesy of Shepherd Gallery
Reproduced with permission

97 Winold Reiss
Interpretation of Harlem Jazz I,
c. 1925
ink on paper, 49.5 x 36.8
Collection of Henry S. Field
Reproduced with permission

98 Winold Reiss
Langston Hughes (1902–67), 1925
pastel on board, 76.3 x 54.9
National Portrait Gallery, Smithsonian
Institution, Washington D.C. Gift of
Tjark Reiss, in memory of his father,
Winold Reiss
Reproduced with permission

99 Richard S. Roberts
*John Hiller (standing centre) and
Alice Johnson Hiller (seated centre)
with their children Simmie, Bernice,
Samuel and Benjamin*, 1920s
silver gelatin print, 18 x 14.5
© Estate of Richard Samuel Roberts

100 Richard S. Roberts
Annie Mae Manigault (1907–76),
1920s
silver gelatin print, 17.2 x 12.5
© Estate of Richard Samuel Roberts

101 Richard S. Roberts
*Unidentified portrait (man with
pistol)*, 1920s
silver gelatin print, 17.4 x 10.4
© Estate of Richard Samuel Roberts

102 Richard S. Roberts
*Unidentified portrait (two young
women in hats with corsages)*,
1920s
silver gelatin print, 17.4 x 10.4
© Estate of Richard Samuel Roberts

103 Richard S. Roberts
*Unidentified portrait (well-dressed
man)*, 1920s
silver gelatin print, 18.4 x 14.3
© Estate of Richard Samuel Roberts

104 Richard S. Roberts
Cornelius C. Roberts (b. 1913), c. 1925
silver gelatin print, 17.5 x 10.4
© Estate of Richard Samuel Roberts

105 Richard S. Roberts
*Robert Harper Kennedy (d. 1972)
and nephew Hale B. Thompson Jr
(b. 1922)*, c. 1927
silver gelatin print, 18.1 x 14.3
© Estate of Richard Samuel Roberts

106 Augusta Savage
Gamin, 1930
bronze, 41.9 x 21.2 x 17.8
Schomburg Center for Research in Black
Culture, Art & Artifacts Division, The New
York Public Library, Astor, Lenox and
Tilden Foundations
photograph: Manu Sassoonian

107 Augusta Savage
John Henry, c. 1940
patinated plaster, 16.5 x 10 x 10
John P. Axelrod, Boston, Mass.

108 Albert Alexander Smith
Dancing Time, 1930
oil on canvas, 51 x 61.4
Hampton University Museum,
Hampton Virginia

109 Albert Alexander Smith
Temptation, 1930
lithograph, 21.6 x 27.9
Schomburg Center for Research in Black
Culture, Art & Artifacts Division, The New
York Public Library, Astor, Lenox and
Tilden Foundations

110 Doris Ulmann
Baptism Scene, South Carolina,
1929–30
photograph, 20.3 x 15.2
Division of Special Collections and
University Archives, University of
Oregon

111 Doris Ulmann
Black Grave, South Carolina,
1929–30
platinum print, NYHS #84,
15.2 x 19.7
The New-York Historical Society,
New York
© Collection of The New-York
Historical Society

112 Doris Ulmann
Foot Washing, South Carolina,
1929–30
platinum print, NYHS #430,
19.7 x 14.9
The New-York Historical Society,
New York
© Collection of The New-York
Historical Society

113 Doris Ulmann
Head Portage, South Carolina,
1929–30
photograph, 20.3 x 15.2
Division of Special Collections and
University Archives, University of
Oregon

114 Doris Ulmann
Nun with Girl, New Orleans, 1931
platinum print, NYHS #444,
19.7 x 14.9
The New-York Historical Society,
New York
© Collection of The New-York
Historical Society

115 James VanDerZee
*The VanDerZee Men, Lenox,
Massachusetts*, 1908
photograph, 15.9 x 12.7
Schomburg Center for Research in Black
Culture, The New York Public Library
photograph courtesy Donna VanDerZee
© Donna Mussenden VanDerZee

116 James VanDerZee
*Kate and Rachel VanDerZee, Lenox,
Massachusetts*, 1909
photograph, 18.4 x 15.9
Schomburg Center for Research in Black
Culture, The New York Public Library

117 James VanDerZee
Miss Suzie Porter, Harlem, 1915
photograph, 19 x 15.9
Schomburg Center for Research in Black
Culture, The New York Public Library
photograph courtesy Donna VanDerZee
© Donna Mussenden VanDerZee

118 James VanDerZee
Victory Parade of 369th Regiment,
1919
photograph on paper, 25.4 x 30.5
Donna VanDerZee
photograph courtesy Donna VanDerZee
© Donna Mussenden VanDerZee

119 James VanDerZee
Nude, Harlem, 1923
photograph, 24 x 18.7
Schomburg Center for Research in Black
Culture, The New York Public Library
photograph courtesy Donna VanDerZee
© Donna Mussenden VanDerZee

120 James VanDerZee
Marcus Garvey in a UNIA Parade,
1924
photograph, 20.5 x 25.4
Schomburg Center for Research in Black
Culture, The New York Public Library
photograph courtesy Donna VanDerZee
© Donna Mussenden VanDerZee

121 James VanDerZee
Protest Parade, 1924
photograph, 20.3 x 25.4
Schomburg Center for Research in Black
Culture, The New York Public Library
photograph courtesy Donna VanDerZee
© Donna Mussenden VanDerZee

122 James VanDerZee
Dancer, Harlem, 1925
photograph, 17.1 x 12.1
Schomburg Center for Research in Black
Culture, The New York Public Library
photograph courtesy Donna VanDerZee
© Donna Mussenden VanDerZee

123 **James VanDerZee**
Swimming Team, Harlem, 1925
photograph, 6 x 23.5
Schomburg Center for Research in Black
Culture, The New York Public Library

124 **James VanDerZee**
Alpha Phi Alpha Basketball Team,
1926
gelatin silver print, 24.1 x 17.8
In the Collection of The Corcoran Gallery
of Art, Washington D.C. Gift of Mr Thurlow
E. Tibbs Jr, The Evans-Tibbs Collection

125 **James VanDerZee**
Dancing School, 1928
photograph on paper, 25.4 x 30.5
Donna VanDerZee
photograph courtesy Donna VanDerZee
© Donna Mussenden VanDerZee

126 **James VanDerZee**
The Barefoot Prophet, 1929
photograph on paper, 30.5 x 25.4
Donna VanDerZee
photograph courtesy Donna VanDerZee
© Donna Mussenden VanDerZee

127 **James VanDerZee**
Black Jews, Harlem, 1929
photograph, 19.1 x 23.5
Schomburg Center for Research in Black
Culture, The New York Public Library
photograph courtesy Donna VanDerZee
© Donna Mussenden VanDerZee

128 **James VanDerZee**
Self Portrait, 1931
photograph on paper, 25.4 x 30.5
Donna VanDerZee
photograph courtesy Donna VanDerZee
© Donna Mussenden VanDerZee

129 **James VanDerZee**
Couple, Harlem, 1932
photograph, 19.1 x 23.5
Schomburg Center for Research in Black
Culture, The New York Public Library
photograph courtesy Donna VanDerZee
© Donna Mussenden VanDerZee

130 **Carl Van Vechten**
Zora Neale Hurston (1891–1960),
3 April 1935
photogravure, 1983, from 1935
negative, 22.5 x 14.9
National Portrait Gallery, Smithsonian
Institution, Washington D.C.
Joseph Solomon, as Executor of the
Estate of Carl Van Vechten

131 **Carl Van Vechten**
Bessie Smith (1894–1937),
3 February 1936
photogravure, 1983, from 1935
negative, 22.4 x 14.9
National Portrait Gallery, Smithsonian
Institution, Washington D.C.
Joseph Solomon, as Executor of the
Estate of Carl Van Vechten

132 **James Lesesne Wells**
Cover for The Negro Wage Earner,
1930
offset print of linoleum cut,
22.9 x 36.2
Addison Gallery of American Art, Phillips
Academy, Andover, Mass. Gift of the artist

FILMS

Within Our Gates, 1919
Dir. Oscar Micheaux
Courtesy of the Filmoteca Espanol
Collection, Spain

Josephine Baker in Berlin, 1927
Excerpt from *Double Headed Eagle*
Dir. Lutz Becker
Courtesy Lutz Becker
© VPS 1971

Borderline, 1927
Dir. Kenneth Macpherson and H.D.
Courtesy of George Eastman House,
New York

Eleven PM, 1927
Dir. Richard Maurice
Courtesy of the Library of Congress,
Washington D.C.

Sur un air de Charleston or
Charleston, 1927
Dir. Jean Renoir
Courtesy of UGC DA International, Paris,
and the National Film Archive, London

Zou Zou, 1934
Dir. Marc Allegret
Courtesy of Editions René Chateau, Paris

Song Of Freedom, 1936
Dir. J. Elder Wills
Courtesy of the Raymond Rohauer
Estate, New York

Looking for Langston, 1989
Dir. Isaac Julien
Courtesy of BFI Films, London
© Isaac Julien and Sankofa Film & Video

Contributors

MARTINA ATTILLE

Born in St Lucia and resident in London since 1961, Martina Attille is a film-maker and lecturer for whom representations of black women remain a central and complex narrative device. Continuing the proposition of her award-winning film *Dreaming Rivers* (1988), her project, *Urban Loving*, seeks out a geography of desire specific to a local expression of time and space. Presently a member of the Black Women Artists' Study Group, established in 1995, she was formerly a founding member of Sankofa Film and Video Collective (1984). She has lectured at the University of California, San Diego, Duke University, North Carolina, and Goldsmiths College, University of London.

DAVID A. BAILEY

David A. Bailey is a photographer, writer, curator and lecturer. He is a founder member of Autograph, the Association of Black Photographers, and has served as a board member and committee member on a wide range of arts organisations and individual projects. He was co-editor, with Stuart Hall, of *The Critical Decade: Black British Photography in the 1980s*, published in 1992, on black artists and theorists who have been at the vanguard of shaping and contextualising black British contemporary art practice. He was curator of *Mirage: Enigmas of Race, Difference and Desire* at the Institute of Contemporary Arts in 1995. He is currently Co-director of the African and Asian Visual Artists' Archive (AAVAA), London.

ANDREA D. BARNWELL

Andrea D. Barnwell is a PhD candidate in the Department of Art and Art History at Duke University, Durham, North Carolina. Her primary research interests include the Arts of West Africa and the Black Americas. She is currently writing her dissertation entitled *Three Contemporary African Women Artists: (Re)Appropriating Her Own Image*.

SIMON CALLOW

Simon Callow is an actor, director and writer. He has appeared on stage (as Faust in *Faust*, 1988, and Burgess in *Single Spies*, 1989), in many films (notably as Gareth in the hugely popular *Four Weddings and a Funeral*, 1994), and on television (as Mr Micawber in *David Copperfield*, 1986, and John Mortimer in *Trial of OZ*, 1991). His books include *Being an Actor* (1984), *Shooting the Actor* (1990), *Orson Welles: The Road to Xanadu* (1995) and a highly acclaimed biography of Charles Laughton (1987). He reviews books and provides diary contributions for many newspapers including *The Times* and the *Evening Standard*. *Carmen Jones* (1991) and *Les Enfants Du Paradis* (1996) are among the the plays he has directed.

HENRY LOUIS GATES JR

Henry Louis Gates is W.E.B. Du Bois Professor of Humanities at Harvard University and Director of Harvard's W.E.B. Du Bois Institute for Afro-American Research. He is a member of the American Philosophical Society, the Association for the Study of Afro-American Life and History, and the Council on Foreign Relations. He serves on numerous academic and civic boards and committees, including the Schomburg Commission for the Preservation of Black Culture, the American Civil Liberties Union National Advisory Council and the Black Community Crusade for Children. His books include *Thirteen Ways of Looking at a Black Man* (1997), *Colored People: A Memoir* (1994), *Loose Canons: Notes on the Culture Wars* (1992), *The Signifying Monkey: Towards a Theory of Afro-American Literary Criticism* (1988), and *Figures in Black: Words, Signs, and the Racial Self* (1987). He is general editor of the *Norton Anthology of African-American Literature*, a staff writer for the *New Yorker*, and co-editor of *Transition* magazine.

PAUL GILROY

Paul Gilroy is Professor of Sociology and Cultural Studies at Goldsmiths College, University of London. He has also been associated with the program in African and African American Studies at Yale University. He is currently completing a study of black intellectuals' responses to fascism. He is the author of *There Ain't No Black in the Union Jack* (1987) and *Black Atlantic* (1993).

RICHARD J. POWELL

Richard J. Powell is Associate Professor and Chairman of the Department of Art and Art History at Duke University, North Carolina. He studied Fine Arts at Morehouse College and Howard University before completing his PhD in Art History at Yale University. His articles and essays on topics ranging from primitivism to post-modernism have appeared widely, and his books include *The Blues Aesthetic: Black Culture and Modernism* (1989), *Homecoming: The Art and Life of William H. Johnson* (1991) and *Black Art and Culture in the 20th Century* (1997).

JEFFREY C. STEWART

Jeffrey C. Stewart is an Associate Professor of History and Director of African-American Studies at George Mason University. He holds a PhD in American Studies from Yale University and has contributed to the new generation of critical thinking on African-American history and culture through scholarly publications and museum catalogues, including: *To Color America: Portraits by Winold Reiss* (1989), *Race Contacts and Inter-racial Relations: Lectures by Alain Locke* (1992), *1001 Things Everyone Should Know About African American History* (1996), and several catalogue essays, most recently in *The Migration Series by Jacob Lawrence* (Phillips Collection, 1993). He is curator of the forthcoming exhibition, *Paul Robeson: Here I Stand*, which opens at the Jane Zimmerli Art Museum at Rutgers University in 1998, and the author of the forthcoming biography *The Education of Alain Locke* to be published by Oxford University Press.